GRANITE AND GREEN

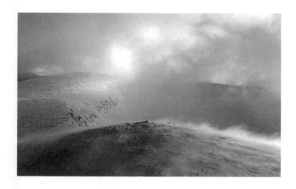

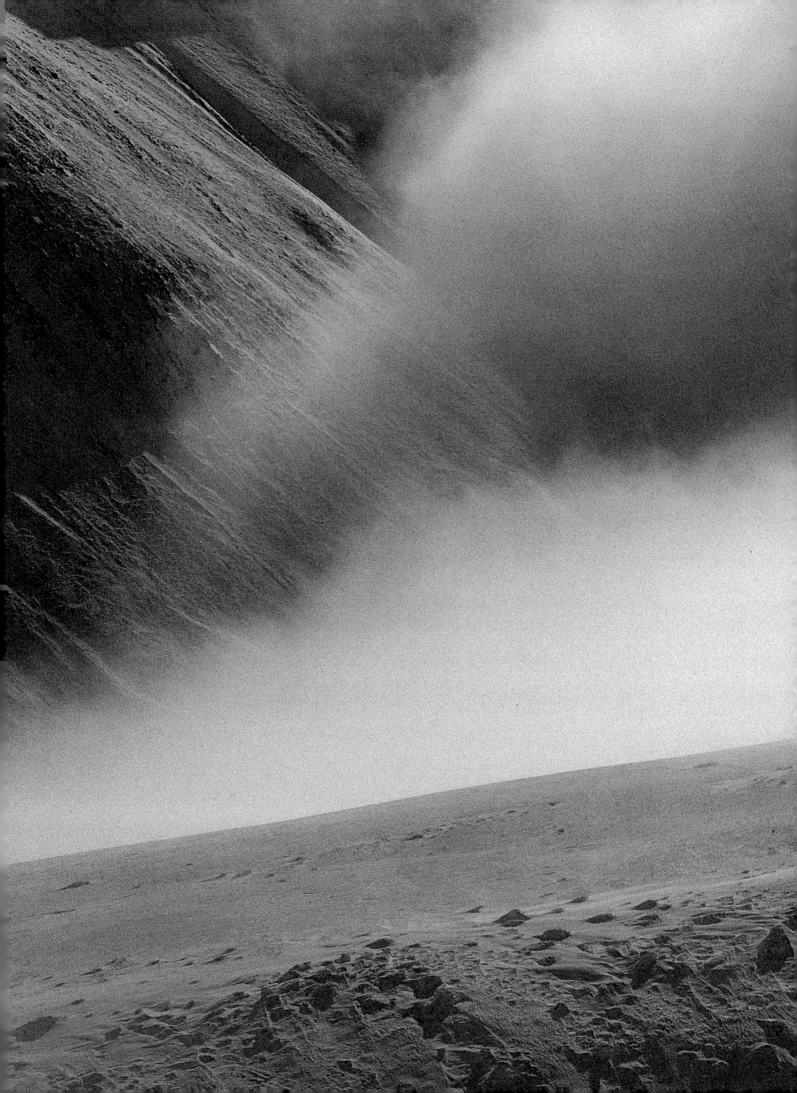

GRANITE
AND GREEN

ABOVE NORTH-EAST SCOTLAND

ANGUS & PATRICIA MACDONALD

Introduction by
JAMES NAUGHTIE

MAINSTREAM PUBLISHING

EDINBURGH AND LONDON

For J. Gordon and Muriel Macintyre

First published in Great Britain 1992 by
MAINSTREAM PUBLISHING COMPANY (EDINBURGH) LTD
7 Albany Street
Edinburgh EH1 3UG

ISBN 1 85158 465 X (cloth)

A catalogue record for this book is available from the British Library

Typeset in 11/13 Garamond by
Blackpool Typesetting Services Ltd, Blackpool
Printed in Singapore by Toppan Printing Co Ltd
Book design by James Hutcheson and Paul Keir

CONTENTS

ACKNOWLEDGMENTS

WE WOULD LIKE TO THANK WARMLY ALL THOSE PEOPLE who have helped in many different ways in the preparation of this book, especially the following: Donald and Aileen Addison, John Hume, Charles McKean and Colin Wishart, all of whom read and helpfully commented on parts of the typescript, and particularly John Fyfe who nobly read all of it – any errors which it nevertheless contains remain, of course, entirely our responsibility; Gordon and Muriel Macintyre – their book; David Todd and colleagues; the staff of Edinburgh Air Centre: John Easson, Tom Carson, Jim Dalgleish, Connie Weir and Colin Williamson; at Edinburgh Flying Club: Dave Andrews, John Berry, Bob Graham, John Lawson and Ian Martin; Air Traffic Services and Meteorological Offices at Kirkwall, Inverness and Aberdeen Airports, Air Traffic Control at RAF Lossiemouth; for film supplies, processing and pre-press help, Norman Houston and Martin Baker of J. Lizars Ltd (Wholesale Department); the staff of Eastern Photocolour Ltd; the staff of Xpress Print Ltd; for their patience and expertise in bringing the book into being, the staff and associates of Mainstream Publishing, especially Bill Campbell, Peter MacKenzie, Penny Clarke, Judy Moir, Judy Diamond, Claire Watts and Janene Reid; for a sympathetic and lively design, James Hutcheson and Paul Keir; for his enthusiasm and his excellent introduction, James Naughtie.

We are also grateful to the following for permission to quote from copyright material in their possession: Faber and Faber, Canongate Publishing, Methuen, Kenneth White, John Murray, Robin Munro, Janet Waller, Aberdeen University Press, The National Library of Scotland and George Bruce.

Angus and Patricia Macdonald
Edinburgh, April 1992

PREFACE

IN THE LATE SIXTEENTH CENTURY, JAMES VI OF Scotland described his kingdom as 'a beggar's mantle fringed with gold'. The fringe of gold was the coast of Fife, including the trading burghs which are strung out along it. In the words of Andrew Fairservice in Walter Scott's *Rob Roy*, this coast was '. . . from Culross to the East Nuik . . . just like a great combined city. Sae mony royal boroughs yoked on end to end . . .'.

Although the Fife coast represented perhaps the greatest concentration of burghs in Scotland, the fertile green howes and prosperous towns of the whole east coast, from the Lothians in the south to Shetland in the north, could be thought of as part of the 'fringe of gold'. Throughout its length it is graced by royal burghs which in medieval and renaissance times were the gateways through which trade and ideas flowed between the rich coastal lowlands of Scotland and the trading ports of northern Europe. The money to pay for imported luxuries was generated by the trading burghs and the goods themselves were imported through them, but the farmland on the coastal lowlands also played its part because it was the export of agricultural surplus, as well as fish, salt and coal, which provided the basis for the trade.

The 'beggar's mantle' of James's description of his kingdom was the hinterland of uplands of granite and ancient rock – the main landmass of the Highlands of Scotland. By describing them thus it is clear that James regarded the Highlands as a kind of wilderness, a barren area which constituted a threat to the wellbeing of the 'civilised' parts of his kingdom. This view of Scotland tells us much about the cultural attitudes of its author. It is a partisan statement from one side of a cultural divide which has existed in Scotland since the times in which Anglo-Norman feudalism took over the lowlands and pushed the more ancient Gaelic culture into the Highlands. It is also a modernist view expressed at the beginning of the emergence of modern Scotland. It is the view of a lover of material possessions, fine clothes and fine wines, of a believer in the idea of progress and a supporter of commerce. The burghs symbolised these modern values and the activities which they generated – commerce, enterprise, the exchange of ideas with the mercantile states of northern Europe – brought Scotland out of the 'dark ages' and into the modern age.

The modernist view is optimistic; it embraces the idea of progress, especially technical progress, and places a high value on the rationalist ideas which allow this to come about. It is a view which regards the 'natural world', the 'wilderness', as at best a treasure house which provides the resources with which civilised people progress, and at worst a sinister, unknown region which is a threat to civilisation, and which, for

the good of mankind, should be conquered and tamed. Such, for many centuries, was the attitude of 'civilised' lowland Scotland to the Highlands. And it was not just wild nature which was perceived as a threat but the Gaelic culture itself. This culture was traditional rather than modern. It regarded nature as something to which humans should accommodate themselves rather than something which should be dominated – a world view largely incompatible with the idea of progress and which slowed down the introduction of commerce, industry and a materialist, cash-based economy into the Highlands of Scotland. Highly sophisticated though this culture was – its bardic schools were its universities – it was, nevertheless, systematically suppressed in Scotland from the time of James VI onwards.

The cultural divide between Highlands and Lowlands is the subject of many of the ballads of the North-east. *Katharine Jaffray*, the original upon which Walter Scott's *Young Lochinvar* is based, is an excellent example. As James Alison, the editor of *Poetry of Northeast Scotland*, has put it, these ballads are 'true "border" ballads, the border being the frontier between the Gaelic-speaking highlands and the Scots-speaking lowlands. This line ran from Glenesk by the forest of Birse and the Pass of Ballater, skirting the Garioch, into Strathbogie. Out of the west came caterans, wild naked "Irishes", thieves of cattle and womenfolk, jolly beggars, wandering pipers and fiddlers, impoverished chieftains and penniless students – all of whom the douce lowlanders ridiculed and feared; but perhaps secretly admired.'

This book deals mainly with the 'fringe of gold', the part of Scotland which, since the foundation of those lamplighters of modernism, the burghs, has been completely conquered by the modern way of life. It also covers the eastern edge of the 'beggar's mantle', the uplands of the North-east. These may both be contrasted with the western Highlands and Islands which, though also part of the modern world, have never espoused the materialist culture in quite the same way, still retaining some vestiges of the Gaelic way of life, not the least of which is the Gaelic language itself.

This book is concerned, therefore, with a part only of that area of Scotland north of the Central Lowlands. The fascination of the North-east is that it lies on the boundary between modern, mercantilist Europe and a more ancient culture which has been pushed to its edge. But the very fact that the ancient cultures with their traditional values still exist may be important for the future development of Europe, in which the modern way of life is becoming less and less tenable.

Katharine Jaffray

Lochnagar cam' frae the West
Into the low countrie,
An' he's coorted Katharine Jaffray,
An' stole her heart away.

Hame he cam', ane Amosdale,
Cam' fae the north countrie,
An' he has gained her father's heart,
But an' her mother's tee.

A bridal day it then was set,
An' the bridal day cam' on,
An' who appeared among the guests
But Lochnagar himsel?

A glass was filled o' good red wine,
Weel drunk between the twa:
Said he, 'I'll drink wi' you, bridegroom,
An' syne boun me awa.

'A few words wi' your bridesmaiden
I hope you'll grant me then:
I'm sure before her wedding day
I would have gotten ten.'

Out spoke then the first groomsman,
An' an angry man was he,
Says, 'I will keep my bonnie bride
Until the sun gae tee;

'Until the sun gae tee,' he said,
'Until the sun gae tee,
An' deliver her ower to her bridegroom,
Which is my duty to dee.'

But he's ta'en her by the middle jimp,
An' never stoppit to ca'.
He's ta'en her by the milk-white han'
An' led her through the ha'.

He leaned him ower his saiddle-bow,
An' kissed her cheek an' chin,
An' then he wissed them a' good nicht,
An' hoised her on ahin'.

He drew a trumpet fae his breist,
An' blew baith lood an' shrill;
A hunner o' weel-airmed men
Cam' Lochnagar until.

A hunner o' weel-airmed men,
Wi' milk-white steeds an' grey,
A hunner o' weel-airmed men
Upon his wedding day.

Horsemen rode, an' bridsmen ran,
An' ladies in full speed,
But you wadna hae seen his yellow locks
For the dust o' his horse's feet.

She turned in the saiddle-bow,
Addressed her late bridegroom,
Says, 'The compliments I got fae you,
I'll return them back again.'

So Katharine Jaffray was mairriet at morn,
An' she was mairriet at noon;
She was twice mairriet in ae day,
Ere she keest aff her goon.

but an' her mother's tee, and her mother's as well *boun me awa*, leave
gae tee, goes down *jimp*, slender

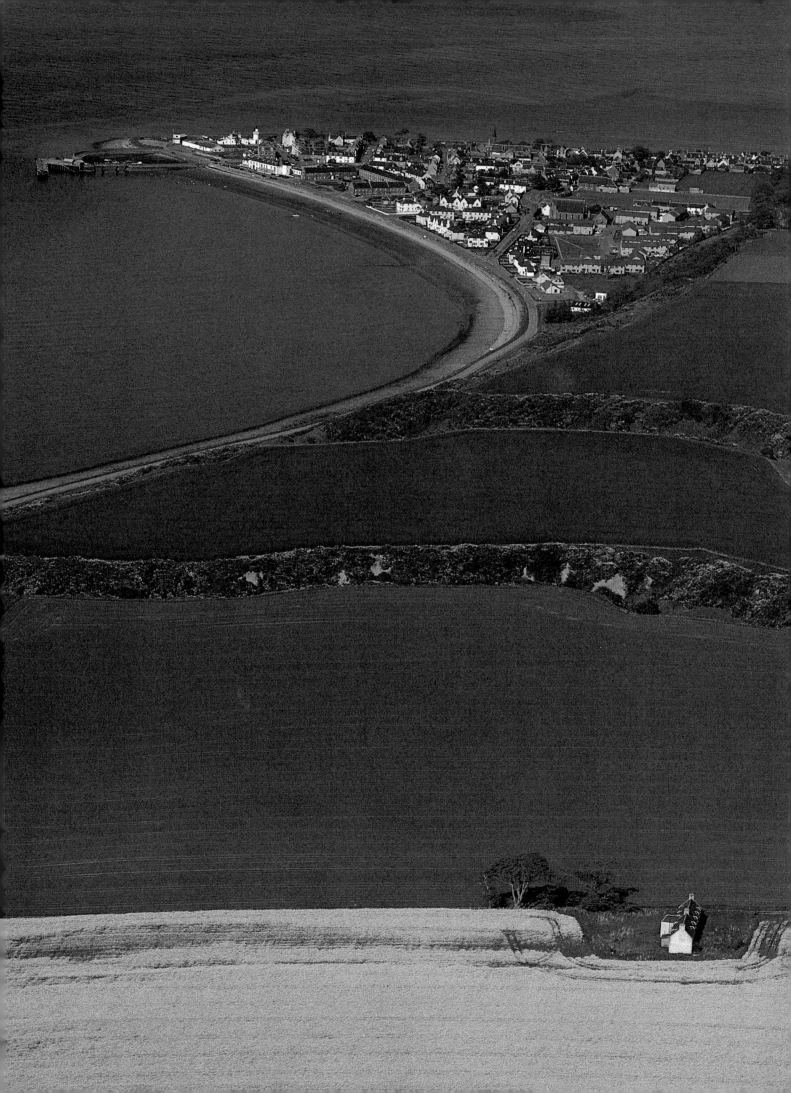

INTRODUCTION

THIS IS A LAND OF RICH SOIL AND GREEN GRASS,
stretching out to a rough and inhospitable coastline and up to the tops
of bare mountains. It's territory where you can be alone easily, beside
a still stretch of water on the Cairngorm plateau or on the empty acres
of a lowland peat bog; but it's a stretch of Scotland where communities
have anchored themselves deep in the land and where they still hold on
to old ways that keep them together, like the language, so that they
believe that they know themselves. Travellers moving northwards from
the Tay who keep to the green path of the coastal plain find themselves
passing through country sometimes fat with juicy farmland, bulging in
its fertility, and sometimes scrawny and bleak, hardly welcoming at all.
They'll find people everywhere, though, who have a kind of confidence
in the place – a knowingness about its permanence. The whole of north-
east Scotland, and the northern islands beyond it, is held together by a
feeling about the past. It seeps out of the landscape and is caught in the
voices but it's somehow kept in check, drained of excess sentimentality
by the memory of hard lives and maybe by the cold east wind off the
sea.

These photographs picture the place as you feel it, but seldom see
it. Look down on Cuminestown, a spreading little village not far from
Banff, surrounded by its fields and farms like a stone spider in a great
green web stretching to the horizon. You see how everything feeds off
the land, how the communities seem to have sprung out of the earth:
from above the place is explained. Along the coast you find fishing
villages, always scrubbed clean, built to keep out the blasts and huddled
together in a way that speaks of the closeness of these people, bound in
interlocking families where the elements and sometimes the economy
have tried to stop them going to sea, and failed. Looking down on this
land you see the history of the place, in the churches and the burgh
buildings where the shape of the medieval settlements was moulded
into the planned villages of the eighteenth century. The bird's eye
catches what we miss: the old marks of ancient peoples still visible on
the land, the shape of the countryside which has been tamed and tilled
but which still seems to be in control.

The first characteristic of the north-east is intimacy. Away from
the Cairngorms themselves, and the swankiness of Deeside, there is no
Highland pomposity in the landscape, and even the most devoted son of
Buchan would have to confess that his motherland was flat, Mormond
Hill aside. But take him away and he'll remember in his dreamy moments
gentle sloping fields, grey stone walls and farm cottages as the marks of a
rich, familiar life played out on the land and in the villages that have
given the place its character. There's romance in this simplicity.

CROMARTY

11

On my wall I have a postcard which shows a red piece of cardboard tied to a fence and little more. Behind, you can just see the shape of a black beast, probably a bull, and the writing on the cardboard says: 'Turriff Show – First Prize'. What a world those words conjure up. Processions of cattle and sheep from all the countryside, gangs of sturdy farm folk on a day away from their labours, red-faced, bright-eyed, undemonstrative even with strong drink taken, happy. Most of all, the voices – the broad, back vowels of Aberdeenshire and amongst them the different twang of the city itself, indistinguishable to the southerner but to the country-dwellers a sound from outside. Even in territory swamped by some of the money of oil, and discovered by people from distant places, the old geography holds sway. Look at these pictures and you will see that after you leave Dundee and plunge into the great red-soiled land of the Mearns, running north to Aberdeen, there's a character in the landscape and in the towns that's consistent. The stone is grey, enough of the people have that squarish face with the broad smile to convince you that they're still in charge of their native patch, and the scene seems familiar all the way.

Painters speak about how a special light is characteristic of a certain place. In the north-east I think you see it best in the early evening. It's unmistakable. On the good days the landscape is washed in a steely, cobalt blue – not the fierce light of sunnier places and not the dreich greyness you often find to the west. This is a rich palette of grey-blue sky, sparkling granite and green fields, splashed with yellow broom and the satisfying warmth of newly ploughed earth. This is the country where Lewis Grassic Gibbon imagined *Sunset Song* and where the life of the old farm touns, the little communities gathered round the farmhouse, is recent enough to be still a culture that's cherished, and for its oral tradition to survive and flourish.

This was a hard life. Farm servants were hired at the feeing markets twice a year and their rations were thin. The bothy ballads, sung lustily now by those of us who hardly knew the old ways, are invested with great sentimentality because they're held to represent a world that has passed away with sadness: well, perhaps it should be remembered that the fields in these pictures were tended at a cost. The communities, with the laird, the minister and the teacher – the dominie – as their pillars, were drawn together by hard taskmasters. The black-clad group at the door of the kirk on Sunday morning wasn't looking grim by accident. A severe approach to life was the making of this place. All the celebration of education and of a sense of community built on individualism grew patiently and solidly, like a dry-stone dyke that will stand happily for centuries.

For me, these people and this way of life are the heart of the north-east that you see spreading out under the eye of the camera. It was the product of the first settlers who found the fertile ground, and it was shaped by the society that began to find itself in the century after the Reformation. By the nineteenth century, when the familiar town plans you see here had been laid out there was a pattern of life that was to last, and be prosperous. Now the changes are faster and so they seem more troubling.

Gaze at Aberdeen. From the air you still see the grander streets stretched out, and the great hole of Rubislaw Quarry where all that granite lay. In Old Aberdeen, where some of the spirit of a fifteenth-century university has been preserved, you can still sense a place that has lasted despite recent ravages, and the harbour is still a harbour, though the fish are now few. Walk up Union Street, though, and it's a horror that you find. A chilling shopping centre has been built to sprawl on the very steps of Marischal College: it flattens out the contours of the city as it was. Aberdeen is still the meeting point of the north-east, where they come from north and south, but it isn't what it was.

You find the real place away from the city. Escape from it to the high corners of the mountains. You can walk through the Lairig Ghru and see hardly a soul on your way for mile upon mile, chased only by the mist. At either end you can descend, like a happy sheep sliding down an Alp to green pasture in the spring, and find yourself in a pleasing domestic landscape. This is the land of the smallish family farm, the engine of life here, where the communities were shaped and their values established, despite the hints, in the form of castles and evocative ruins, of a more swaggering history.

Simplicity and straightforwardness are in the landscape and the people. A journey north to Orkney and Shetland, especially by boat to the sound of fiddlers who won't sleep, is the way for a traveller to put it into sharp focus. Here are wild islands, rough-hewn and bare. And everywhere there survives the evidence of ancient settlements, along with a mysterious atmosphere that speaks of ritual and darkness and perpetuity. It's much better to come to the north-east from this end, though hardly anybody does, than from the cities of the south. So much more is explained. Even in the hospitable mildness of the laich of Moray, or the obvious prosperity of the bigger Aberdeenshire farms, the history is of a life that was never easy, nor promised much. So, like so many places of that sort the people nurtured an independence for their communities. And it was an independence that produced not only riches from the land, all the best whisky in the world, and the fruits of the sea, but traditions in education and lifestyle that were exported happily as generations travelled wide.

The places pictured here, and their people, are proud of their bit of Scotland. Looking down on it, on the harbours and fields and rocky heights, it seems to me solid. This is country whose people will change, because they're subject to the disciplines of the world, but which itself can maintain its character and its power. The landscape can still flash easily on the inner eye, the sounds of its voices still speak of its history and life, its ways still seem its own. From above, these pictures show a place that seems different, set apart by mountains and coast to go its own way. So it has, and so it will continue to do.

James Naughtie
May 1992

13

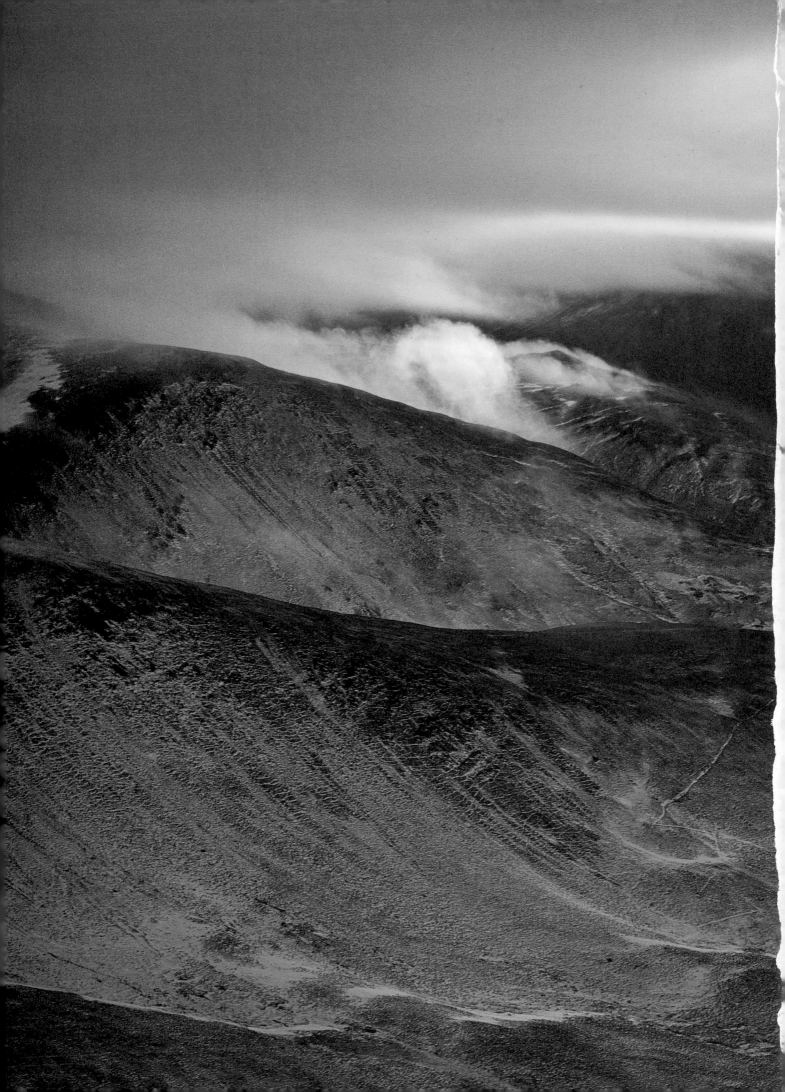

CHAPTER ONE

THE LAND

THE VARIETY OF LANDSCAPE TYPES WHICH ARE TO BE found in North-east Scotland is wide because the landform has emerged from some of the most complicated geological structures on Earth. Initially it was modified by geomorphology and climate alone, but subsequently, and increasingly, by plant and animal populations also. It is tempting to regard the land itself as simply the background against which the human drama is played, but this is too simplistic a view. It is, in fact, an ever-changing entity with which humans, as well as other species, continuously interact, and the present-day landscape must be considered as simply the current version of a system which has evolved slowly and which is still undergoing modification by all of the agencies which helped to form it.

The largest single mass in the landform of North-east Scotland is that of the Grampian Mountains, which constitute one of the most extensive areas of upland in the British Isles. This is an area of classical glaciated landscape, of rounded peaks, corries and wide U-shaped valleys. The underlying rocks are primarily granite or schist, and the soil covering is shallow and unstable, providing relatively poor conditions for vegetation growth. The climatic conditions are harsh, with low temperatures, high precipitation and high winds.

Several types of natural vegetation are found in this region, depending on altitude. At the highest levels an 'arctic-alpine' zone exists, with plants such as heather (up to about 1,000m), dwarf shrubs such as blaeberry (bilberry) and crowberry, and/or mosses and 'reindeer moss' lichen preserving a precarious existence on the loose-textured infertile soils. These inhospitable slopes are the home of the ptarmigan, the most common bird of the high tops all year round, of the beautiful dotterel, and of the elusive snow bunting or snow bird.

The valley bottoms and lower slopes of the uplands are the forest zone. Once thickly wooded with forests of either pine or oak, together with many smaller trees and shrubs, these Highland glens now have a denuded appearance. The forest clearance which brought this about was carried out mainly in the seventeenth and eighteenth centuries when, in the service of short-term profit, a complex ecosystem, which had become established in the millennia following the last Ice Age and which consisted of mature forest with underscrub and a rich variety of bird and animal life, was, in the course of a relatively short time, largely converted into a wet desert of heather and bracken. It was a phenomenon which, though much different in scale, had, and has, similarities with the present day exploitation of the tropical rainforests.

The denudation of the highland areas of Scotland is almost

THE CENTRAL HIGHLANDS SOUTH OF DEESIDE, KINCARDINE AND DEESIDE

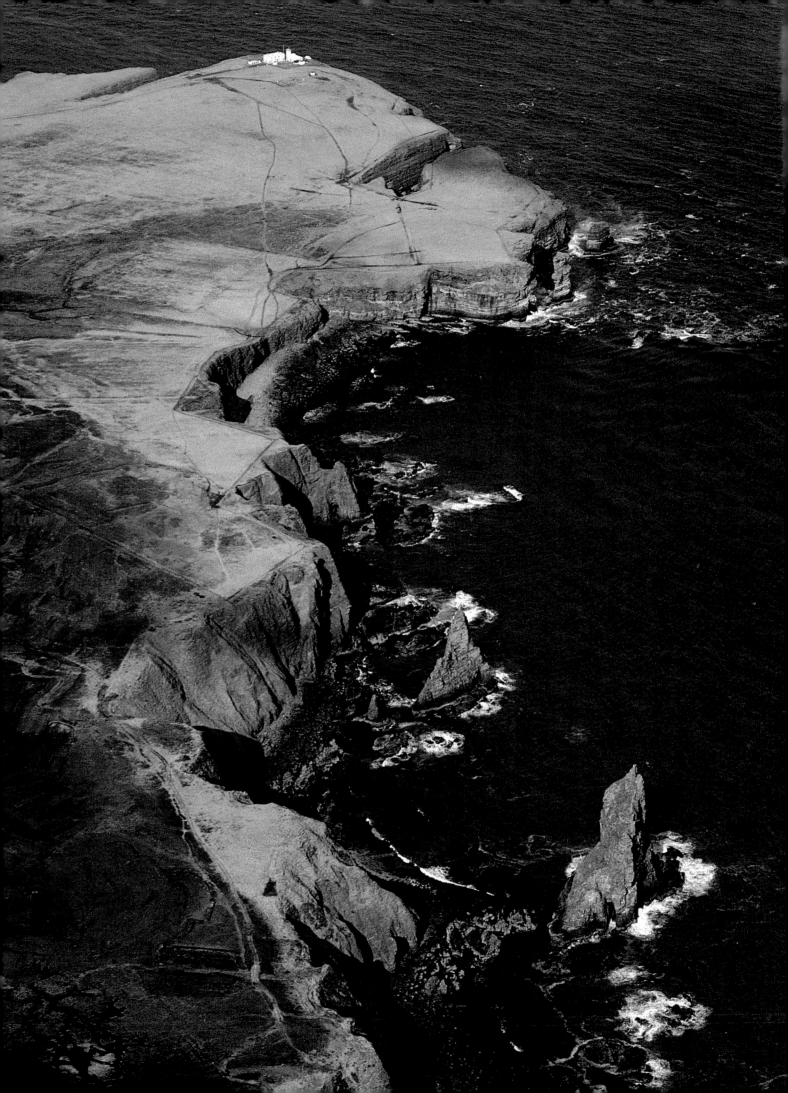

complete, but some very small remnants of the Old Caledonian Forest still remain and can be found in the Grampians. The pinewoods on the lower slopes of the Cairngorms and on Lochnagar are now the largest continuous tracts of forest in Britain which still exist in a more-or-less natural state. In most cases, however, the tree line is much lower than would naturally be the case, and a heathland, mainly of heather, now lies between the forest edge and the 'arctic' zone.

The upland areas of the North-east are fringed by the rolling lowland landscapes of Angus, Kincardine, Aberdeenshire and the Moray Firth coast, while further north the 'Flow Country' of Caithness provides a very large area of flattish wetland. The lowland fringes of the Grampians consist of glacial till (boulder clay) overlying, for the most part, Carboniferous Old Red Sandstone, which has produced soil which is both colourful and fertile. Similar geological structures are found in Caithness and in Orkney. These parts of the North-east are the areas where the effects of human activity are most obvious. Intensive forms of arable farming are practised and in the enclosed fields of these systems the monocultures of cereals and vegetables are the antithesis of what is natural. In recent years the proportion of semi-natural hedges and shelter-belt woodlands has greatly diminished in these areas, which has further contributed to their unnatural appearance.

The North-east is rich in coastal scenery which has been affected little by human activity. From the sheets of rock which underlie the soils of the coastal lowlands have been formed the spectacular cliffs of Angus, Aberdeenshire, Caithness and Orkney. These are interspersed with large stretches of sandy beach and sand-bar such as are found north of the Don in Aberdeenshire and along the coast of the Moray Firth.

The largest areas of wetland in North-east Scotland, if not in the British Isles, occur in Caithness and Sutherland in the Flow Country. Just over one-third of all peatland in Scotland is situated in the 'flows' (gently rolling bogs) which lie between Strath Naver and Strath Halladale. Peat, defined as soil containing more than 80 per cent organic matter by dry weight, will only form in conditions of waterlogging. This occurs in Scotland, mainly due to the combination of very high rainfall with low rates of evaporation due to cloud cover, low temperature and high relative humidity. It is a matter of controversy, though, whether these northern peatlands are natural: they may have formed following forest loss due either to human activity or to a change in climate.

There is therefore much variety and also much food for contemplation in the diverse landscapes of North-east Scotland, related as they are to correspondingly diverse ecosystems and human cultures, both in the past and in the present day.

DUNCANSBY HEAD,
CAITHNESS

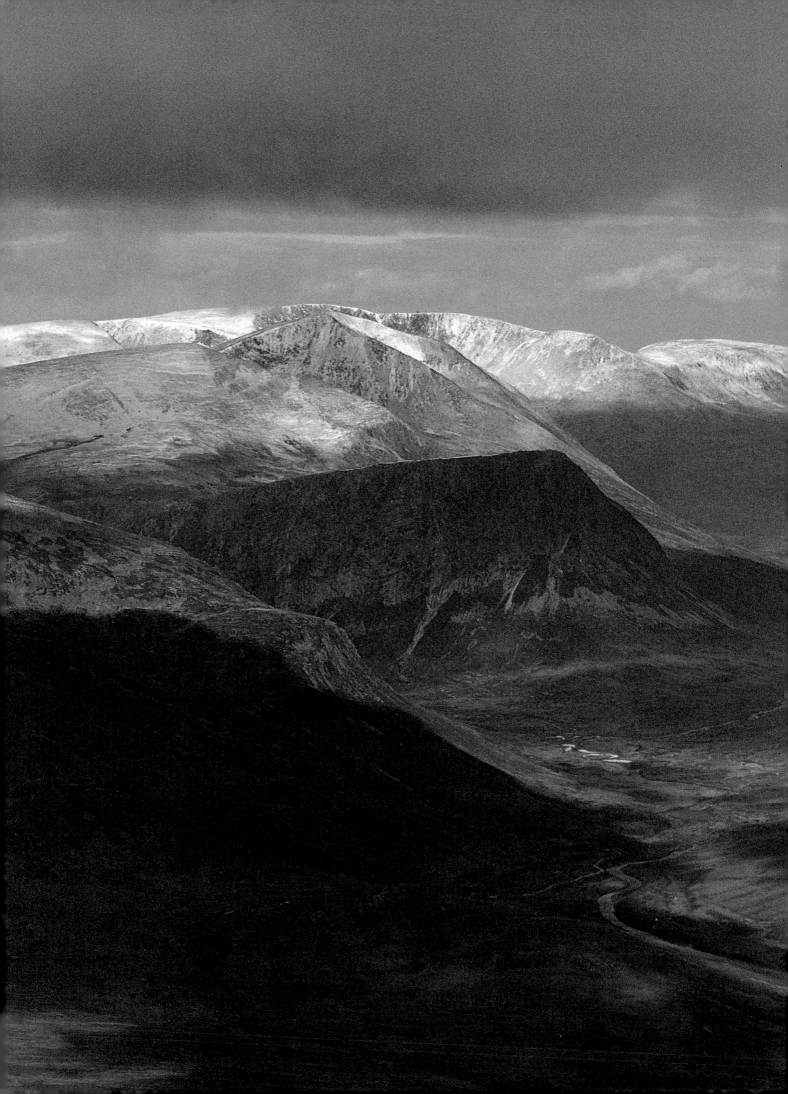

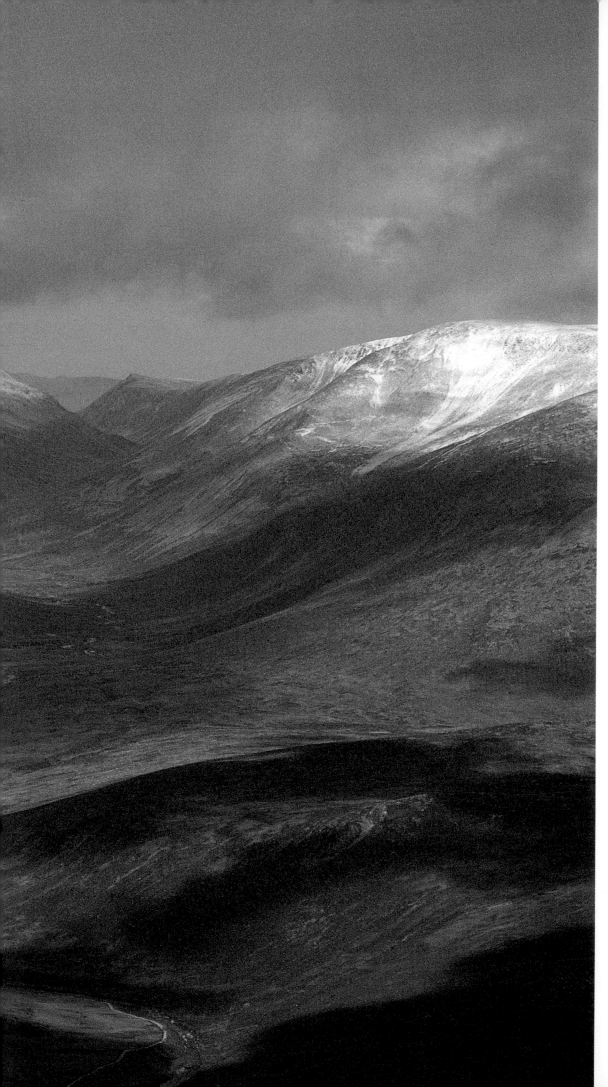

THE LAIRIG GHRU AND
THE CAIRNGORMS
FROM THE SOUTH,
KINCARDINE AND
DEESIDE

Scotland is a small country.
Its mountains are modest in
scale compared to the Alps
and its areas of semi-natural
wilderness small in relation
to the vast areas of Asia,
North America or
Greenland. There is,
nevertheless, a certain
grandeur about the
Grampian plateau which can
be appreciated here.

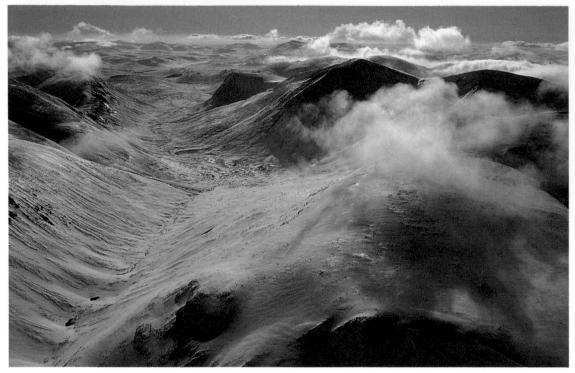

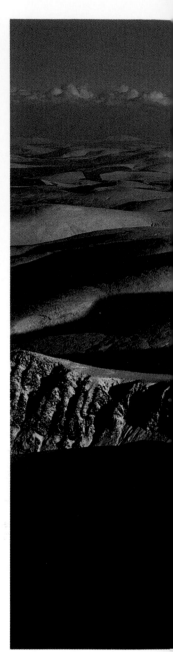

CAIRNGORMS – GLEN DEE, THE DEVIL'S POINT AND CAIRN TOUL, FROM ABOVE BRAERIACH, KINCARDINE AND DEESIDE

Glen Dee and the Pools of Dee are on the left and Cairn Toul on the right in this view. The upland area in the background is virtually uninhabited as far as the line of the Highland Boundary Fault thirty miles to the south. The earthbound traveller in Scotland who does not venture beyond the inhabited glens or the public roads gains a false impression of the true composition of this upland massif which forms the core of the eastern Highlands.

The territory

Up here in the white country

any tree for a totem
any rock for an altar

discover!

this ground is suicidal

annihilates everything
but the most essential

poet – your kingdom

KENNETH WHITE

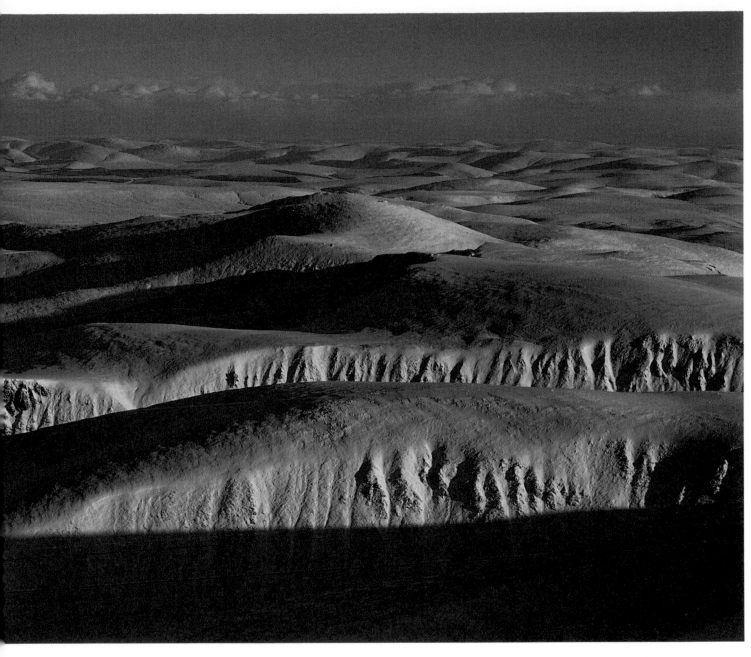

SUMMITS OF THE
CAIRNGORM PLATEAU,
FROM ABOVE
BRAERIACH,
GRANTOWN AND
STRATHSPEY, AND
MORAY

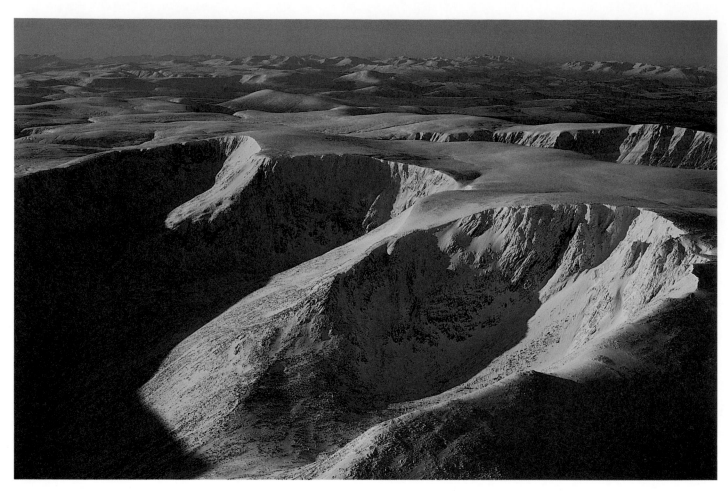

THE CORRIES OF
BRAERIACH AND
CAIRN TOUL, FROM
ABOVE BEN MACDUI,
KINCARDINE AND
DEESIDE

The granite which forms the
Cairngorms is about 400
million years old and the
survival of this mountain
mass is due to its extreme
durability. The complex
forms of these mountains
were caused by several stages
of weathering and erosion.
The smooth, rounded tops
were probably created during
a prolonged period of
chemical weathering when
the climate was much

warmer than today. They
may then have been
protected under a very thick
ice sheet during early ice
ages. The spectacular corries
seen here, which have been
sculpted from the eastern
faces of Braeriach and Cairn
Toul, are the result of several
stages of later glacial action.
The massive single corrie
which divides Braeriach
from Cairn Toul was
probably formed by ice from
a retreating ice cap and this
has become indented with
smaller, later corries
excavated by small glaciers
which have formed as a
result of snow deposition.

Caul', Caul' as the Wall

Caul', caul' as the wall
That rins frae under the snaw
On Ben a' Bhuird,
And fierce, and bricht,
This water's nae for ilka mou',
But him that's had a waucht or noo,
Nae wersh auld waters o' the plain
Can sloke again.
But aye he clim's the weary heicht
To fin' the wall that loups like licht,
Caulder than mou' can thole, and aye
The warld cries oot on him for fey.

NAN SHEPHERD

wall, well *waucht*, copious drink *or noo*, previously
wersh, lifeless *sloke*, satisfy the thirst *thole*, bear
cries oot on, denounces *fey*, bewitched

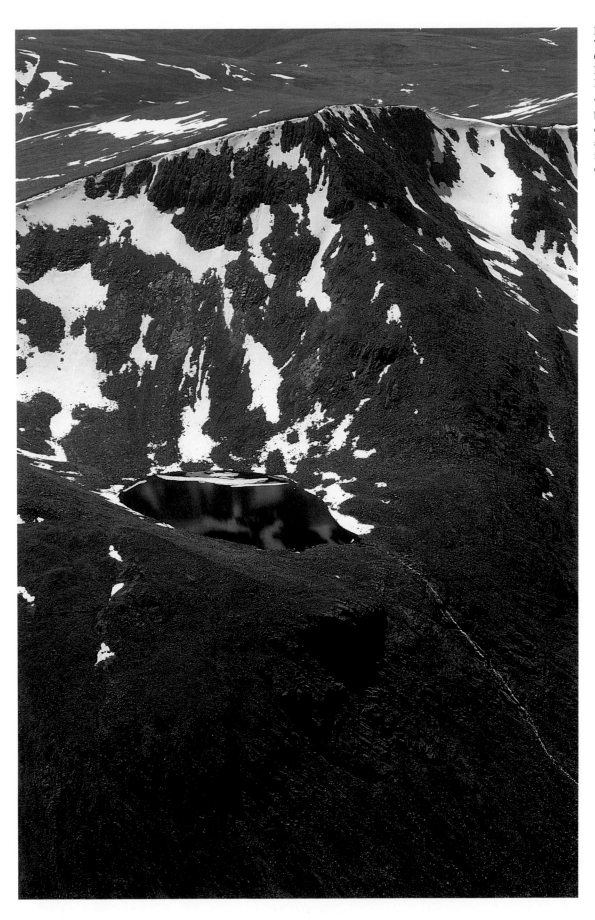

LOCHAN UAINE AND
THE ANGEL'S PEAK,
CAIRN TOUL,
KINCARDINE AND
DEESIDE

The superb Lochan Uaine,
below the Angel's Peak, is an
example of a lochan lying in
a secondary corrie, excavated
from the side of a much
older, larger one.

LOCH EINICH, BADENOCH AND STRATHSPEY

When the Grampian ice-cap retreated, the ice was discharged northwards along the lines of pre-glacial drainage patterns. Several large basins, of which the one containing Loch Einich is an example, were carved out of the north slopes of the Cairngorm plateau in the process. This view looks southwards into the Einich basin, which is a classic U-shaped valley.

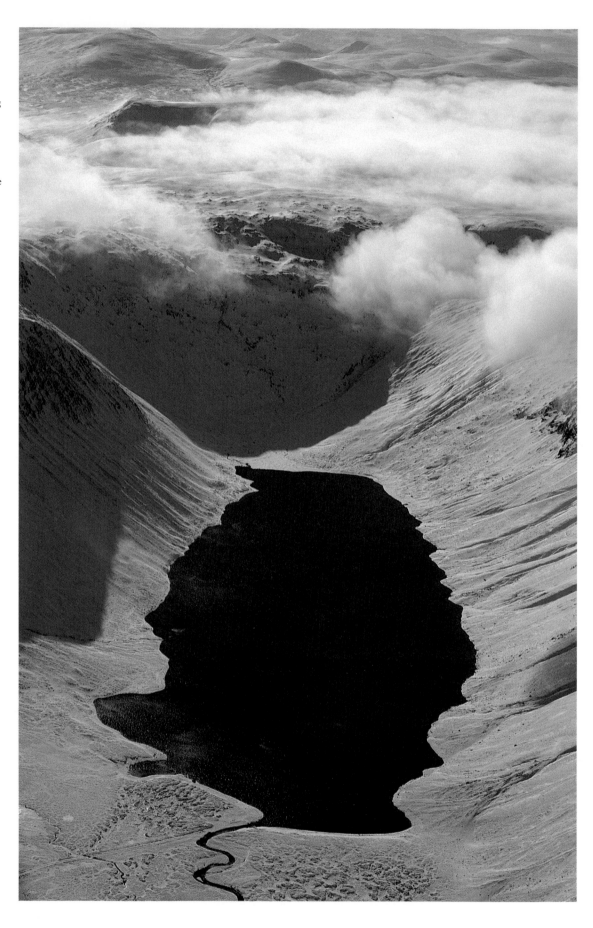

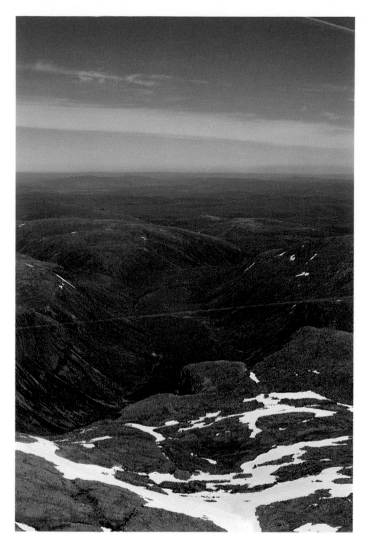

THE LAIRIG GHRU, KINCARDINE AND DEESIDE

The Lairig Ghru cuts the Cairngorm plateau into two parts. It is believed that this famous pass was formed when part of the Cairngorm ice-mass moved southwards, against the prevailing direction of flow, and carved a gash through the mountains to join up with pre-glacial channels flowing eastwards in the direction of where Aberdeen is now situated.

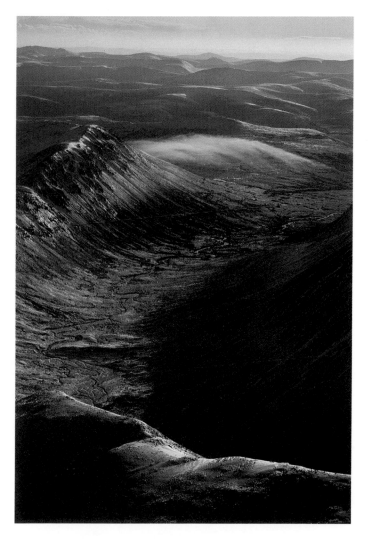

LOCH AVON, MORAY

The U-shaped valley of Loch Avon was sculpted from an earlier pre-glacial drainage line by ice discharging from the Grampian ice-sheet. It is believed that this divided at a point close to where the eastern end of the loch now lies and part of it was diverted northwards to form Strath Nethy, the head of which is seen as a hanging valley on the left of this view.

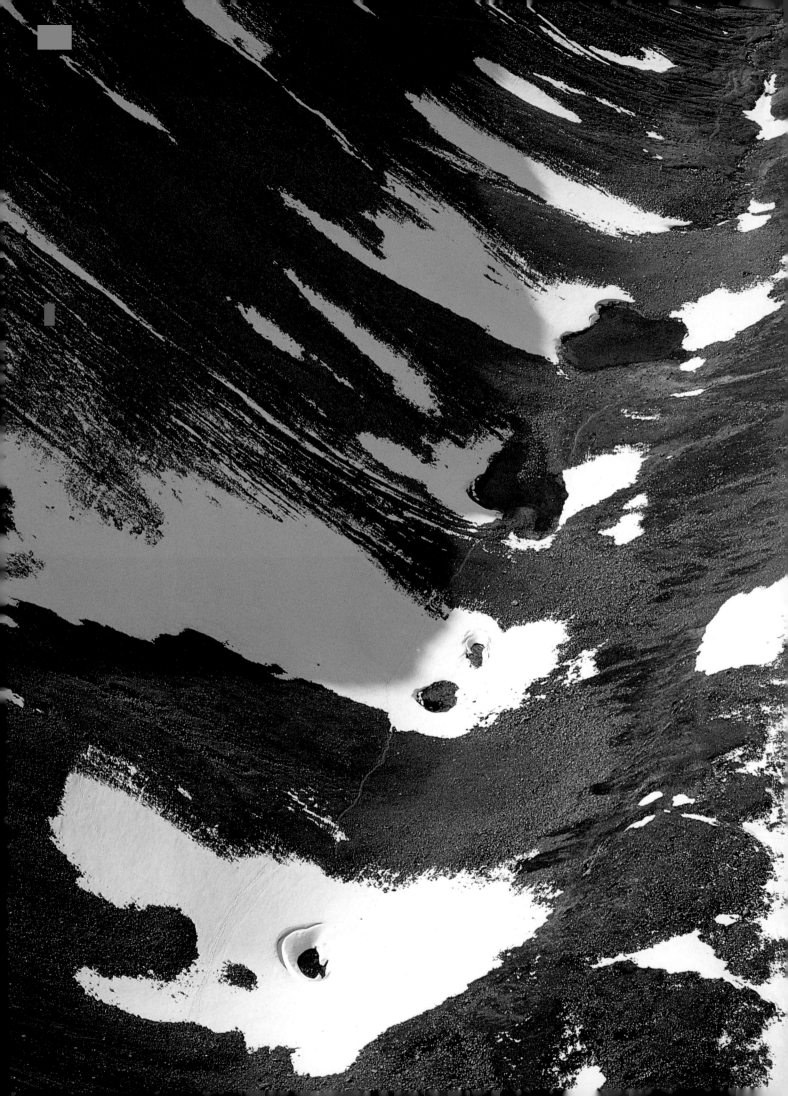

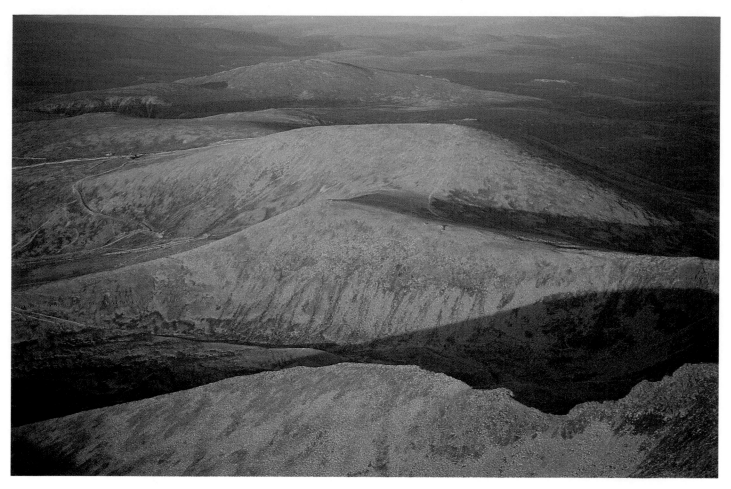

THE NORTHERN
CORRIES,
CAIRNGORMS,
BADENOCH AND
STRATHSPEY

The tops of the Cairngorms
are the nearest thing to an
arctic environment to be
found in Britain. The soils at
these levels are thin,
unstable and, due to
incomplete chemical
weathering, infertile. The
vegetation consists mainly of
dwarf shrubs, lichens, sedges
and rushes. The rates of
plant growth are so slow that
it is said to take up to ten
years for the mark of a single
footprint to disappear.

THE POOLS OF DEE,
LAIRIG GHRU,
KINCARDINE AND
DEESIDE

In the present day the
inexorable processes of
weathering and erosion
continue to wear down this
ancient mountain mass. Here
the mechanisms of
solifluxion, the movement
under gravity of rock
fragments loosened by ice
and water, are clearly seen
operating in the Lairig Ghru.

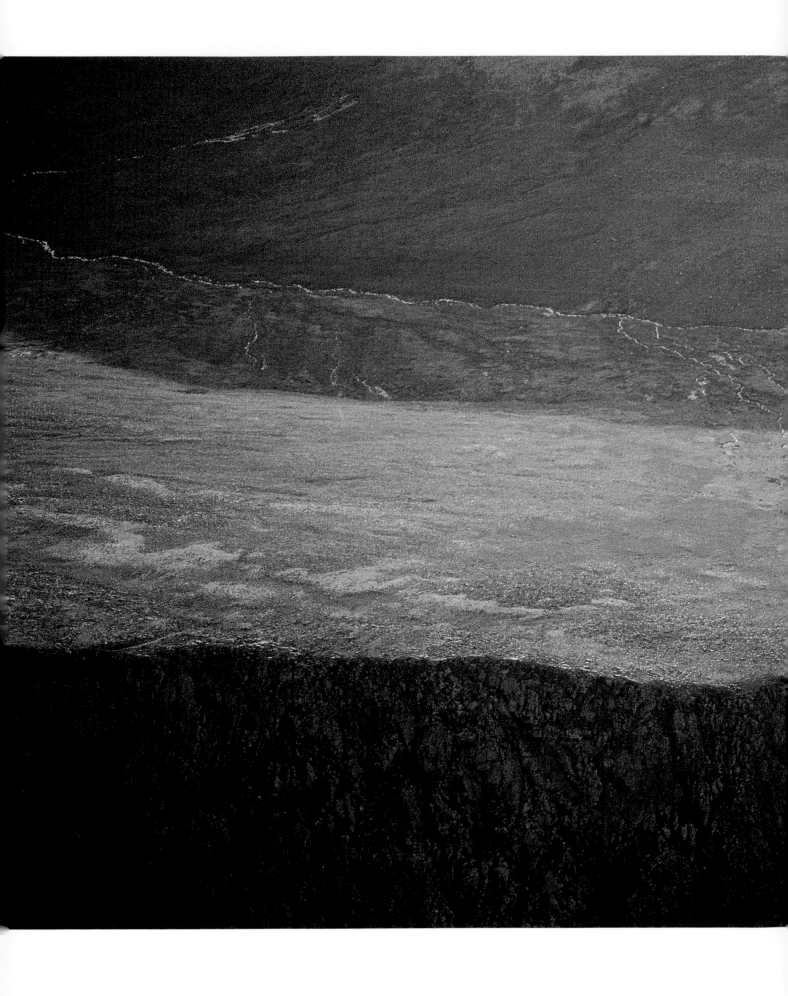

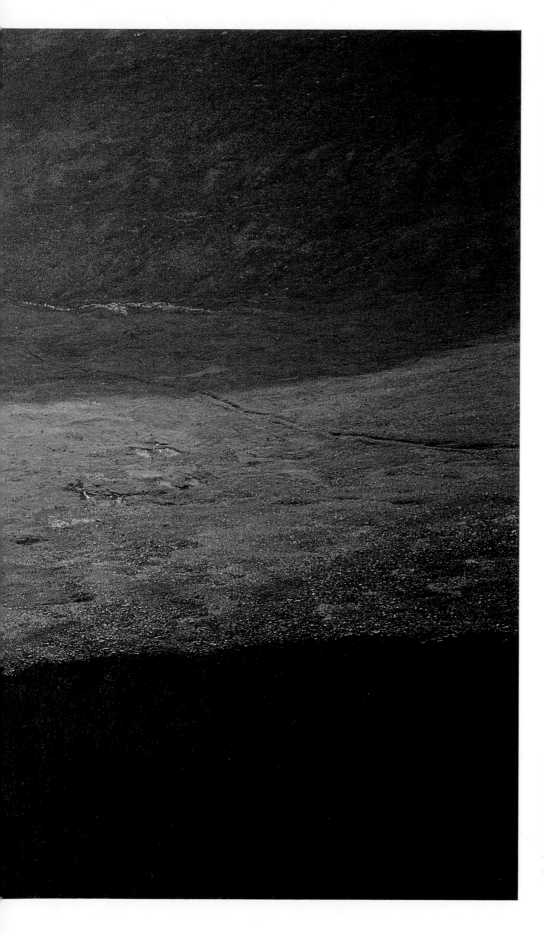

LURCHER'S GULLY
FROM ABOVE THE
LAIRIG GHRU,
BADENOCH AND
STRATHSPEY

The instability and thinness
of the soil cover of the upper
levels of the Cairngorms,
which make the vegetation
highly vulnerable to
disturbance by large
numbers of hillwalkers and
skiers, are evident here.

SCOTS PINES,
GLENFESHIE,
BADENOCH AND
STRATHSPEY *(overleaf)*
The hardiness of the Scots
pine is evident here where
the trees eke out a precarious
existence in the shifting
gravels of the braided
River Feshie.

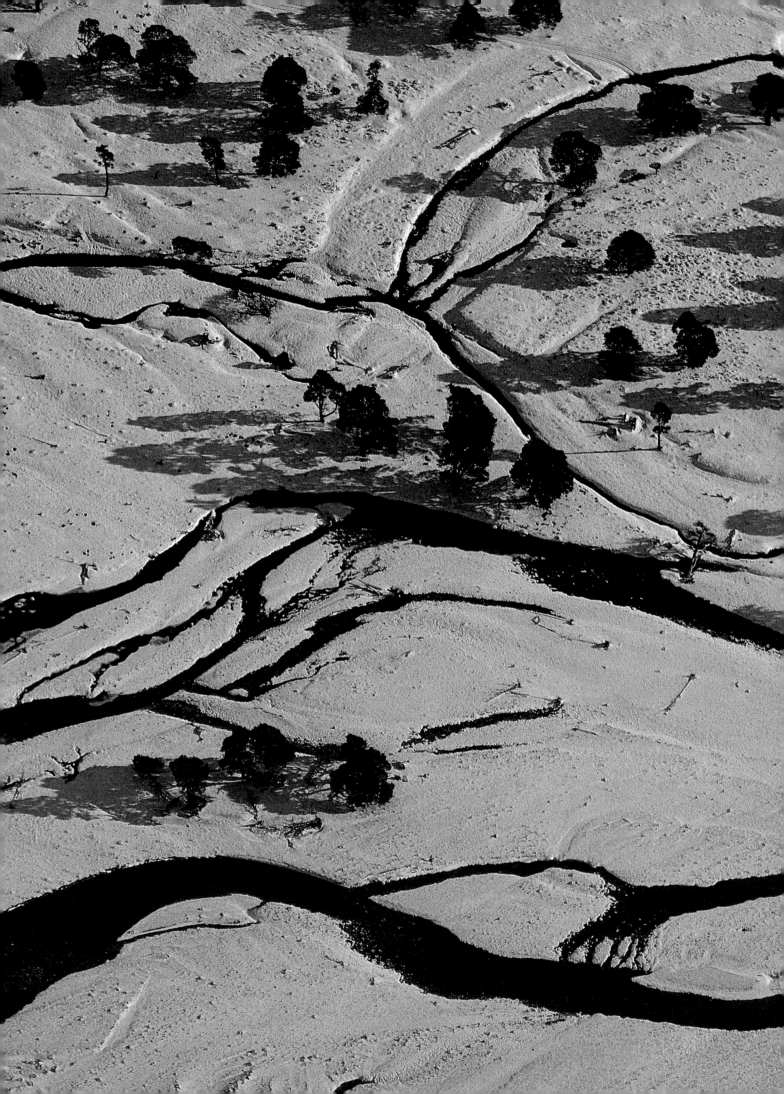

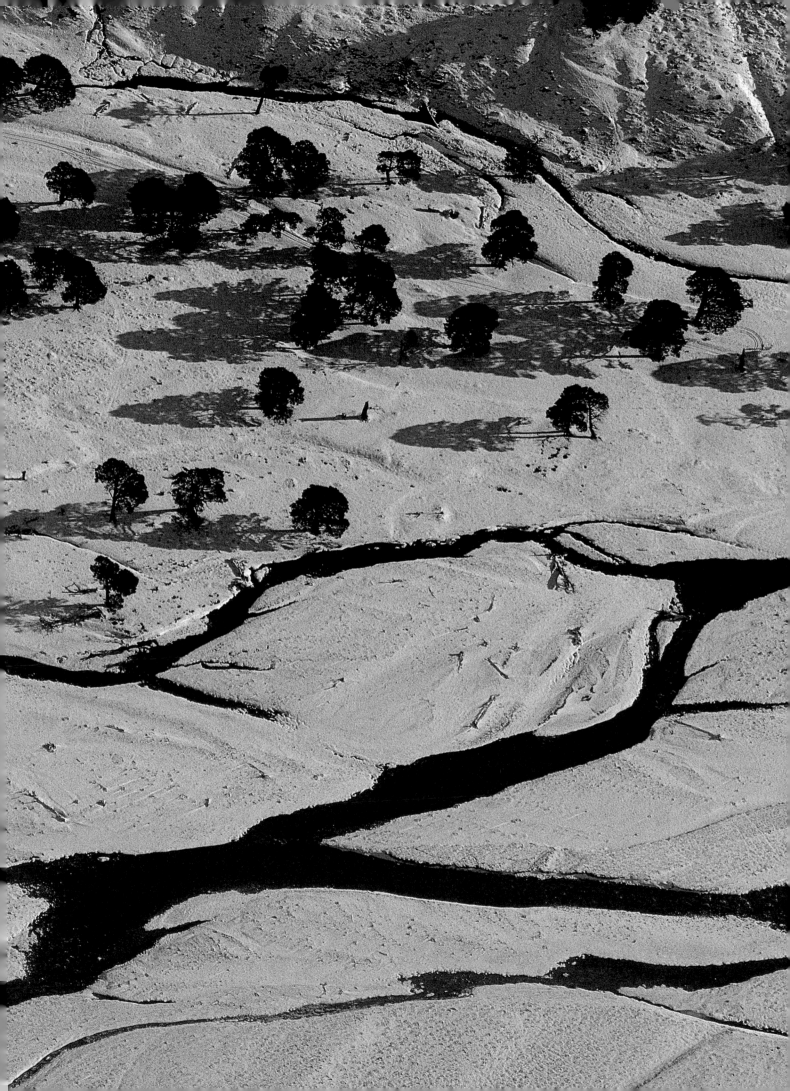

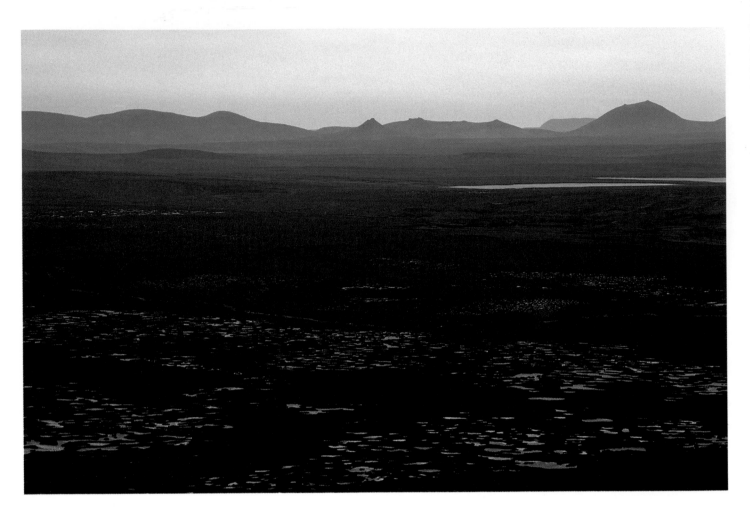

BLAR NAM FAOILEAG, CAITHNESS

The extreme north-east of the Scottish mainland contains the largest stretches of wetland in Britain. The appearance is one of desolation and it is a matter of conjecture as to whether the lack of trees in this landscape is natural or due to human activity in pre- and early-historic times. These wetlands are blanket mires in which, under conditions of continuous waterlogging, peat is laid down continuously under a thin layer of active vegetation, such as sphagnum moss, which is capable of growing in wet, acidic conditions.

Blar nam Faoileag is probably the largest area of actively growing mire in Britain. It forms a rare habitat for moorland bird species such as dunlin and greenshank. This particular area is of special interest because, unlike adjacent mires, it is almost completely undamaged by artificial drainage or burning.

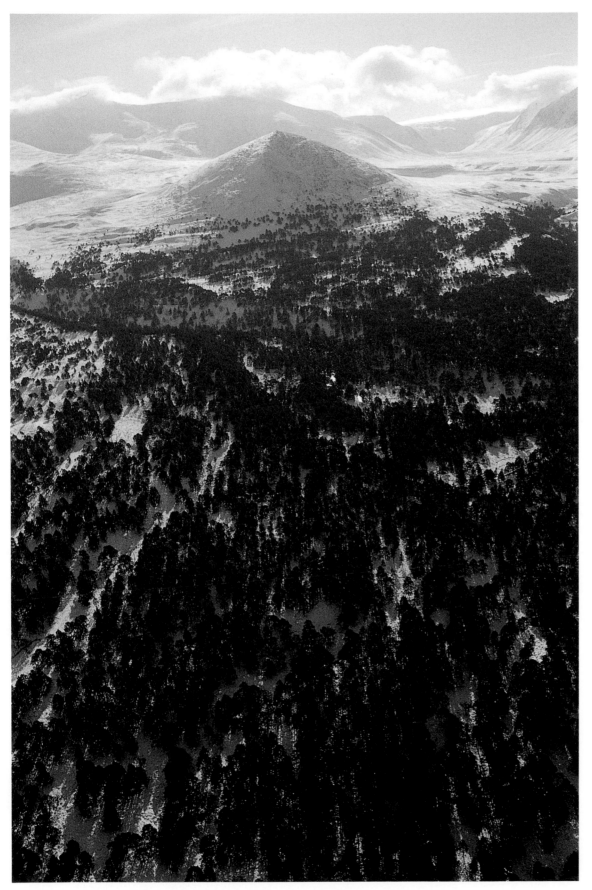

ROTHIEMURCHUS
FOREST, LOOKING
TOWARDS THE EINICH
BASIN, BADENOCH
AND STRATHSPEY

Parts of the forests of Scots
pine and birch which
surround the Cairngorms, of
which the Rothiemurchus
Forest is perhaps the best
known, are the largest tracts
of semi-natural woodland in
the British Isles and some of
the few places where it is
possible to experience the
feeling of being in a natural
forest. There is great
diversity within the forest in
both the density of the tree
cover and the form of the
trees, the most mature of
which are up to 300 years
old. Regrettably, due to the
grazing pressure of deer, the
number of very young trees
is small and this is a threat to
the continuing stability of
the forest.

COASTAL FEATURES, HOY, ORKNEY

The Old Red Sandstone cliffs on Hoy, Orkney, display textbook examples of coastal erosion. The sea first attacks the strata at shore level to form caves, and, when the roofs of these collapse, long, straight indentations appear which allow the waves to gain access to joints and fissures in the rock inland from the cliff edge. Parts of cliff then become isolated as stacks, and thus the shoreline recedes.

THE OLD MAN OF HOY, ORKNEY

The Old Man of Hoy is perhaps the most famous coastal stack in the British Isles and represents the final stage in the coastal erosion sequence.

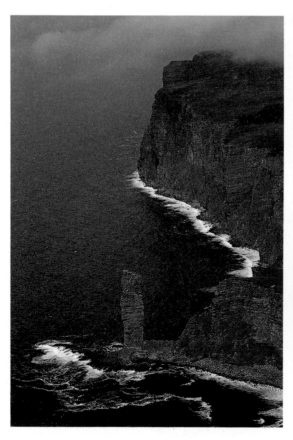

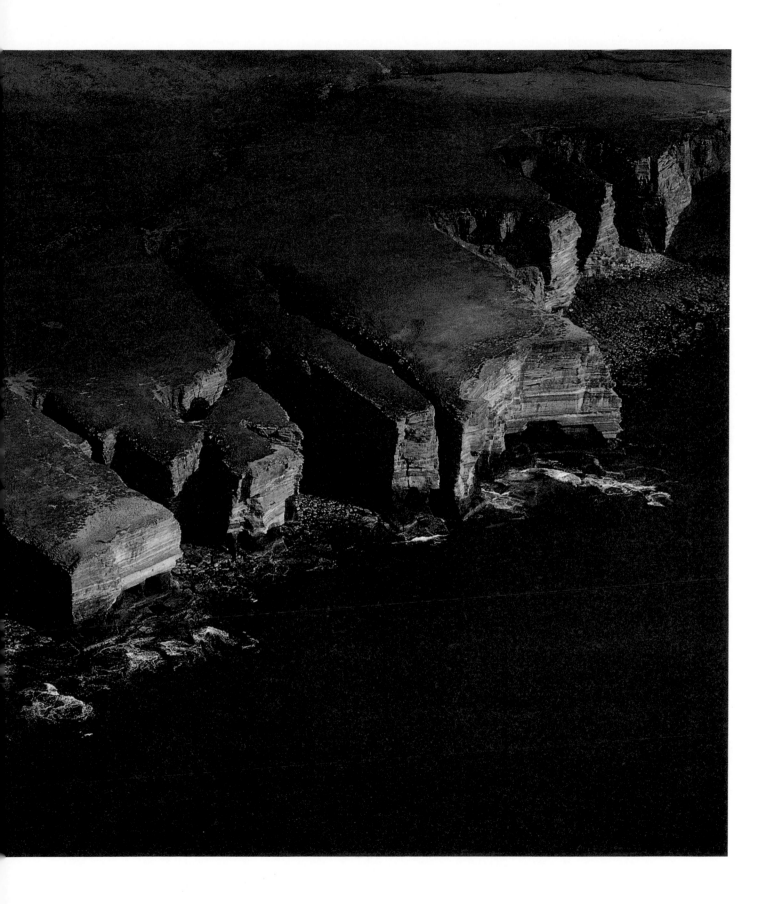

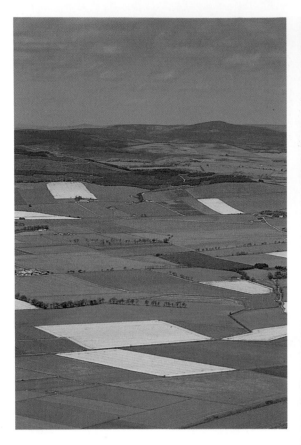

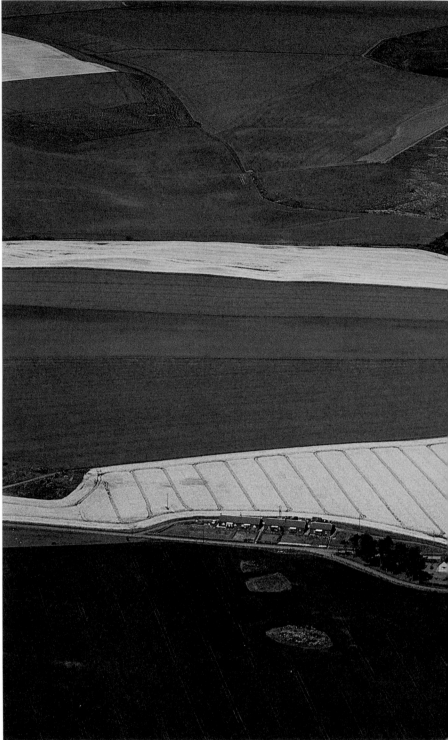

Below and around where Chris Guthrie lay the June moors whispered and rustled and shook their cloaks, yellow with broom and powdered faintly with purple, that was the heather but not the full passion of its colour yet. And in the east against the cobalt blue of the sky lay the shimmer of the North Sea, that was by Bervie, and maybe the wind would veer there in an hour or so and you'd feel the change in the life and strum of the thing, bringing a streaming coolness out of the sea. But for days now the wind had been in the south, it shook and played in the moors and went dandering up the sleeping Grampians, the rushes pecked and quivered about the loch when its hand was upon them, but it brought more heat than cold, and all the parks were fair parched, sucked dry, the red clay soil of Blawearie gaping open for the rain that seemed never-coming.

LEWIS GRASSIC GIBBON, *Sunset Song*

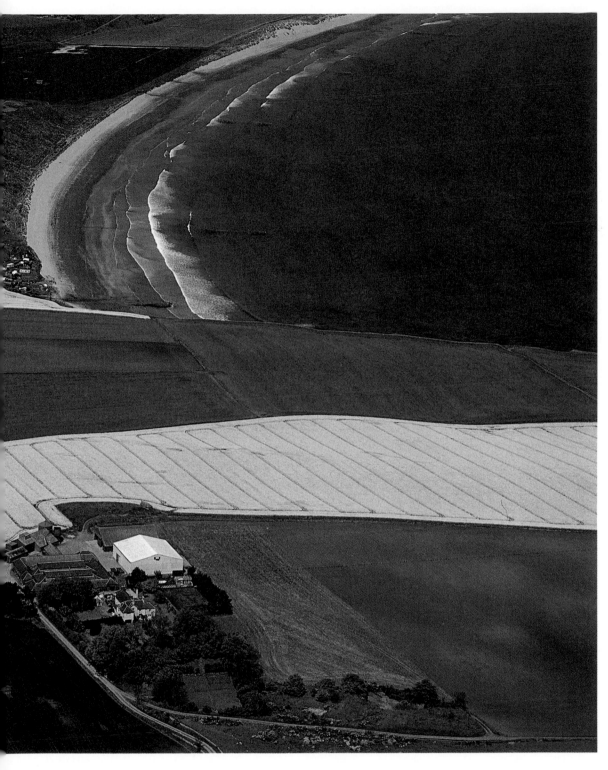

THE MEARNS, STRATHMORE (*opposite*)

From Strathmore in the south to the Black Isle, north of Inverness, a broad strip of coastal lowland runs around the eastern and northern fringes of the Grampian Mountains and is broken in only one place, at Stonehaven, where a thin finger of upland reaches the coast. The picture shows a typical stretch, near Laurencekirk, with the fieldscape bounded by the North Sea in the east and rising ground in the west.

The natural vegetation here is deciduous forest and in prehistoric times this scene would have been very different, with a carpet of trees and underscrub rich in forest bird and animal life, interspersed with bogs and mires, covering the land. By the medieval period most of the trees had been removed and in the age of 'improvement' in the eighteenth century, the wetlands were drained and the present-day pattern of intensively worked fields established.

NEAR LUNAN BAY, ANGUS

THE BAR, CULBIN, NAIRN

Long sandspits are common along the entire east coast of Britain and The Bar at Culbin is a particularly spectacular example. The land adjacent to the coast here was a fertile and very prosperous estate in late medieval times but was gradually buried by the deposition of sand. This is carried down the rivers, such as the Spey and the Findhorn, which flow northwards from the Grampians, and is deposited initially on the shore but then carried inland on the wind in the frequent gales to which this coast is subjected. The area was completely overwhelmed by the late seventeenth century. Since the early decades of the nineteenth century the sand has been stabilised by forestry and presently supports a large plantation of conifers under the control of the Forestry Commission. The Bar remains natural and unstable and is migrating westwards at the rate of a little less than a mile every century.

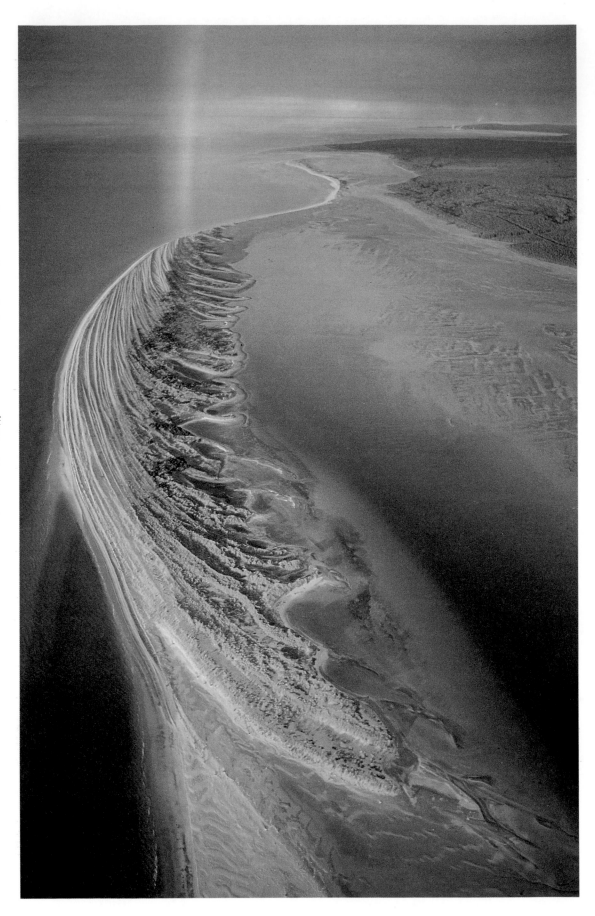

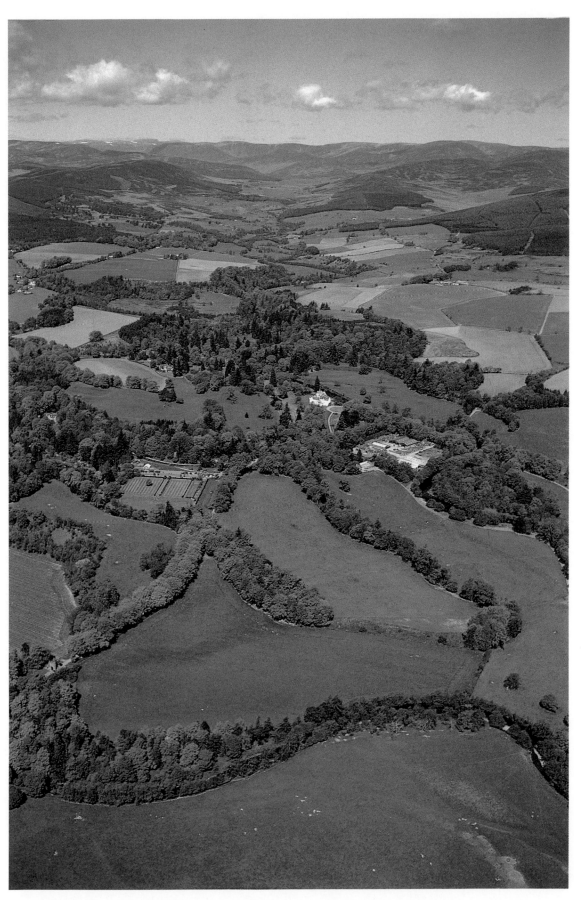

CORTACHY CASTLE,
GLEN CLOVA AND THE
HIGHLAND LINE,
ANGUS

The foreground here is
typical of the landscape of
Strathmore in which
parkland alternates with
enclosed fields. In the
background the heather-clad
uplands of the mountains of
the Mounth rise beyond the
Highland Line.

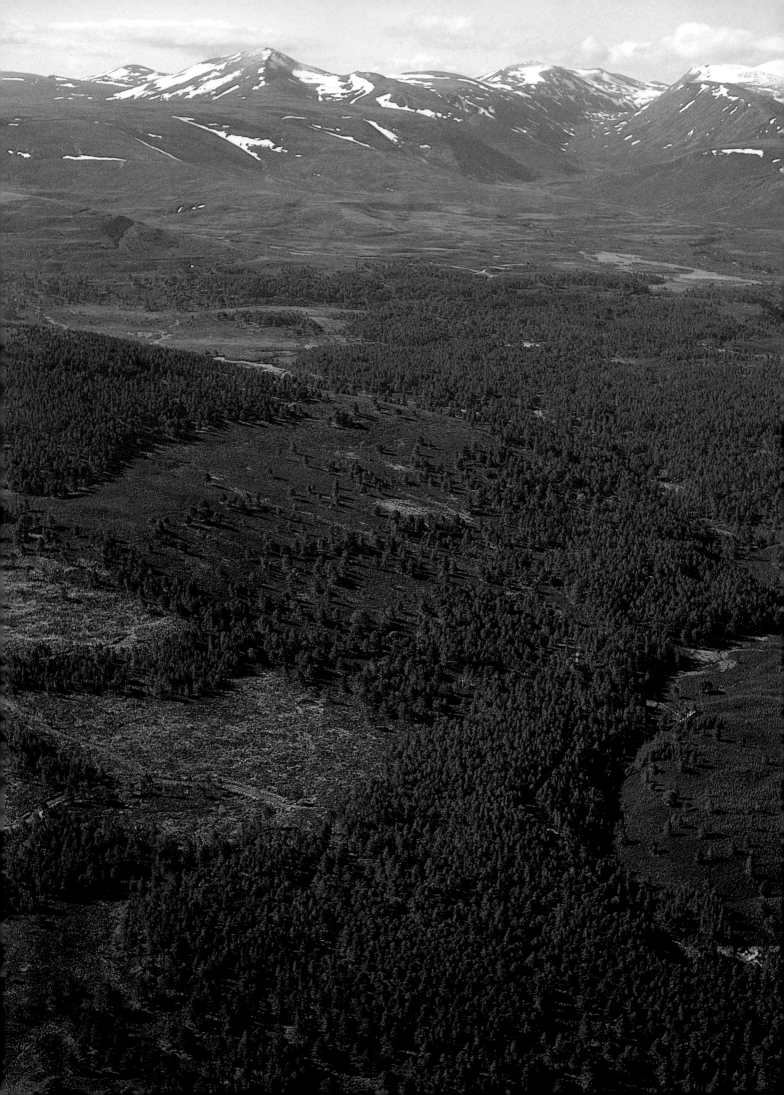

EARLY HUMAN MARKS

To understand a people, one must first understand their country. Without a knowledge of the routes of access and of egress by land and sea, of the regions of mountains and moorland over against those of forest and flood plain, of the conditions of climate and natural environment – in a word, without a geographical setting – any study of human communities in past or present times must be a meaningless abstraction.

S. PIGGOT, *Scotland Before History*

AS WAS OUTLINED IN THE LAST CHAPTER, THE NORTH-eastern part of Scotland is a land of mountains subdivided by steep-sided U-shaped valleys and surrounded by a narrow coastal plain. The origins of this land-mass are complex. The most recent major determinants of the present form were the glaciers of the last Ice Age. These retreated some 10,000 years ago, leaving landforms which were more or less those of the present day. The climatic trend which brought about the retreat of the ice continued after its departure and, as the air and the soil became warmer, the types of vegetation changed from those of arctic tundra to pine forest and eventually to dense deciduous forest teeming with wildlife, the seas and rivers providing habitats for a rich variety of aquatic life.

Such was the condition of the land when the first humans of prehistoric Scotland migrated into the area at around 7000 BC. This was the Mesolithic period – the Middle Stone Age. Its people were hunter-gatherers and had stone axes, and evidence from their middens suggests that their diet was rich, consisting mainly of fish, shellfish, sea mammals (mainly seals) and seabirds, supplemented occasionally with meat from hunted animals. Bone and horn were used for making implements and ornaments, and hide for clothing and boat building. It is likely that these people came from northern Europe by voyaging in stages along the North Sea coast, although the number who reached as far as the North-east of Scotland was probably very small, scattered along the sea coasts and in the river valleys.

The Mesolithic hunter-gatherers lived in caves or in wooden-framed shelters. Little evidence of them remains and their lifestyles have been variously depicted as idyllic and as squalid. In one scenario the mild climate and abundant food supply is thought to have allowed a carefree and leisured existence: a life which was free of the toil which is associated with an agricultural society and of the burden of material possessions. In another scenario the Mesolithic families were disease-ridden savages, crouching in insanitary hovels at the mercy of wild predators, parasites and the uncertainties of a natural food supply. In the

PINE FOREST,
ABERNETHY,
BADENOCH AND
STRATHSPEY

41

absence of direct evidence, it is impossible to know whether either of these views is accurate, but the knowledge of conditions in hunter-gatherer societies in recent times would suggest that the state of well-being of the Mesolithic population could have been quite satisfactory.

Agriculture came to Scotland in the Neolithic period in the fifth and fourth millennia BC. It seems likely that the ideas and the where-withal, in the form of stock animals and seedcorn, were brought into the region by an immigrant people from Northern Europe. As with the Mesolithic settlers, the principal means of transport is likely to have been by water. The addition of agriculture to the fishing, hunting and gathering activities of the previous era brought about a way of life in the Highlands of Scotland which, for the bulk of the population at least, was to remain unaltered in its main elements until the dawn of the industrial age.

The introduction of farming created two requirements which were to have a profound effect on the subsequent appearance of the land-scape and the structure of society: the clearance of the forests and the establishment of permanent settlements. The sound of the woodcutter's axe which was heard for the first time in the Neolithic Age and which was destined to ring out over the next five millennia was the noise which accompanied the earliest serious attempts by humans to modify the landscape of Scotland. In prehistoric times forest clearance was used principally as a means of making land available for agriculture, and this led eventually to the creation of the rich farmland on the coastal plains of the North-east. In subsequent centuries, however, the forests were extracted from the less accessible uplands for largely commercial pur-poses, and thus began the process which resulted in today's 'wet deserts' in the mountains and moorlands of this area. It is difficult to imagine how such a vast forest as once grew over practically the whole of Scotland could have been so completely obliterated, until one remembers the length of time (around 5,000 years) over which this occurred.

The North-east of Scotland contains some of the most spectacular surviving remains from the Neolithic period. At Skara Brae in Orkney, for example, which dates from the late fourth millennium BC, the most complete group of Neolithic houses in Europe is to be found, while the profusion of burial cairns, long barrows, henges and stone circles which occur throughout the region point to a society in which some individuals had considerable power to control and direct labour. There is also evidence from the Neolithic period for the evolution of specialist manufacture and trade, particularly in relation to stone-cutting imple-ments. Large quantities of axe heads and other tools have been found in Scotland which originated in 'axe factories' in Ireland or at Great Langdale in northern England. The fact that labour could be spared for manufacture and trade specialisms, as well as for the design and con-struction of cairns, henges and megalithic structures, further implies that a stable social structure had evolved and that food production tech-niques were more than adequate to supply the basic needs of the popula-tion. It seems likely, therefore, that a fairly complex society, within which the accumulation of personal wealth and power on a scale which

STONES OF STENNESS, ORKNEY

The combined henge and stone circle of Stenness is an arresting structure, despite the fact that the henge has been almost totally eradicated by the action of ploughing over the centuries. The existence of megaliths such as these invites speculation as to the nature of the society which erected them. They surely point to the existence of a way of life in which the bare necessities of food, shelter and clothing were being won from the environment with relative ease by the mixed farming and hunting communities which inhabited settlements such as Skara Brae. Otherwise, how could the enormous effort required to build these structures have been spared from activities essential to ensure the mere process of survival?

would have been impossible in the semi-nomadic lifestyle of the hunter-gatherer, evolved in the Neolithic period following the introduction of farming and the establishment of settled communities. Thus, in the Neolithic Age were the foundations laid of medieval and even of modern Scotland.

The techniques of metal-working which gave rise to the term 'Bronze Age' appeared in Scotland around 2000 BC. The earliest work was in copper and gold, the raw materials for which could be acquired locally, but the alloying of copper with tin to produce bronze, which was much harder than either of its constituents and which produced

more effective cutting edges for tools and weapons, was quickly adopted. The tin would probably have been imported from Cornwall, but the techniques in use were those of the European workshops, indicating that contact with both southern Britain and Europe was maintained throughout the period.

It is likely that the structure of society in the Bronze Age was similar to that of the Neolithic period, but the demands of metal-working must have given further impetus to any tendency towards increased stratification and specialisation. The production of metal involves a knowledge of mining and therefore of geology. If some essential raw materials are unavailable locally – as was the case with tin in Scotland – it involves making journeys and trading, which introduces the possibility of treaties and trade agreements concerned with the supervision of resources and control of routes. It also implies the creation of a highly specialised group of individuals trained in the mysteries of practical chemistry and the techniques of casting and forging. All of this implies an ever-increasing level of complexity in the structure of society which may, therefore, reasonably be assumed to have occurred as the Bronze Age progressed.

In the early centuries of the first millennium BC bronze gave way to iron as the material for cutting edges; the Iron Age had begun. Iron was a far superior material from which to make tools and weapons and also had the advantage of being more plentiful in Britain. Celtic-speaking people were migrating into Britain from Europe at this time and with them came new ideas and new techniques. The pattern of life seems nevertheless to have undergone no sudden change from that of the Bronze Age although the disappearance of elaborate burial structures at this time suggests a fairly significant alteration in religion and beliefs.

The Celtic society of the Iron Age seems to have had a tribal structure, there being around fifteen tribes in all occupying the area of present day Scotland. They were, therefore, fairly large and the society appears to have been stratified with, at the highest level in each tribe, a ruling class or family from which the chieftain was selected. The majority of the population were smallholders who had some kind of title to occupy and work an area of land, and the homesteads in which they lived were probably located in groups. It is likely that a system of co-operative tillage of land and of rights of pasture on commonly held ground was in operation. Between the chieftain class and these common farmers there existed an aristocracy, a class of nobles who appear to have enjoyed exclusive rights to areas of land not held commonly. There must also have been a class of specialist craftsmen engaged in the production of weapons, tools and other artifacts, as well as of bards, and, of course, of priests.

The most spectacular tangible remains to have survived from the Iron Age are the many hillforts. As their name suggests these were normally located on hilltop sites, consisting of an enclosure formed by one or more concentric rings of ditches and ramparts and varying in size from less than a single hectare to an area large enough to accommodate several hundred dwellings. They began to appear in the landscape in the

eighth century BC and are the earliest form of military structure in Scotland. Some of the best examples are to be found in the north-east.

The earliest Iron Age forts had massive walls constructed from timber posts and horizontal ties infilled with masonry. The volume of timber involved was considerable and it is thought to have been incorporated to allow the wall of unshaped boulders to stand with a vertical face and thus provide a formidable barrier to an intruder. It is, therefore, unlikely that the building of such structures would have been possible before the introduction of iron-edged tools.

The walls of many of the forts have been vitrified – which is to say that at some time the timber elements were ignited, the resulting conflagration burning with such intensity that the masonry fused into a single congealed mass. The circumstances which caused this phenomenon are a matter of conjecture. Vitrification of a fort may have been the result of military action and therefore a process of destruction; it may have been accidental or it may even have been a deliberate part of the building process intended to produce a solid, impenetrable core for the defensive rampart. Archaeological opinion seems currently to favour the first of these explanations.

The purpose of the hillforts is debated. They were probably the citadels of the local chieftains of a fragmented, tribal society and it is unlikely that they were ever called upon to withstand the type of systematic siege which was to be a feature of the medieval period. Rather, they would have functioned to resist the opportunistic and impulsive raiding associated with feuding and cattle thieving. It is probable that the larger settlements were centres of administration, craftwork and trade, in which case they would have been the direct precursors of the medieval burghs.

Another group of distinctive structures, unique to Scotland, which appeared in the Iron Age were the brochs – circular-plan towers with thick, very high walls. Around 500 were built and they are the country's earliest constructions which can be considered works of architecture. They were fortresses but could not have withstood prolonged siege and probably originated as refuges against short-term raids from the sea. They may also have functioned as symbols of authority. They appeared in the landscape around 100 BC but their popularity or usefulness was short-lived as not many were occupied for more than a few hundred years.

In the first century AD yet another culture invaded Britain from the south and its influence spread gradually northwards. This latest incursion emanated from Rome but the Celtic culture of Iron Age Scotland, and especially the parts north of the Central Lowlands, managed to resist the influence of the Roman Empire. It was one of the very few parts of Europe to do so. The Roman Army came to the Highlands; it even fought and won a great battle there – *Mons Graupius*, which gave the Grampians their name – but it was never completely victorious because the Romans were never able to occupy or pacify the region. The old Celtic culture therefore lived on through the Roman era and, after its demise, reasserted itself over the whole of Scotland north of the River Forth.

GURNESS BROCH, ORKNEY

The broch at Gurness lies at the centre of a complex of buildings of various ages and is for this reason not typical. It was probably built in the first century AD, together with two rings of outer defences. The space between the broch and the latter was then filled with a series of irregularly shaped houses to create a settlement which amounted to a small village. This complex remained in occupation until around AD 400, after which the site was abandoned for 200 years before being reconstructed by the Picts. All of the remains seen in the photograph are from the earlier period of occupation.

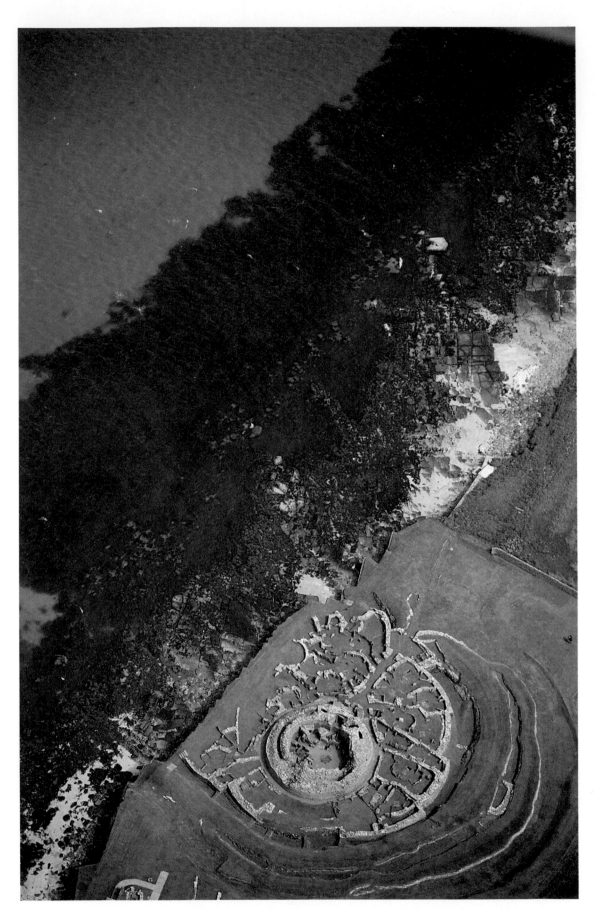

The Celtic people who occupied the North-east for most of the first millennium AD are known to us as the Picts. It is possible that such political unity as did exist across their territory was in some measure initially due to the presence of the Romans as an external threatening power. Their most notable legacy is a series of enigmatic symbol stones and the distribution of these implies that this loose federation of tribes established a common cultural base over the eastern half of Scotland from Orkney to the Tay. By the sixth century, when the influence of Christianity was spreading from Ireland, a Pictish capital had been established in the vicinity of the inner Moray Firth, most probably at Craig Phaedrig or Burghead.

From the ninth century onwards the lands of the Picts were subjected to increasing pressure from Norse invaders, initially in the form of piratical Viking raids but increasingly from the establishment of permanent settlements. The Picts were gradually pushed south out of Orkney and even from parts of the northern mainland of Scotland in the late first millennium AD, but they also came under pressure in the south from the Scots of Dalriada, another Celtic people, who had come from Ireland and occupied south-western Scotland. The Pictish kingdom formally came to an end in AD 843 when it was united with that of the Scots of Dalriada to form the Celtic kingdom of Alba under Kenneth McAlpin. This was to be the foundation of modern Scotland but, for some reason which has never been fully explained, the Pictish culture became completely obliterated by that of the Scots.

The height of Norse power in Scotland occurred in the eleventh century with the establishment of the Earldom of Orkney, which co-existed with the kingdom of Alba. The Earldom was a stable entity with permanent systems for estate management and tax collection, whose jurisdiction included Orkney, Shetland, the Western Isles as far south as the Isle of Man, and parts of mainland Ireland and Scotland. Nevertheless, both the Celtic peoples and the Norse earls were to be pushed northwards and westwards at the beginning of the present millennium by the rising tide of feudalism from mainland Europe. The Vikings were forced out completely in the twelfth century. Perhaps their most enduring legacy, though, apart from their place names which are to be found in many parts of Scotland, was the strong political axis which they established on the West Coast and in the Western Isles. This survived in the form of the Lordship of the Isles, ironically the political entity which had expelled the Vikings in the first place. The clan system which developed under the Lordship in the twelfth century may be thought of as a direct successor to the tribal organisations of the Iron Age Celts. It was to become one of the principal repositories of Celtic tradition in Scotland.

By the end of the Middle Ages a part of the cultural boundary between the ancient Celtic traditions of Europe and the new materialistic feudalism had become established in Scotland. The old traditions were still alive in the western Highlands and Islands but the ideas of feudalism had taken possession of the East. The North-east therefore formed, and to some extent still forms even in the present day, a battleground between these ideologies.

SKARA BRAE, ORKNEY

Skara Brae is the best preserved Neolithic settlement in western Europe. It is a village of ten houses on the coast of mainland Orkney which was overwhelmed with a covering of sand and which lay undetected for around 3,000 years until uncovered by a storm in 1850. From the remains found within the site archaeologists have deduced that the village was occupied by a people who reared livestock, sowed cereal crops, collected shellfish and practised fishing. Cattle were the most important domesticated animal but sheep, goats and pigs were also kept and it is likely that the hunting of wild animals also took place. Each house in the village is cruciform in its arrangements with a dresser opposite the entrance and a bed on each side of a centrally placed hearth, all of the furniture being made of stone flags. The artifacts which have been found in the village indicate that trade links had been established with Ireland and southern Britain.

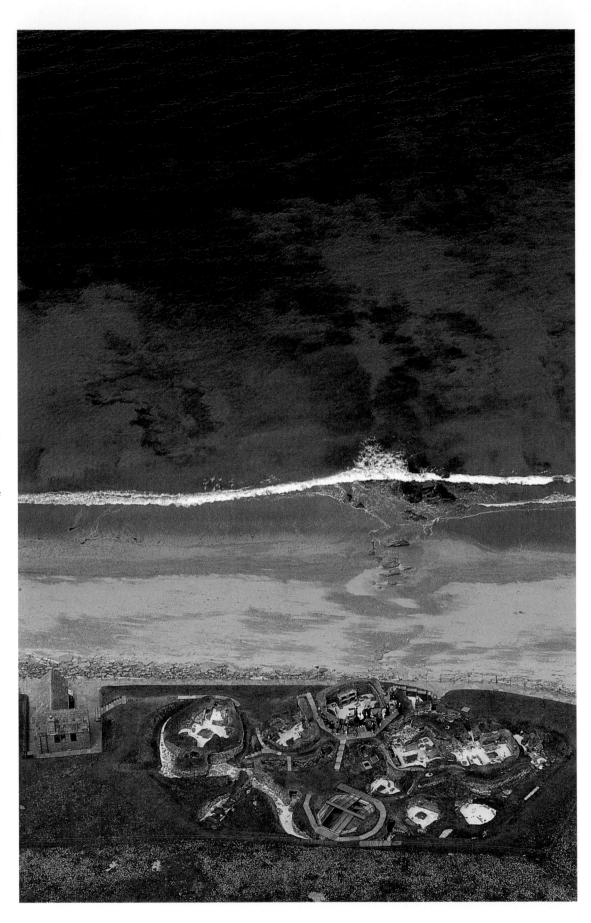

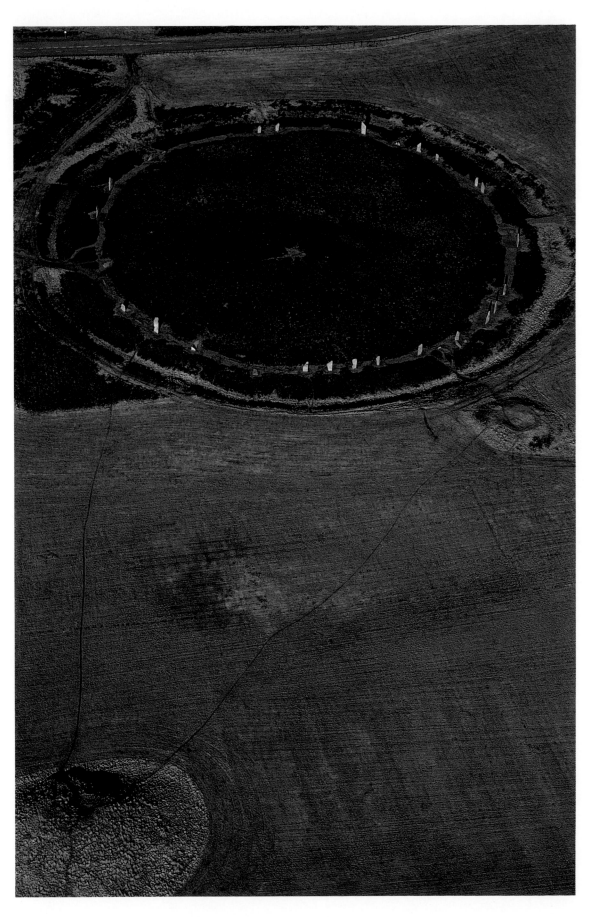

RING OF BRODGAR, ORKNEY

Stone circles are perhaps the most awe-inspiring of the structures which survive from the Neolithic period and some of the most spectacular in Britain are to be found in the North-east of Scotland. Few people who visit the Ring of Brodgar and the nearby Stones of Stenness, which are both situated close to water in the bare, gently rolling and windswept landscape of mainland Orkney, are unaffected by the experience.

The Ring of Brodgar is a stone circle of immense size – around 100m in diameter – which is set within a henge (a circular area enclosed by a ditch). Originally there were around sixty stones but only twenty-seven remain standing today. The purpose of this structure is a matter of conjecture. Henges seem to have been used to delineate areas in which ceremonial or ritualistic activities took place but in Scotland stone circles appear to have had a sepulchral function. It is also possible that they had astronomical uses associated with the monitoring of the passage of the seasons.

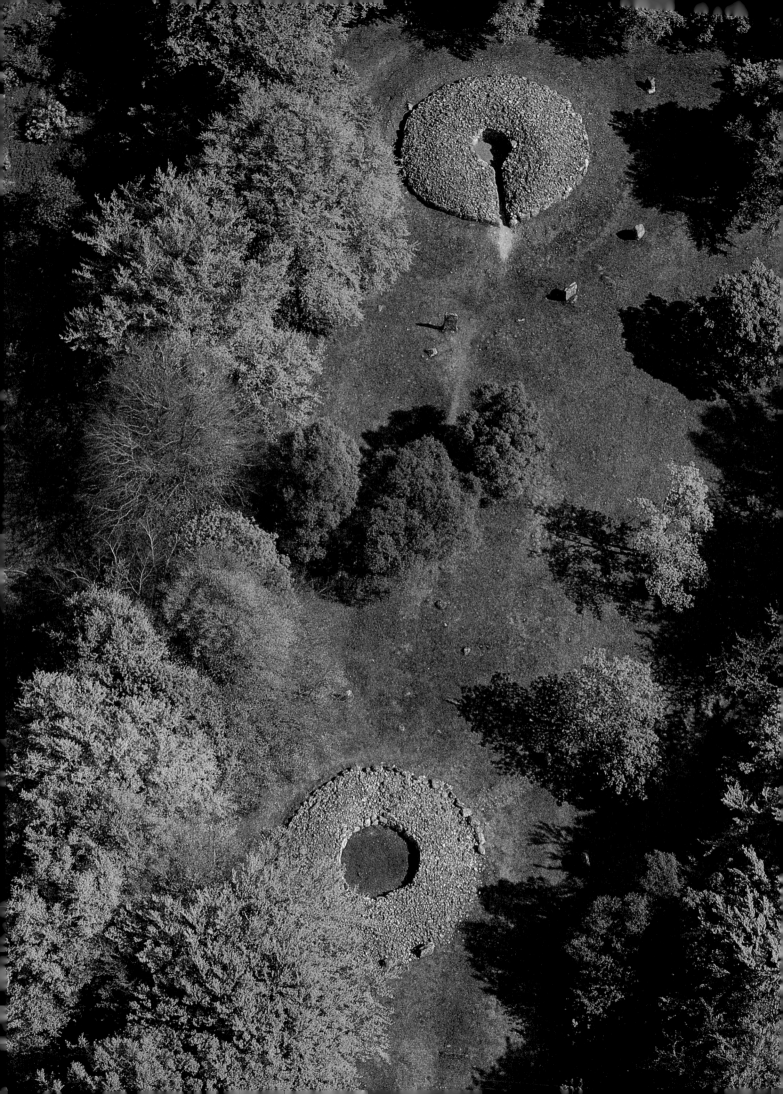

CLAVA CAIRNS, INVERNESS

There are three cairns on this site near Inverness. Of the two which arc shown here, one is a passage grave and the other a ring cairn. The inner chamber of the passage grave was originally roofed by the corbelling technique and the passage itself by the use of flat flagstones. The ring cairn, however, is thought to have been unroofed. The central chamber of this would simply have been filled after the burial with earth and stones to the level of the walls.

To build these burial chambers, the Neolithic peoples must have evolved a social organisation in which a high degree of co-operation was possible, perhaps as a consequence of a high degree of stratification, with kings or chiefs powerful enough to direct the large input of labour which must have been required.

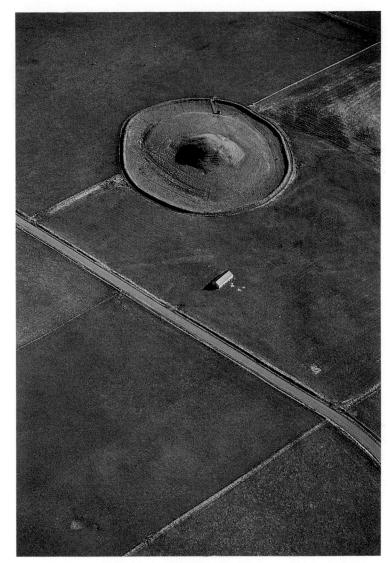

MAES HOWE, ORKNEY

Maes Howe is the finest chambered tomb in Britain and one of the supreme achievements of prehistoric Europe. Externally it consists simply of a mound 35m in diameter and 7m high situated within a levelled platform encircled by a low bank. The mound itself is of clay and stones and it conceals a miniature work of architecture in the form of an inner burial chamber 4.5m square, constructed in masonry. The quality of the latter is outstanding. The stone has been split along its bedding planes to produce large flags with flat sides and sharp edges and these have been assembled, with wafer-thin joints, into a dry-walled inner chamber with a high soaring corbelled roof.

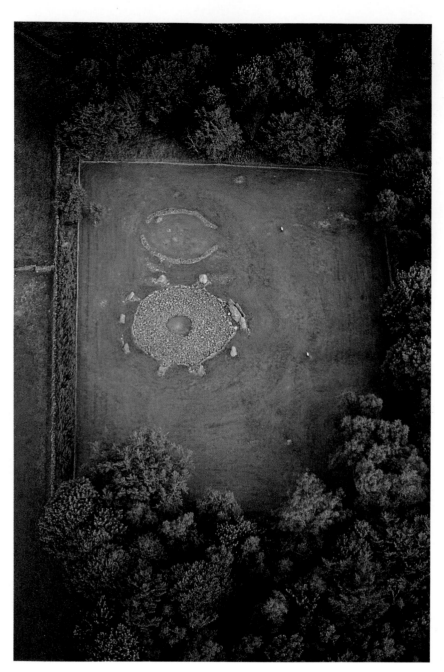

TAP O' NOTH HILLFORT, GORDON
(right and overleaf)

At an elevation of 563m above sea level, Tap o' Noth is both one of the highest as well as being one of the largest and most spectacular of the vitrified forts.

Two defensive systems are present at Tap o' Noth: a splendid vitrified rampart enclosing an area 105m by 40m and a larger, possibly earlier, enclosure formed by an outwork which consists of a stone wall with a core of boulders. At least 145 hut circles have been found within the area of this outer boundary, indicating the existence in the first millennium BC of a considerable settlement, amounting almost to a town, at this very high level.

RECUMBENT STONE CIRCLE, LOANHEAD OF DAVIOT, GORDON

Recumbent stone circles consist of a circle of standing stones, graded in height with the larger stones oriented to the south west. The two tallest stones flank a recumbent stone from which this circle type takes its name. A ring cairn – the base of which is clearly visible in the photograph – normally occupies most of the area within the circle. Peculiar to this part of Scotland, such circles are all associated with cremation burials and it is believed that this particular example was in use for many centuries for rituals of life, fertility and magic until it became disused around 2000 BC.

Also visible in the photograph are the remains of two semi-circular walls which define the boundaries of a cremation cemetery. This was built after the stone circle had been abandoned and prolonged the use of the site until around 1200 BC. This sacred place occupies a broad area of level ground close to the summit of a gentle hill which is typical of the locations chosen for recumbent stone circles.

And then a queer thought came to her there in the drooked fields, that nothing endured at all, nothing but the land she passed across, tossed and turned and perpetually changed below the hands of the crofter folk since the oldest of them had set the Standing Stones by the loch of Blawearie and climbed there on their holy days and saw their ter-raced crops ride brave in the wind and sun. Sea and sky and the folk who wrote and fought and were learnéd, teaching and saying and praying, they lasted but as a breath, a mist of fog in the hills, but the land was forever, it moved and changed below you, but was forever, you were close to it and it to you, not at a bleak remove it held you and hurted you.

LEWIS GRASSIC GIBBON, *Sunset Song*

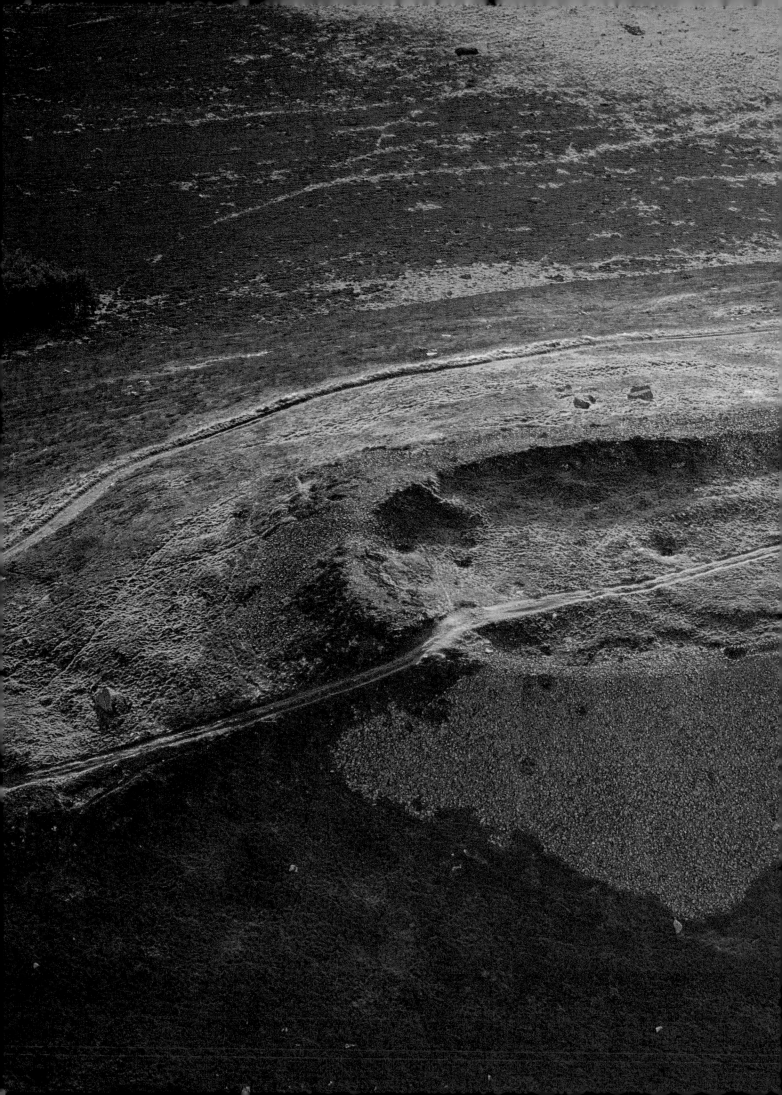

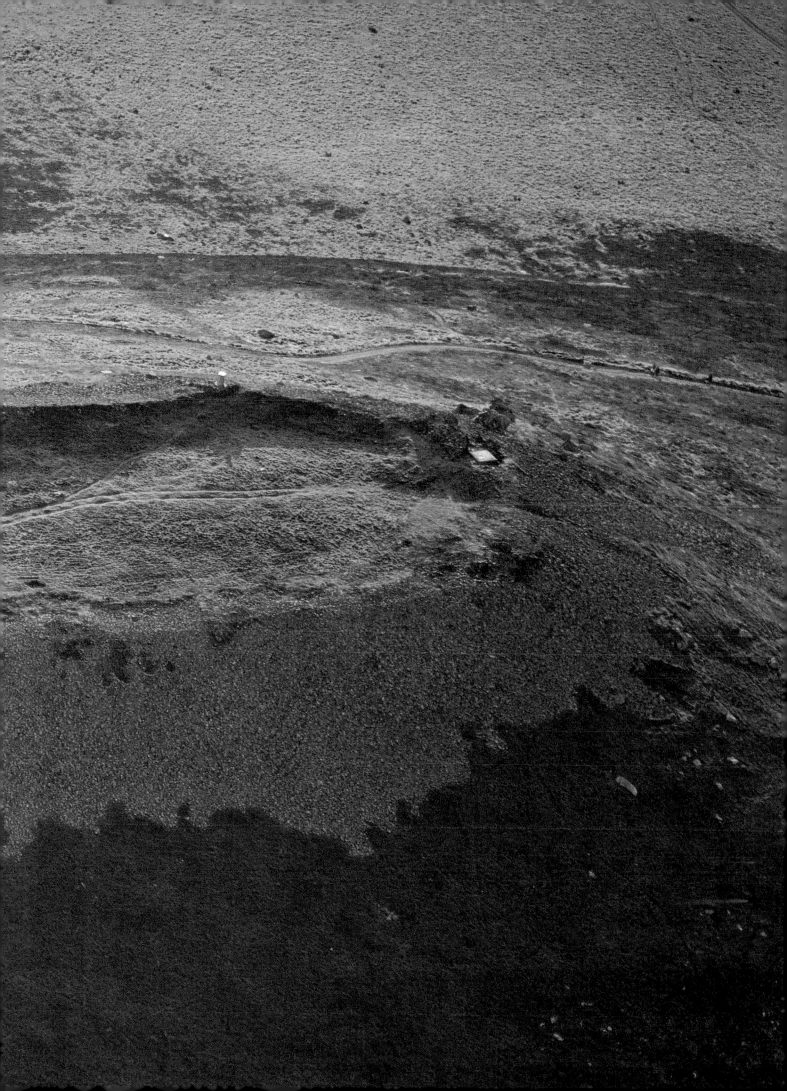

WHITE CATERTHUN HILLFORT, ANGUS

The most spectacular defensive structures at Caterthun are the twin stone walls whose rubble remains give White Caterthun its name. This fort also contains the remains of a rock-cut cistern in which its water supply was stored.

White Caterthun was the first ancient monument to be taken into state care following the passing of the first Ancient Monuments Act in 1882. This piece of legislation, which covered only fifty ancient monuments in the whole of Great Britain (there are currently around 4,500 scheduled monuments in Scotland alone), was vigorously opposed by landowning interests and took nine years to pass through Parliament in a series of battles which may be likened to those currently occurring over the conservation and proper husbanding of the natural environment.

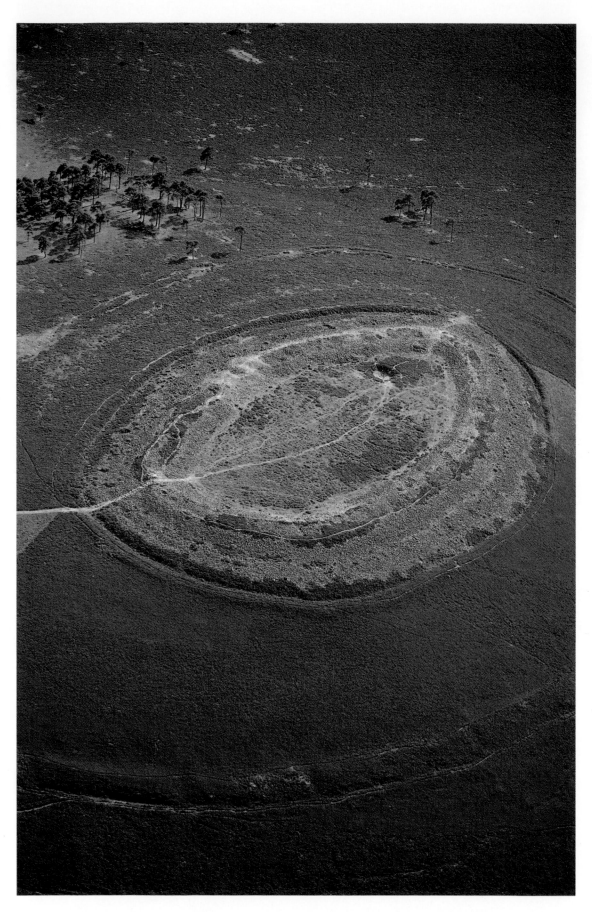

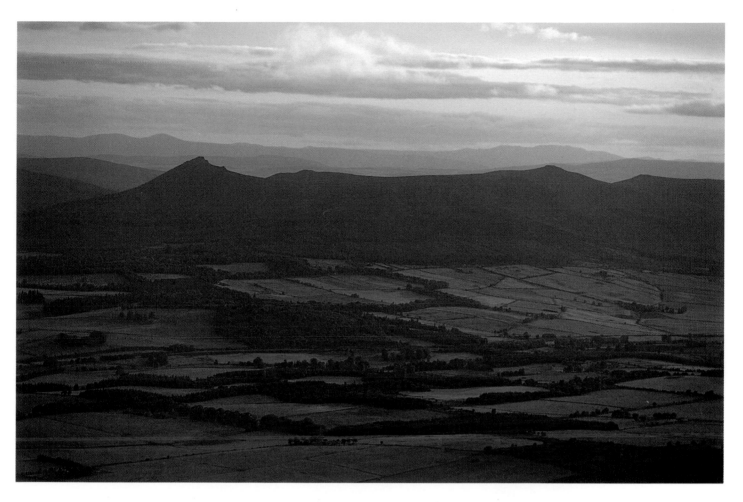

THE BATTLEFIELD OF *MONS GRAUPIUS*, GORDON

'We, the most distant dwellers on earth, the last of the free, have been shielded until today . . .'

These words were said to have been uttered by Calgacus, the leader of the Celtic tribes, in a speech made before the battle of *Mons Graupius* in which he and his men suffered defeat at the hands of the Roman Army. It is unlikely, however, that the leader of a people with such a rich heritage as the Celts would have perceived himself as being a 'distant dweller'. Distant from where? Distant from Rome, of course. The report of the speech appears in the Roman account of the battle and may be the first example of what was to become the norm in Scottish historiography: history written from the point of view of a colonial occupying power.

The location of the site of *Mons Graupius* is still a matter of conjecture. As the archaeologist Gordon Maxwell has stated: '. . . archaeology will be deprived of one of its more entertaining sideshows . . . if the battlefield is ever found.' The northern slopes of Bennachie, which are shown in the photograph, are perhaps the most favoured location at present. If they are indeed the site of the battle, then Bennachie itself is the legendary *Mons Graupius*, which gave its name to the Grampians.

PICTISH FORT, BURGHEAD, MORAY

The promontory at Burghead is the site of one of the largest forts to have existed in early historic Scotland. It may have been the capital of northern Pictland – a centre of military and naval activity – and the stronghold of King Bredei, who was visited by St Columba in the sixth century AD and who played an important part in the conversion of the Pictish people to Christianity.

The fort, which consisted of an inner citadel with massive stone walls of coursed masonry protected by an outer defensive structure of three lines of ramparts on the landward side, was built in the fourth or fifth century AD and dismantled, probably by the Vikings, in the ninth century. A large portion of the remains were further destroyed when the present planned-village of Burghead was built in 1805–9. Much of the masonry from the citadel wall was used in the building of the harbour and this erstwhile centre of Pictish power is now the undulating grassy top of the promontory. The modern town was built over the outer defence works.

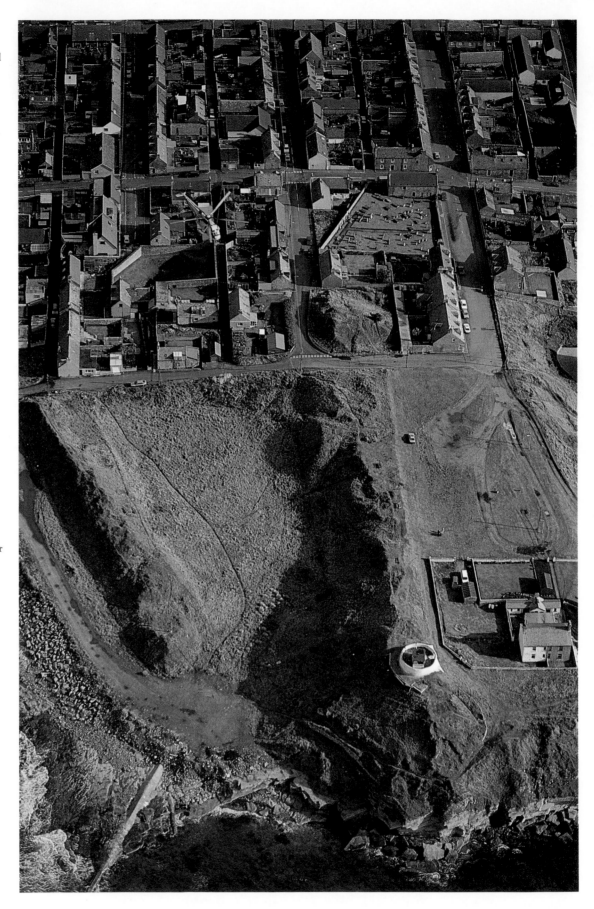

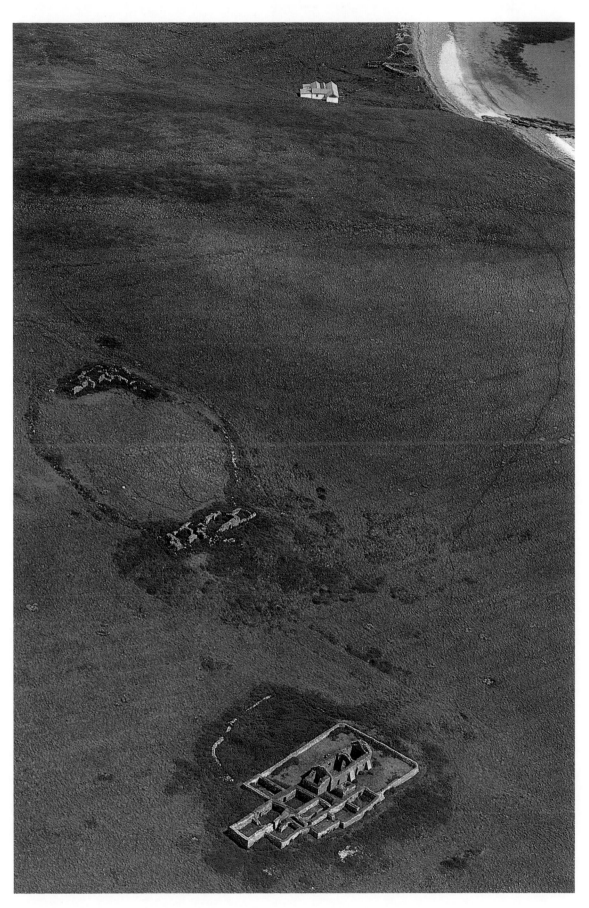

EYNHALLOW CHURCH, ORKNEY

Eynhallow is a Celtic church of the twelfth century but it was almost certainly built on an earlier Norse foundation because its name derives from the Old Norse words *Eyin Helga* – Holy Isle. It was probably the site of a monastery at the time of the Earls of Orkney. The church is of sophisticated design with a rectangular nave and chancel and with a square-plan porch. It is similar in its layout to the church at the Brough of Birsay.

BROUGH OF BIRSAY, ORKNEY

The Brough of Birsay, the remains of which can just be discerned here at the left tip of the island, is thought to have been the capital of the Norse Earldom of Orkney in the tenth and eleventh centuries. Although a large part of the settlement has been lost due to coastal erosion, the remains of an interesting complex of buildings, including hall houses, multi-room houses, sauna bath-houses and a late Norse smithy – which would have been essential for the manufacture and repair of iron tools and weapons – are to be found here.

The most spectacular building at the Brough of Birsay is a Romanesque church of sophisticated plan with a square chancel and semi-circular apse at the east end and traces of a square tower at the west. This building forms one side of a courtyard which is thought to have been the centre of a Benedictine monastery. The establishment of a uniform pattern of religion, based on a diocesan system, was an important aspect of the founding of a stable realm under the Earls of Orkney.

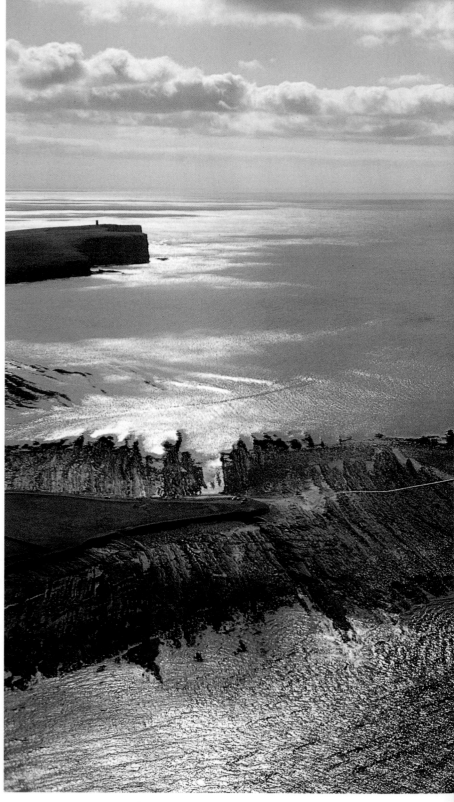

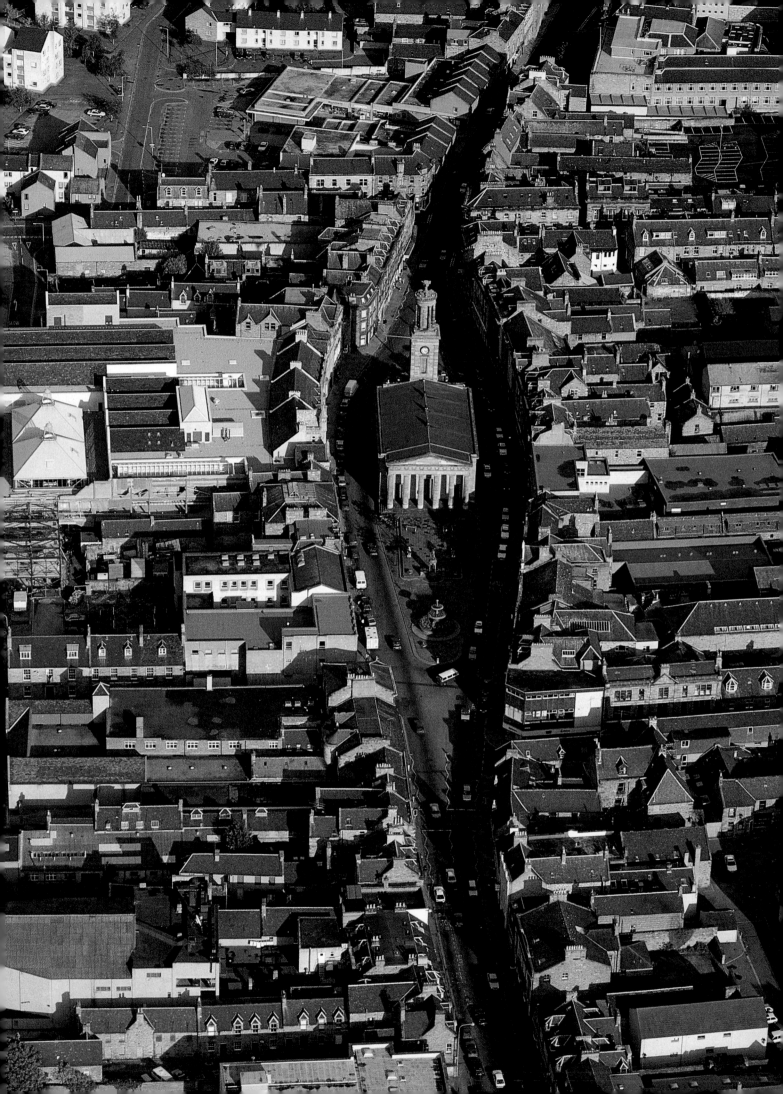

CHAPTER THREE

BURGH, VILLAGE AND CITY

ALTHOUGH THERE IS EVIDENCE OF HUMAN ACTIVITY IN Scotland dating back almost to the end of the last Ice Age, the pattern of settlement and communications which is to be found in the North-east today is principally medieval in origin. It was in the twelfth century, following the establishment of the feudal nation of Scotland, that the first of the medieval burghs was founded. These, together with the contemporary baronial castles, abbeys and cathedrals, established the basic distribution of settlements and roads which has lasted to the present day.

Three subsequent periods can be identified in which significant modification to this pattern has occurred. These are the late eighteenth century, when the movement for agricultural 'improvement' led to the establishment of 'planned villages' – a new form of nucleated settlement; the first Industrial Revolution of the nineteenth century, which brought about the rapid growth of a few of the existing settlements into industrial towns; and the later nineteenth century, in which the largest of these became cities.

It was in the late eleventh and early twelfth centuries that the paraphernalia of feudalism were introduced into Scotland. The most active feudal monarch was David I, who reigned from 1124 until 1153 and who established the administrative and legal framework of the post-medieval state of Scotland. In doing so he consolidated the changes which had been occurring since the ninth century as new political ideas on statehood and nationhood percolated into Scotland from Europe and displaced those of the traditional Celtic and Norse societies. There were four principal aspects to David's plan for modern Scotland: the establishment of feudalism; ecclesiastical reform; provision for the maintenance of law and order; and the encouragement of local and foreign trade.

The last of these involved the creation of towns. It happened suddenly: in the space of a few decades the first twelve burghs in Scotland – the ancestors of the modern towns – were founded, and over the next 300 years a further sixty would come into being. The early towns were created principally as centres of trade but also served as centres of administration and for the maintenance of law and order. The need for these social and political functions had probably existed since Neolithic times when agriculture and a settled way of life became established, but the necessary conditions for them, in the form of a relatively coherent political and administrative structure over a large area, did not exist in Scotland until the introduction of feudalism.

ELGIN, MORAY

Elgin, which was one of the first burghs to be created in Scotland, is an example of the simplest type of burgh plan. The single wide high street, which served as a market place, was tapered at both ends and the lines of the burgages, the narrow strips of land on which the burghers built their houses, ran back at right angles from this to the burgh boundary. As well as serving as a market place, the spacious high street provided a central site for the burgh kirk. The present Greek Revival church by Archibald Simpson was built in 1825–8 on the site of its medieval predecessor.

The siting of a burgh was determined largely by geographical considerations, typical locations being a congruence of overland routes, a river crossing or a suitable site for a harbour. Many were set up on uninhabited sites and were therefore the very first of the 'new towns' which were to be created in every subsequent period in which a significant socio-economic upheaval was in process. Like the new towns of every age, they conformed to a standard plan. The typical layout was simple. It consisted of a single wide street (the 'hiegate' or high street), in which the weekly market and annual fair were held, with lines of burgages on each side. Nevertheless, variations on the basic layout were many and were usually determined by topography. Sometimes the high street was wedge-shaped on plan, sometimes simply a wide parallel-sided street with triangular or squared ends.

The burgages were the plots of land let to the burghers and were narrow strips running back from the high street to a lane (frequently called the 'cowgate') which formed the boundary of the burgh. The burgher would build his house on the high street and the remainder of the burgage would form his kailyard with associated byre for animals. The burgher was, in other words, a smallholder as well as a merchant and had rights of common grazing for his animals on the burgh's land.

Most of the early burghs prospered and their increasing populations were usually accommodated without marked extension to the overall boundaries by the expedient of building extra houses on the open parts of the burgages. The lanes between these became minor streets, closes and wynds, made up of buildings which were smaller and meaner than those which faced the high street.

Life in the more successful of the medieval burghs was truly cosmopolitan. In this first age of capitalism in Scotland fortunes were quickly made and could equally quickly be lost. Many traders operated close to the fringes of the law and smuggling was rife. The merchants were international figures who travelled widely and who brought back to Scotland a taste for foreign luxuries, many building large houses for themselves in their home burghs and often employing foreign builders and craftsmen for the purpose. Thus were foreign ideas introduced into the local traditions of art and architecture.

Few, if any, buildings dating from the period in which burghs were founded have survived to the present day. Most burghs underwent a process of rebuilding from the sixteenth century onwards and the majority of the older buildings in burghs today are from no earlier than the eighteenth century, most being of nineteenth or twentieth century construction. The original pattern of streets and closes was normally preserved, however.

The restructuring associated with the unification of Scotland and the introduction of feudalism established a pattern of settlement and land use which was to remain substantially unaltered until the eighteenth century. From this time the age of agricultural 'improvement' and the first Industrial Revolution which followed it brought about changes in the landscapes and townscapes of Scotland. The most significant of these occurred in the countryside, which became transformed as the old run-rig system of agriculture was abandoned in favour of the cultivation

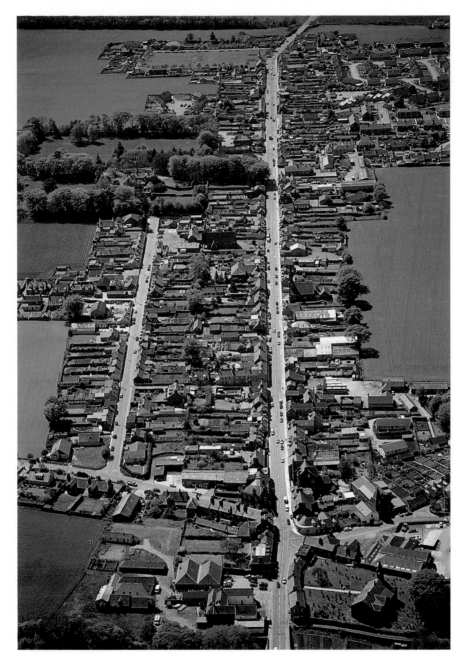

LAURENCEKIRK,
KINCARDINE AND
DEESIDE

Laurencekirk was established
in 1770 by Lord
Gardenstone, a local
landowner. Handloom
weaving of linen was to be
the principal occupation here
but there was also a linen
spinning mill and a
bleachfield. Unlike most
planned villages, which were
controlled directly by the
landowner through a factor,
Laurencekirk was created a
free burgh of barony and
was, therefore, a self-
governing entity. By 1800 its
population had grown to
over 500, making it one of
the most successful of the
planned villages, but like
most other settlements of the
time it never entirely
fulfilled the aspirations of its
founder. Times were
changing and the cottage
industries for which the
planned villages were created
could not compete with the
new mechanised textile
factories which were
springing up in places such as
Glasgow and Dundee.

of 'level', enclosed fields and the 'improving' landowners abandoned
their baronial castles and built classical country houses, surrounded by
landscaped parks.

The substantial fall in the number of people required to work the
land, which the Agricultural Revolution brought about, led to a migra-
tion of population to the burghs – which consequently grew in size –
and to the introduction into Scotland of the 'planned village', a type
and size of settlement which had hitherto been very rare. The initiative
to build a new village was in most cases taken by a landowner, enabling
any part of the population which was surplus to direct agricultural needs
to remain in his area. Thus, the local demand for farm produce was

maintained, an important consideration for the profitability of the new 'improved' farms in an age without convenient overland transport. It was necessary, however, that the village populations should generate the wealth needed to pay for farm produce; this they did by exporting the products of their labours. It was envisaged that these new villages would become centres of rural industry. Textile manufacture, mainly of linen and wool on a cottage industry basis, was the most common objective and this had the added advantage that it would make use of raw materials supplied by agriculture.

Another objective of the planned village movement was the prevention of social unrest. There was undoubtedly a feeling among the landowners, in an age which produced the French Revolution and in which the upheavals of the Jacobite wars in Scotland were still within living memory, that a population which was gainfully employed in manufacturing would not have time to contemplate political upheaval or otherwise to misbehave.

The success of the planned village movement was very limited. Most people who inhabited the new settlements were content to operate as smallholders, cultivating a parcel of land attached to their plot and offering their skills as agricultural labourers or craftworkers to anyone willing to provide employment. It proved difficult to attract people with the type of entrepreneurial skill required to set up a thriving cottage-based manufacturing enterprise. There was an abundance of people willing to carry out basic operations such as spinning, weaving and so on, but a lack of 'middle men' who had the capital resources and the initiative to organise and co-ordinate the manufacturing and to market the products. In addition, as the Industrial Revolution gained momentum, it proved impossible for cottage-based industries to compete in terms of price with mechanised processes of manufacture.

It is nevertheless a fact that, whereas around forty burghs were established in the hundred years following the accession of David I, somewhere in the region of 150 new settlements were created in the same period following the birth of the planned village movement. They were, of course, very slight establishments in comparison to the medieval burghs – in most cases little more than a handful of cottages strung out in a single straight line which did not warrant, in the Age of Reason, the epithet of High Street – and, with their handfuls of linen weavers and cobblers, could not compare to the cosmopolitan breadth of their earlier counterparts, with their diplomatic connections and their trading and cultural links with the Baltic, the Low Countries and the Mediterranean.

The settlements in North-east Scotland which in the nineteenth century grew to urban scale, did so for predictable reasons, mostly connected with location. Kirkwall, Inverness, Perth, Dundee and Aberdeen had all grown large in the period up to 1800 due to a combination of favourable location with respect to transport (in this period water-borne transport by river or sea was the most important) and a relatively prosperous hinterland. In the nineteenth century, following the age of 'improvement', Kirkwall, Inverness and Perth expanded to become small towns whose prosperity depended upon a mixed economy.

Aberdeen and Dundee became industrial cities of roughly equal size and they, together with Edinburgh and Glasgow, are to this day the major centres of urban population in Scotland.

Both Aberdeen and Dundee underwent a quadrupling of their populations in the course of the nineteenth century as farm workers, displaced by the Agricultural Revolution, were drawn to the new employment opportunities of these expanding industrial centres. They evolved in quite different ways. In Aberdeen a range of industries was developed including textiles, engineering, shipbuilding, food processing and granite quarrying, and this diversity produced a stable economy which protected the population from the adverse effects of a slump in any one of them. Mass unemployment, with its attendant social ills, has therefore never affected Aberdeen in the way it has other industrial centres.

Dundee was at the other extreme. It was almost exclusively a textile town, with the bulk of its population employed in the manufacture of flax and jute products. In 1871, for example, 62 per cent of the workforce was engaged in the textile industry. The largest other single industrial employer was engineering with only 5.6 per cent. In Aberdeen, where textiles was also the major employer with 25 per cent of the workforce, the equivalent statistics were 8 per cent in building, 6 per cent in engineering, 7 per cent in food processing and 7 per cent in general manufacturing.

The phenomenal expansion of the Dundee jute industry in the nineteenth century was due principally to Britain's position as an imperial power. Each of the wars of the nineteenth century brought about an increase in demand for heavy cloth for a wide variety of purposes, from sails for men-o'-war to sandbags for dugouts. The conquering and exploration of new territories in Australia, Africa and other parts of the 'third' world required canvas for tents and wagon covers, and the exploitation of the resources of these territories required sacks for bulk packaging. Nothing was so important to the needs of an expanding empire in this era as a plentiful supply of jute products and therein lies the key to the success of Dundee, the jute capital of the world in the nineteenth century. Its prosperity was not, however, to be enjoyed by everyone. Textiles was a low-wage industry which employed a high percentage of female labour, mainly because women could be paid lower wages than men. Again, the statistics are revealing. In 1871, 87 per cent of the female workforce of Dundee was engaged in industrial activity while only 8 per cent was in domestic service, the most common form of female employment in nineteenth-century Britain. This compares with figures for Edinburgh of 46 per cent in domestic service and 39 per cent in industry. Many of the women who worked in the Dundee jute and flax mills were Irish immigrants – refugees from the potato famines of the 1840s.

This low-wage economy of Dundee caused much hardship in the nineteenth and early twentieth centuries. Housing conditions were particularly unsatisfactory, with most families living in privately rented accommodation of a very low standard. Once the jute industry began to decline in the twentieth century, as manufacturing production was

transferred to the Indian sub-continent where labour costs were even lower than in Dundee, the scourge of mass unemployment was felt and the levels of deprivation became intolerable. On the other hand, the jute barons themselves made substantial profits.

The legacy of Dundee's history can still be seen in the townscape today. The jute industry contracted greatly in the twentieth century, but many of the original mills still exist although most have been converted to alternative uses. The best of the tenements in which the workers lived still form a useful part of the city's building stock, as do the large villas of the jute barons – though many of these have been altered for institutional use. The most obvious legacy, however, is in the suburbs: here the state intervened where the industrial employers had failed, and built the extensive housing estates which were required to accommodate the large industrial population. Throughout the twentieth century Dundee has, in fact, taken a pioneering role in the provision of public-sector housing and in the present day a higher proportion of the population lives in council houses than in any other British city.

Despite its dominance, jute was not the only commodity to come out of industrial Dundee. In the nineteenth century the city was also famous for the production of two other 'J's': jam, which absorbed the produce of the local fruit-growing areas in the Carse of Gowrie and Strathmore, and journalism. D. C. Thomson and Company, the Dundee newspaper proprietors, have given to the world a unique range of publications and are now the only major newspaper and periodical publishing house which is owned and controlled by Scots in Scotland. Ironically, given the way in which most Scots vote, the company has a decidedly right-wing editorial policy, but few of its readers seem to take much notice of this. It produces such distinctive periodicals as *The Weekly News*, *The Sunday Post* and *The People's Friend*, but perhaps the most memorable creations of this organisation are such seemingly immortal comic characters as Desperate Dan, Dennis the Menace, Oor Wullie and Korky the Kat.

Thus, in the development of towns in this small region on the fringe of Europe may be seen a substantial part of the history of the evolution of human society. Towns have always been associated with commerce and it is significant that, in the form in which they exist today in this part of the world, they should have been introduced in the feudal period – the age in which mercantilism was imposed on Celtic Scotland by an Anglo-Norman intrusion. This, and every subsequent development in the saga of the evolution of modern urban living, can be glimpsed here, though never, except perhaps in the case of industrial Dundee, could it be said that the towns of the North-east are prime examples of any stage of that development. Their fascination lies in their proximity to the edge, and their susceptibility, therefore, to the influence of the more ancient – and what many might consider the wiser – culture which lies beyond the Highland line.

TOWER BLOCKS, DUNDEE

These tower blocks, on the northern fringe of Dundee, were constructed as part of the post-Second-World-War programme to solve the city's desperate housing shortage. They featured in John Schlesinger's television film *An Englishman Abroad* in which they represented the Moscow apartment blocks in which Guy Burgess lived. No special effects were needed to aid authenticity!

This kind of housing works extremely well in the politicians' statistical analysis and when viewed from an altitude of 2,000 feet. Much of it works less well at ground level.

ELGIN, MORAY

The lines of the burgages of medieval Elgin show up clearly in this view. Originally each would have contained a single timber-framed house at the High Street end and the remainder of the plot would have been open and served as a kailyard. From the sixteenth century onwards the original houses were gradually replaced by stone buildings and the open backs of the burgages were built up with more houses as the prosperity and population of the burgh increased. In time, the first stone houses were in turn replaced and most of the buildings in the photograph are of nineteenth- or twentieth-century origin. The pattern of the medieval town may still be discerned, however.

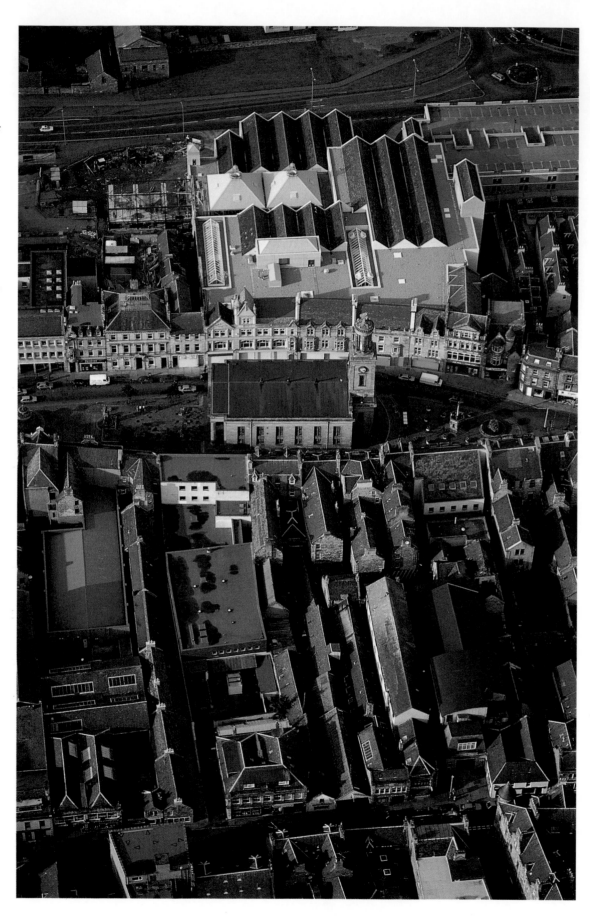

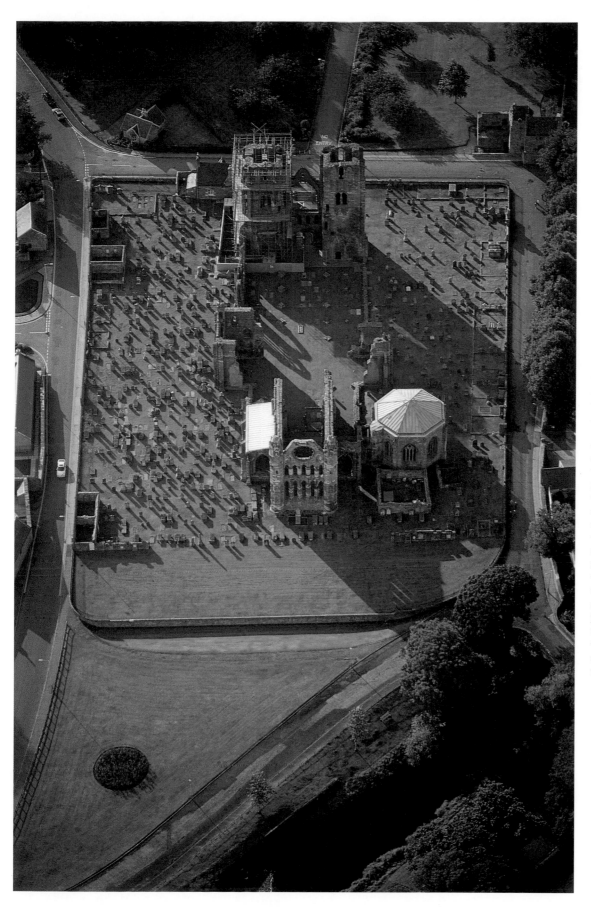

ELGIN CATHEDRAL, MORAY

Elgin became the seat of the Bishopric of Moray in 1224 at which time the Church of Holy Trinity, at the eastern edge of the burgh, became a cathedral. In its final form, which resulted from a late thirteenth-century rebuilding, it was exceptional in Britain because its nave was flanked by pairs of aisles. Considerable foreign influence is evident, particularly from the Ile de France, indicating that the masons working in Scotland at this time were well acquainted with contemporary European architectural practice – something which was to disappear in the fourteenth century in the period of isolation which coincided with the wars of independence.

The planform of such a church has been described as symbolising the journey of the soul to Paradise. The poor sinner enters by the west portal between the two square-plan towers, which are symbols of the material world and of the conflict of duality. In the distance is the rose window, the circle of wholeness, perfection and the spiritual world. The wide nave, the vessel in which the journey will be conducted in the company of other voyagers, provides ample space in which to carry out the work of salvation.

ARBROATH, ANGUS

The medieval burgh of Arbroath, with its broad high street curving from the shore to the precinct of its abbey, lies at the top of this picture. A second wide street, Market Street, can be seen to its right and is an indication that the town prospered in medieval times. Arbroath was an ecclesiastical burgh founded in 1178 to provide an income for the abbey, which was entitled to the tolls and taxes which were earned by its trading activities.

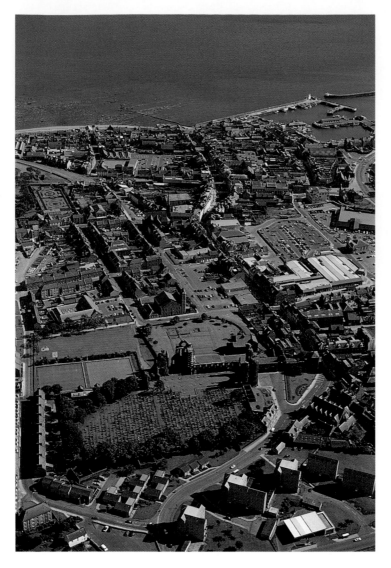

Scotland

It was a day peculiar to this piece of the planet,
when larks rose on long thin strings of singing
and the air shifted with the shimmer of actual angels.
Greenness entered the body. The grasses
shivered with presences, and sunlight
stayed like a halo on hair and heather and hills.
Walking into town, I saw, in a radiant raincoat,
the woman from the fish-shop. 'What a day it is!'
cried I, like a sunstruck madman.
And what did she have to say for it?
Her brow grew bleak, her ancestors raged in their graves
as she spoke with their ancient misery:
'We'll pay for it, we'll pay for it, we'll pay for it!'

ALASTAIR REID

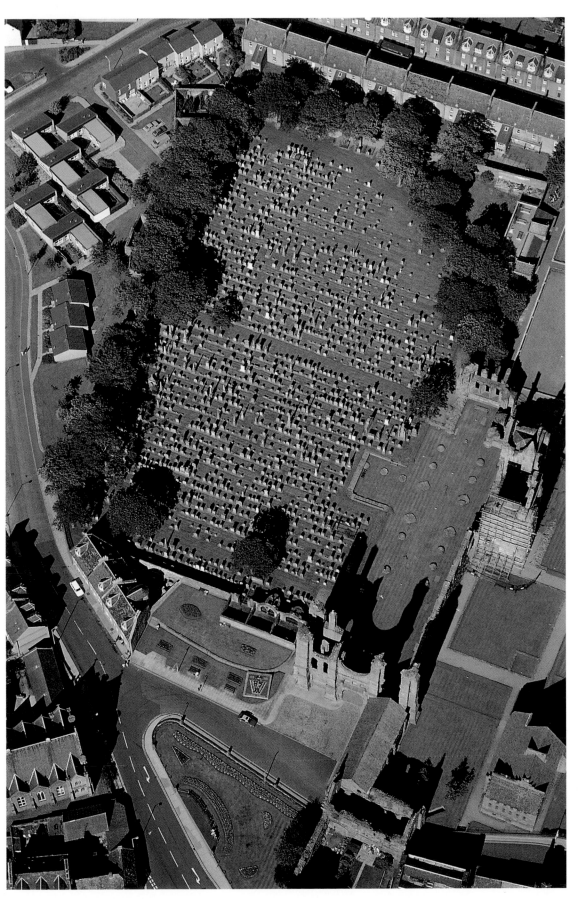

ARBROATH ABBEY, ANGUS

The Abbey of Arbroath was founded by King William the Lion in 1178. Many endowments, in the form of tithes, land and fisheries, were gifted to it by both the Crown and the Scottish nobles and the abbey reflected this wealth. The building was a significant work of architecture and represented the highest aspirations of the age. It served as a university, as an art school, as a craft college and as a hospice for the poor, the sick and the infirm. The finest scholars in Scotland were there and any promising youth who was spotted by his parish priest could join them.

The best-known event in the history of Arbroath was the signing there in 1320 – at the time of the wars of independence from England – of the Scottish Declaration of Independence. This contains some fine rhetoric and has been much quoted by twentieth-century Scotsmen. The signatories, however, were a group of Anglo-Norman nobles who wished to govern Scotland as vassals of Robert the Bruce – who was also of Anglo-Norman descent, and who had not, throughout the wars, displayed an unswerving loyalty to the cause of Scottish independence. The most often quoted section of the Declaration is: *'It is not for glory or riches or honours that we fight, but only for liberties . . .'* The statement was less than wholly honest: the principal 'liberty' which was sought was a diabolical one: the freedom to impose feudal overlordship on the Scottish people.

MONTROSE, ANGUS

Montrose lies halfway between Aberdeen and Dundee and is situated on a spit of land which encloses a large tidal basin at the mouth of the River South Esk. The lucrative tolls from the ferries which crossed the narrow strip of water linking this basin with the North Sea, which formed part of the important overland coastal route between Dundee and Aberdeen, were gifted by William the Lion to the Abbey of Arbroath, ten miles to the south.

The plan of Montrose, which was founded between 1124 and 1153, conformed to the normal medieval arrangement of high street with burgages and, as with most of the early burghs, the lines which were chosen for these were sympathetic to the natural rhythms of the landscape and climate. As a townscape it was much praised both as a satisfying complement to the rural landscape and as a sympathetic background to the activities of its townspeople. The 'architects' and planners of these early burghs exhibited a feeling for the basic requirements of people which was to be found all too lacking in subsequent ages of town building.

On one of the few natural harbours on the east coast and close to a large area of productive agricultural land as well as rich salmon fisheries, Montrose was ideally situated for a trading burgh. In the thirteenth century, and again in the seventeenth, it became one of the most prosperous burghs in Scotland, after Edinburgh and Aberdeen. Despite this, the backs of the burgages did not become totally built up as they did in many other burghs, and they remain today as welcome breathing-spaces in the urban fabric.

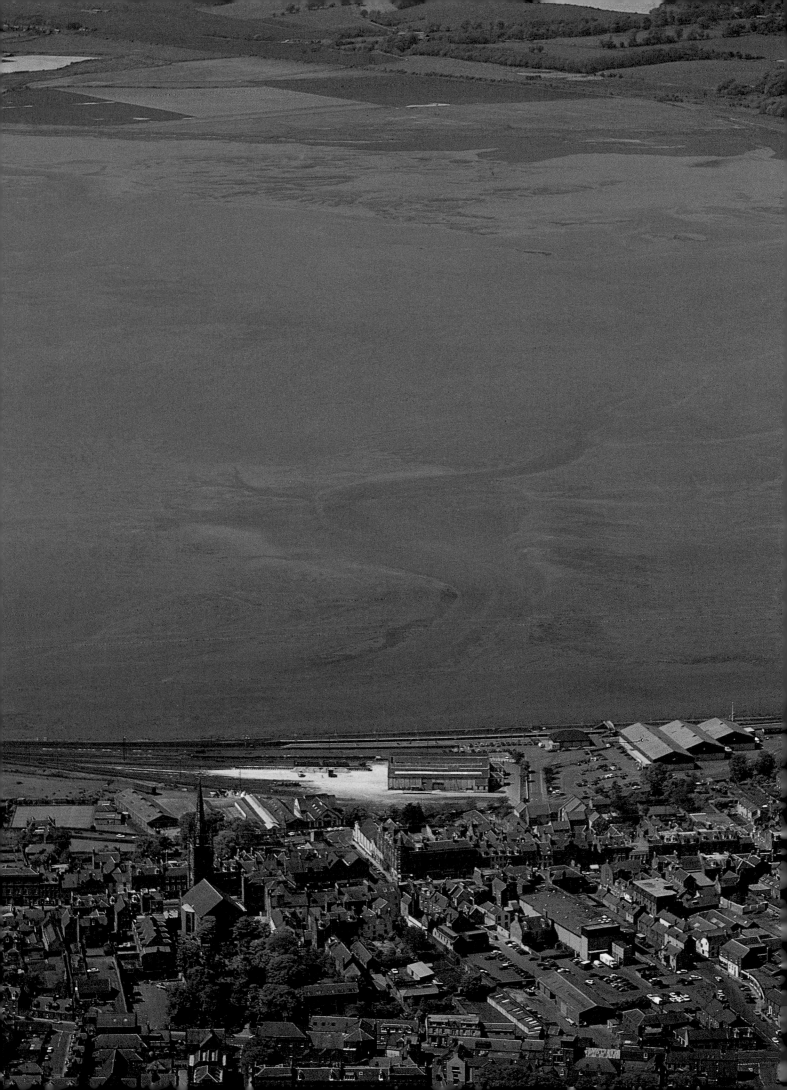

DUNKELD, PERTH AND KINROSS

The burgh of Dunkeld, like that of Brechin, owes its existence to the ecclesiastical foundation to which it is attached. It is likely that a Celtic religious community existed here from the earliest days of Christianity in Scotland, but Dunkeld gained importance as an ecclesiastical centre when Kenneth McAlpin chose it as the organising centre for the Culdee monasteries in the ninth century at a time when Iona, the spiritual heart of Dalriada, became increasingly subject to Viking raids. Dunkeld became the seat of a bishopric in the twelfth century following the Normanisation of Scotland, and the cathedral whose ruin is visible today was built in two stages, in the thirteenth and fifteenth centuries.

Dunkeld was also important as the crossing point of the Tay on the main route through the Grampians from Perth to Inverness. The magnificent five-arch bridge was built by Thomas Telford in 1809 following his appointment as surveyor and engineer to the Commission for Highland Roads and Bridges.

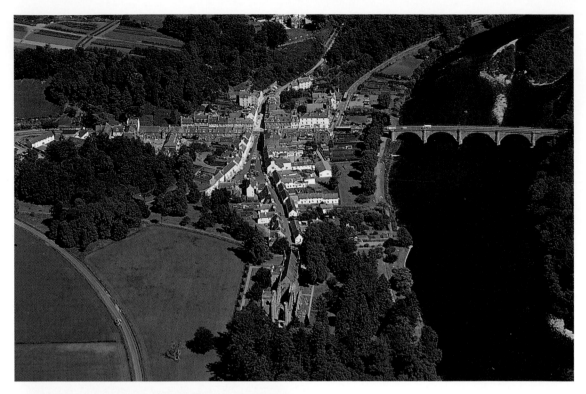

BRECHIN, ANGUS

The cathedral at Brechin was built in the thirteenth century following the foundation of the bishopric, but the attached round tower is earlier and pre-dates the Normanisation of Scotland. It was probably constructed around AD 1000 as an addition to an existing monastery. It is a Celtic design inspired by the many similar structures to be found in Ireland and it served as a belfry and place of security in time of war. It is one of only two in Scotland and the explanation of its presence here is that the original foundation at Brechin was a settlement of the Culdees – groups of monks who lived together in communities of cells but without the controlled monastic way of life of a written Rule and whose influence spread from Ireland in the eighth century in a movement to encourage stricter observances by the Celtic clergy.

The ecclesiastical burgh of Brechin was founded in 1165 and the town was later to prosper as a centre of linen manufacture. Near the top of the picture can be seen a group of eighteenth-century burgher houses with gable ends to the street. Buildings of this pattern were once common in Scottish towns.

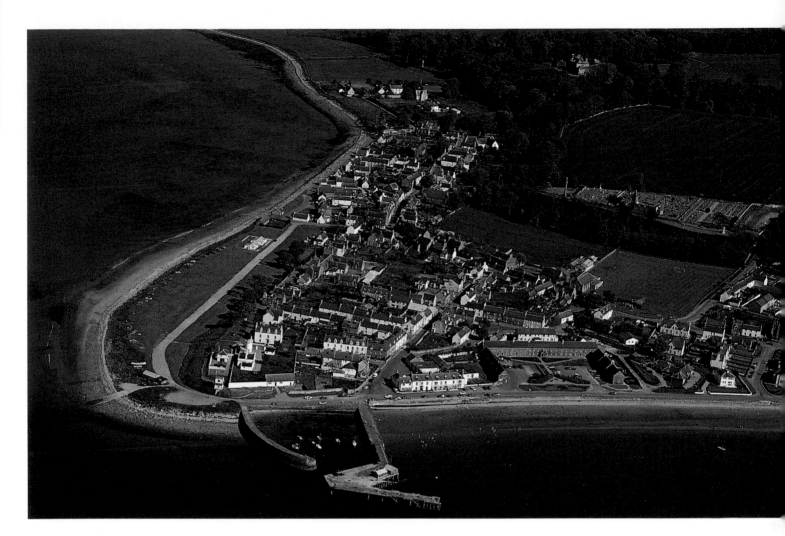

CROMARTY, ROSS AND CROMARTY

Cromarty, which lies at the entrance to the Cromarty Firth, was created a royal burgh in 1264, a status which it enjoyed until 1685. It was a prosperous fishing community in the seventeenth century and was bought in 1765 by a local laird, Sir George Ross, who rebuilt the harbour and established a brewery, a cloth factory, a nail- and spadeworks and a ropeworks there. All of these enterprises were successful, but the prosperity of the town was checked in the nineteenth century due to its being bypassed by the new road and rail routes north from Inverness. As a consequence, little further building was carried out and the town which exists today is largely a product of the late eighteenth century. It is a uniquely undisturbed example of the townscape of the 'Age of Improvement'.

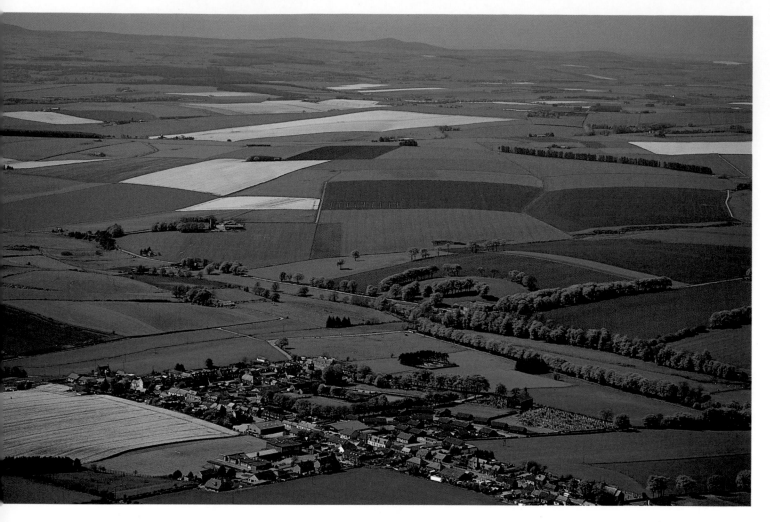

CUMINESTOWN, BANFF AND BUCHAN

Cuminestown, which is typical of many planned villages in the rolling, fertile lands of Buchan, was laid out in 1763 on poor quality land which in agricultural use had yielded an annual rent of £11. It was intended to be a centre for linen manufacture and was an immediate success. People flocked to take up building plots and the total annual rent increased to £150. From the landowner's point of view this was the ideal planned village. It provided gainful employment for a population which was surplus to agricultural production and a market for the produce of the new, efficient farms, while at the same time yielding an increased cash rent from land which had formerly been marginal. It was to be much imitated by other local landowners.

CUMINESTOWN, BANFF AND BUCHAN

This part of Cuminestown shows a mixture of single- and two-storey houses. None of the original buildings has a front garden, a typical feature of most Scottish planned villages which was intended to prevent the accumulation of household rubbish on the main thoroughfare. Generous gardens were provided at the rear for growing household vegetables, however, and these are obviously being put to good use for this purpose in the present day. Indeed, careful scrutiny of the photograph will reveal that a range of other activities is also being carried out, indicating that the spirit of enterprise is still alive in Cuminestown, something which would no doubt have pleased its founder, Joseph Cumine.

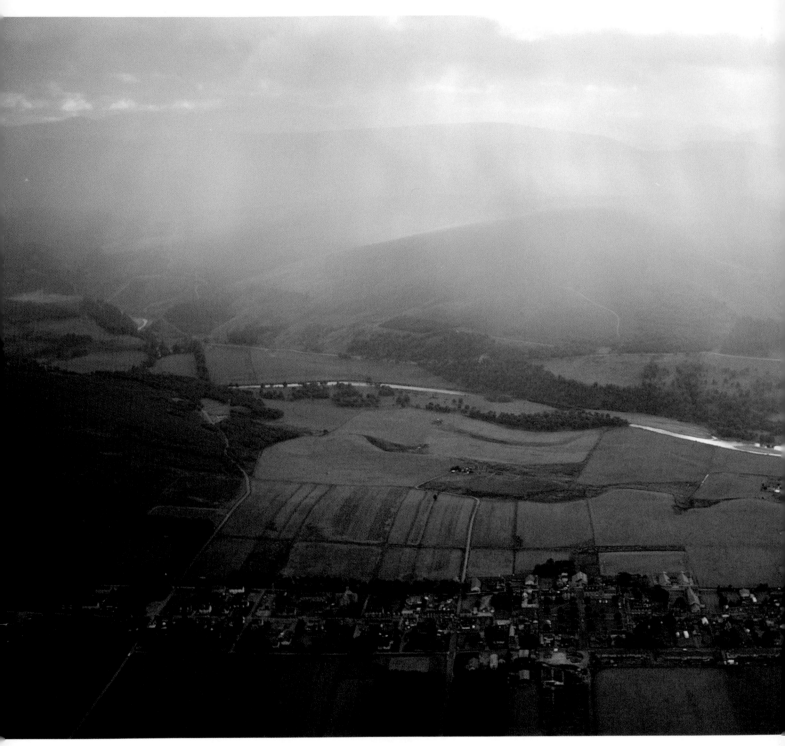

TOMINTOUL, MORAY

Tomintoul is one of the highest of the planned villages, being situated in the foothills of the Cairngorms. Great care was taken with its siting. It was located centrally within the estate of the landowner – in this case the Duke of Gordon – was close to a recognised overland route and was situated on a well-drained ridge, but within reach of good water and peat supplies. Another feature of the site which was stressed by the surveyor, George Milne (who was paid £4 9s. 0d. to survey it and draw up the plans), was the suitability of the surrounding land for bleachfields. Like its contemporaries, this new village was intended to become a centre of rural industry but, as with many others, it was slow to develop.

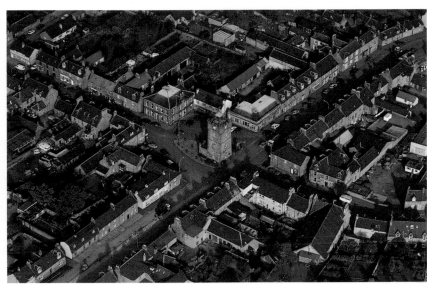

DUFFTOWN, MORAY

The layout of Dufftown is conventional for a planned village and consists of a grid-iron plan of streets on which were placed two-storey cottage-type houses. The tower, at the intersection of the two principal streets, transmits a mixture of architectural messages. It is difficult, for example, to understand why the builders of a tower-house fortress should have found it necessary to provide a clock with which their besiegers, though not themselves, could tell the time. The building, which acted as a jail and a council chamber and is now used as a tourist information office, nevertheless serves as a focal point of the townscape.

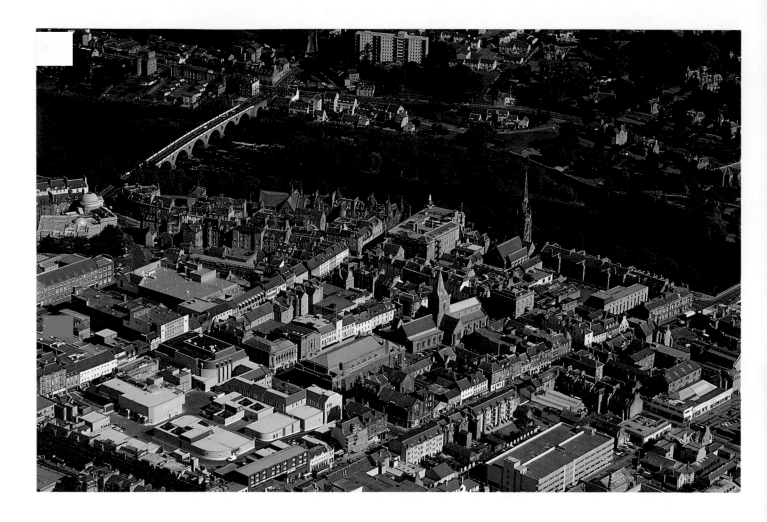

PERTH, PERTH AND KINROSS

Perth was one of the first royal burghs to be founded in the reign of David I and from very early times it had two main streets, High Street and South Street, which are plainly visible

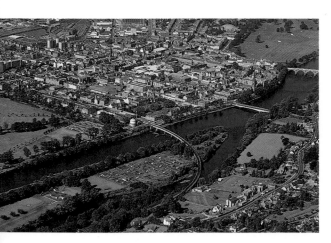

running across from the bottom left in this view of the medieval town centre. The burgh prospered due to its central location in Scotland and its position on the River Tay, where it served both as a crossing point and as a seaport because the river is navigable by seagoing vessels to this point.

By the end of the eighteenth century Perth had become one of the most active of the old Scottish burghs and was famous for shoemaking, paper-making, printing and its linen industry. By this time the open burgages of the medieval town had become completely filled with a dense mass of building and in the nineteenth century a programme of expansion beyond the medieval boundaries was undertaken.

By the beginning of the nineteenth century, genteel society was strongly represented in Perth, having been attracted there by the demand for professional services and by the existence of both a Grammar School and an Academy, in which the sons and daughters of the professional classes could be educated. The Grammar School had been in existence since the twelfth century, but the Academy, which was founded in 1761, was the first of its kind in Scotland. Grammar schools, in eighteenth-century Scotland, had curricula which were centred on the teaching of the classics, particularly Latin. Academies were 'modern' institutions which taught subjects such as mathematics, book-keeping, navigation and the natural sciences. The two were

amalgamated in 1807.

The expansion of the town of Perth in the early nineteenth century took the form of rows of fine Georgian houses, which were placed around the perimeter of the medieval town overlooking the river and the North and South Inches – areas of common land seen flanking the built-up area in the lower picture.

INVERNESS

Although situated on the east coast the position of Inverness at the head of the Moray Firth places it in the physical centre of the northern and eastern Highlands. It also lies at the convergence of a series of natural routes and has for centuries been a centre of trade. A burgh was created in 1153 but the importance of the town as the place through which travellers and goods for most parts of the Highlands must pass increased greatly from the early eighteenth century, when a system of military roads was constructed in connection with the Jacobite wars. This was supplemented in the nineteenth century by the Caledonian Canal and then by the Highland railway system which is centred on Inverness. The cable-stayed Kessock Bridge, which is seen in the photograph, is part of the principal modern road through the Highlands. Inverness also has a busy airport with daily schedules to most parts of the Highlands and Islands as well as to London. The town therefore bustles with activity and has done so for at least 300 years. Much new building has been carried out and little of the ancient picturesque centre remains. There is, however, what the late Colin McWilliam has described as 'the finest man-made riverscape in Scotland'.

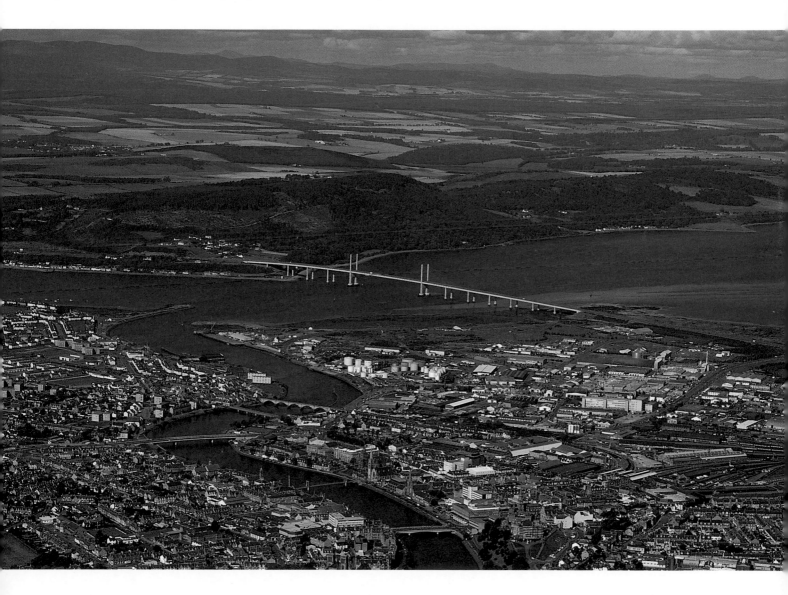

KIRKWALL, ORKNEY

The origins of Kirkwall are
obscure but it is likely that
there was a Viking
settlement here in the early
medieval period. It became
the principal town in Orkney
following the building of St
Magnus Cathedral, seen in
the centre of this view,
which was begun in 1137
and is regarded as the finest
Romanesque work in Britain
north of Durham Cathedral.
The Earl's Palace, in the top
right of the photograph, is
also a significant work of
architecture and has been
described as the 'most
mature and accomplished
piece of Renaissance
architecture left in
Scotland'. The ruined
building immediately to the
right of the Cathedral is the
former Bishop's Palace.

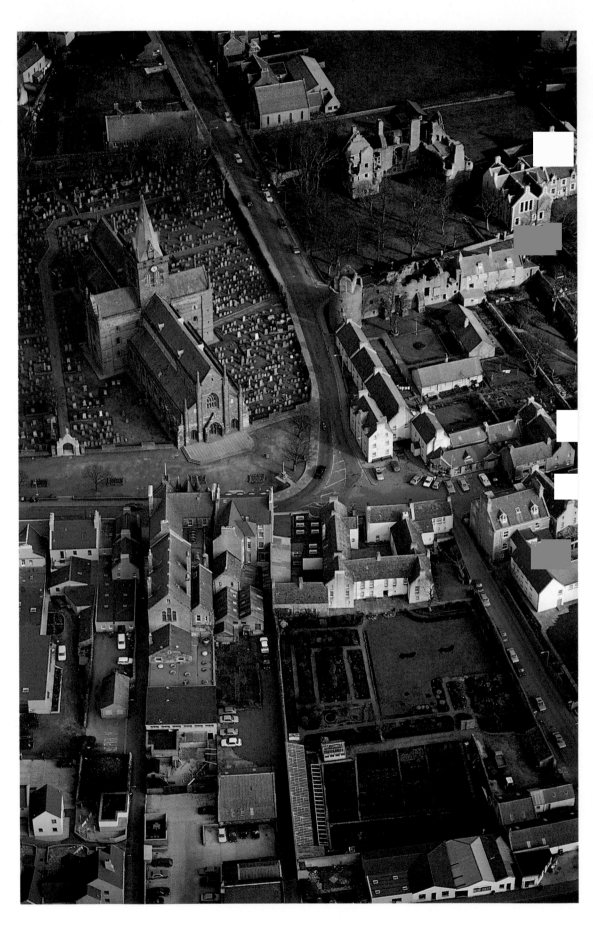

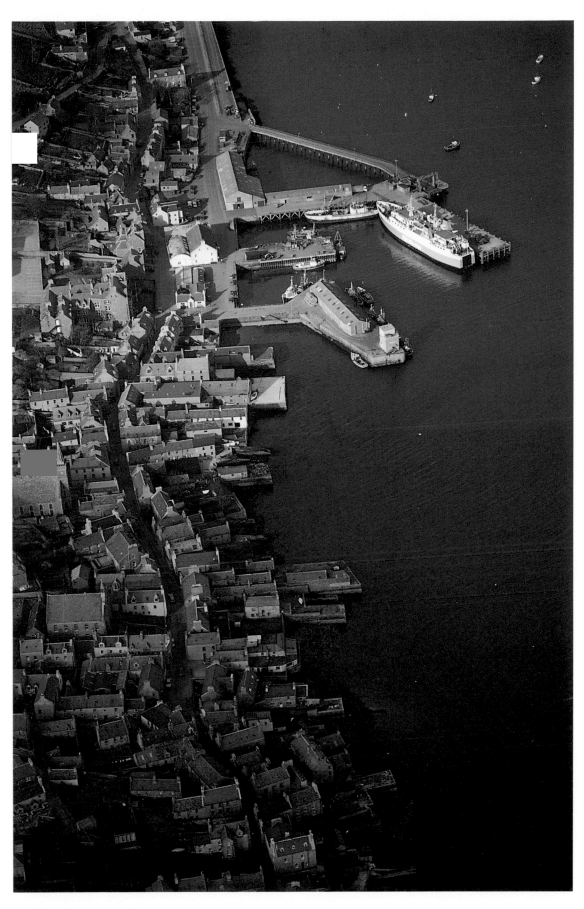

STROMNESS, ORKNEY

The layout of Stromness, with houses and storehouses, each with its own pier and presenting gable ends to the sea, is typical of a trading port of the northern North Sea. The older buildings are no earlier than the eighteenth century as, despite its favourable location and natural harbour, Stromness was slow to develop and did not become a burgh until 1817. The erratic line taken by the main thoroughfare is a consequence of its origin as a pathway running along the shore side of the waterfront buildings. Stromness expanded greatly in the nineteenth century as a base for the Arctic whaling trade.

BRAEMAR, KINCARDINE AND DEESIDE

The River Dee rises in the Cairngorms and flows first southwards and then eastwards a total of 85 miles to the sea at Aberdeen. Its valley, known as Deeside, was 'discovered' in 1848 by Queen Victoria, and the royal family became Highland landowners shortly thereafter when Prince Albert bought the Balmoral estate in 1852. From this time on the formerly quiet Highland strath became the annual destination of a host of tourists from all strata of society.

The two small clusters of squalid houses of Castleton and Auchindyne on the Braes of Mar were joined in 1870 and became the very respectable Victorian tourist resort of Braemar, situated just a few miles from Balmoral Castle itself. It was not the first resort in the Highlands, nor was it the largest, but it had the most respectable address. It also became the venue of the most exclusive of Highland games – the Braemar Gathering – which is held annually in the arena seen in the foreground of the photograph and which is attended to this day by members of the British royal family.

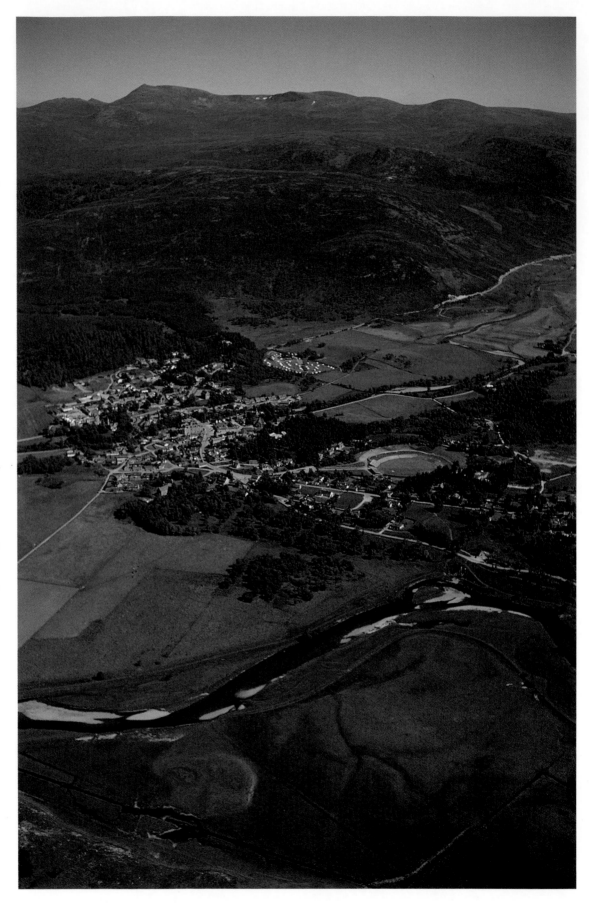

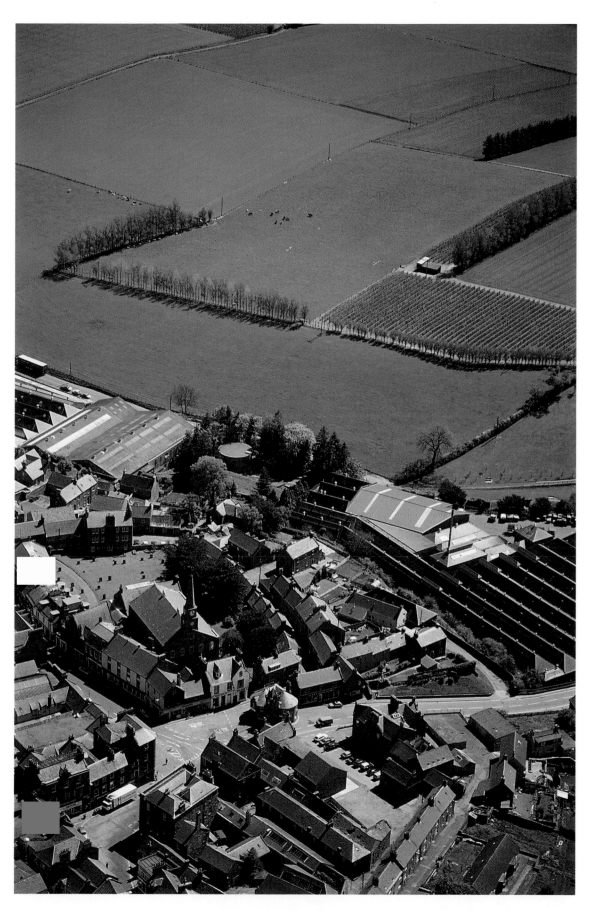

KIRRIEMUIR, ANGUS

Kirriemuir is typical of the many small towns which lie at the north-western edge of the fertile rolling landscape of Angus, next to the rising mass of the Grampian Mountains. Handloom weaving has been carried out in these towns on a cottage-industry basis for many centuries and in the late eighteenth century this flourished in Kirriemuir, which became the main centre of the craft in Angus. By the end of the eighteenth century around 3.6 million yards of cloth were being produced annually in Kirriemuir and the town had become famous throughout Britain for its good quality linen. In the nineteenth century the trade became industrialised and small centres such as Kirriemuir and Brechin could not compete with the large-scale production capacities being set up in, for example, Dundee. The growth of the town was checked, therefore, but not before it had acquired small factories of its own, as can be seen in the photograph. Factory-produced linen is still made in Kirriemuir in the present day.

Kirriemuir was the birthplace of J. M. Barrie, creator of *Peter Pan*.

BRIG O' BALGOWNIE, ABERDEEN

The origins of Aberdeen are obscure, but its prime location on the North Sea coast at the confluence of the two great rivers which flow eastwards from the Grampians – the Dee and the Don – made it inevitable that it would form the site of an important royal burgh in medieval times. It was destined also to become a diocesan centre. The religious community grew up on the Don while the burgh, whose activities were most definitely concerned with this world rather then the next, became established on the Dee. The Brig o' Balgownie crosses the Don close to the site of St Machar's Cathedral, the seat of the bishopric.

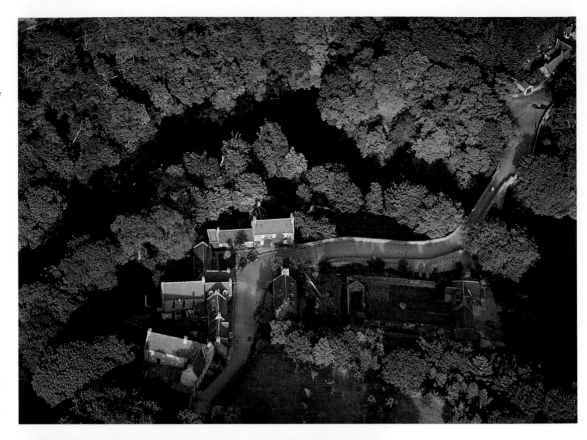

ST MACHAR'S CATHEDRAL, ABERDEEN

St Machar's was the cathedral of the Bishops of Aberdeen. The present building dates from the fifteenth century but is, in fact, only a part of the original. The church once had a Latin-cross plan with a high central tower over the crossing but this collapsed in 1688, taking with it the choir and the transepts. The towers of St Machar's, with their corbelled tops, are reminiscent of tower-house architecture and give this building a distinctive appearance. They are derived from the local vernacular tradition and such borrowings were typical of Scottish church building of the late medieval period. They produced a style of architecture found nowhere else in the world.

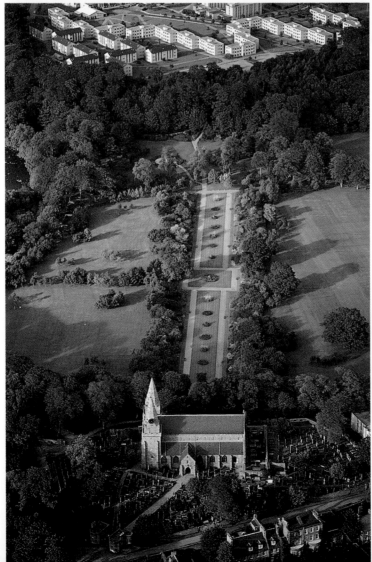

In a green howe at the hert o the
 granite toun,
Nae mair nor a sclim o steps frae
 the stane centre

from *Heart of Stone*
ALEXANDER SCOTT

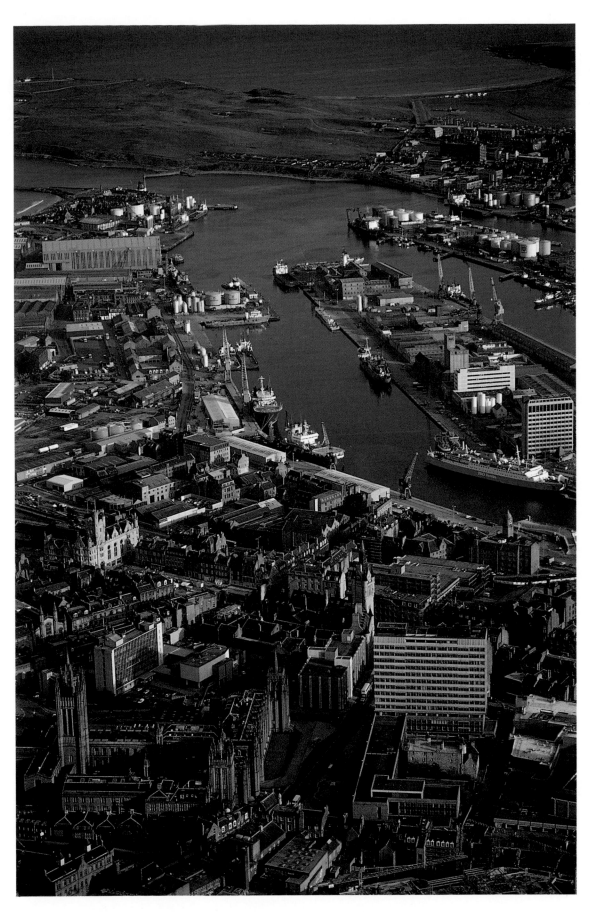

PROVOST SKENE'S HOUSE AND MARISCHAL COLLEGE, ABERDEEN

Throughout its existence Aberdeen has been a major fishing and trading port and in the late twentieth century it became the principal service base for the North Sea oil and gas industry. A consequence of these successive activities is that the town has undergone continuous rebuilding since its foundation. A fragment of medieval architecture is visible here, in the form of the sixteenth-century Provost Skene's house, which is the rubble masonry building at the bottom right of the photograph under the modern office block. Skene was Provost in 1676–83 and was a wealthy ship owner. Today his house lies in the shadow of the Modernist municipal buildings which are a monument to twentieth-century ideals not dissimilar to those of a medieval merchant. To the left of Provost Skene's House is the magnificent 'Tudor Gothic' Marischal College, part of Aberdeen University, which was completed in 1906.

The area between these buildings and the harbour's Upper Dock is filled with architecture from every century from the sixteenth to the present. In the dock itself can be seen the ferry terminal for Shetland, an island community with which Aberdeen has long had trading links.

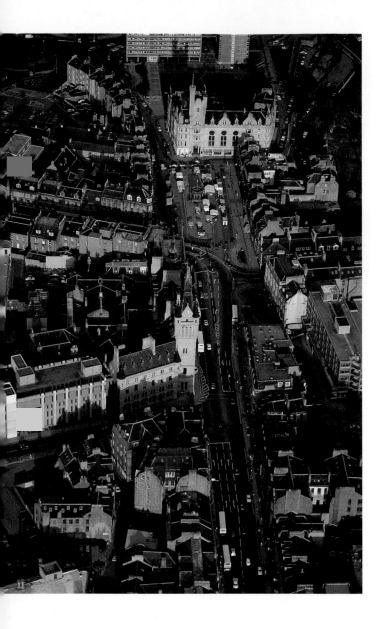

from *Heart of Stone*

But neither auld mistaks nor new mishanters
Can steerach the fine fettle o ferlie stane,
The adamant face that nocht can fyle,
Nae rain, nae reek,
Fowr-square til aa the elements, fine or foul,
She stares back straucht at the skimmeran scaud o the sun
Or bares her brou til the bite o the brashy gale,
Riven frae raw rock, and rockie-rooted,
A breem bield o steive biggins,
A hard hauld, a sterk steid
Whaur bonnie fechters bolden at ilka ferlie,
The city streets a warld o wild stramash
Frae clintie seas or bens as coorse as brine
For fowk sae fit to daur the dunt o storms
Wi faces stobbed by the stang o saut
Or callered by country winds
In a teuch town whaur even the strand maks siller,
The sweel o the same saut tide
Clanjamfries crans and kirks by thrang causeys
Whaur cushat's croudle mells wi sea-maw's skirl,
And hirplan hame half-drouned wi the weicht o herrin
The trauchled trawler waffs in her wake
A flaffer o wings—a flash o faem-white feathers—
As the sea-maw spires i the stane-gray lift
Owre sworlan swaws o the stane-gray sea
And sclents til the sea-gray toun, the hert o stane.

ALEXANDER SCOTT

mishanters, disasters *steerach*, destroy *fettle*, vigour
brashy, stormy *waffs*, flutters

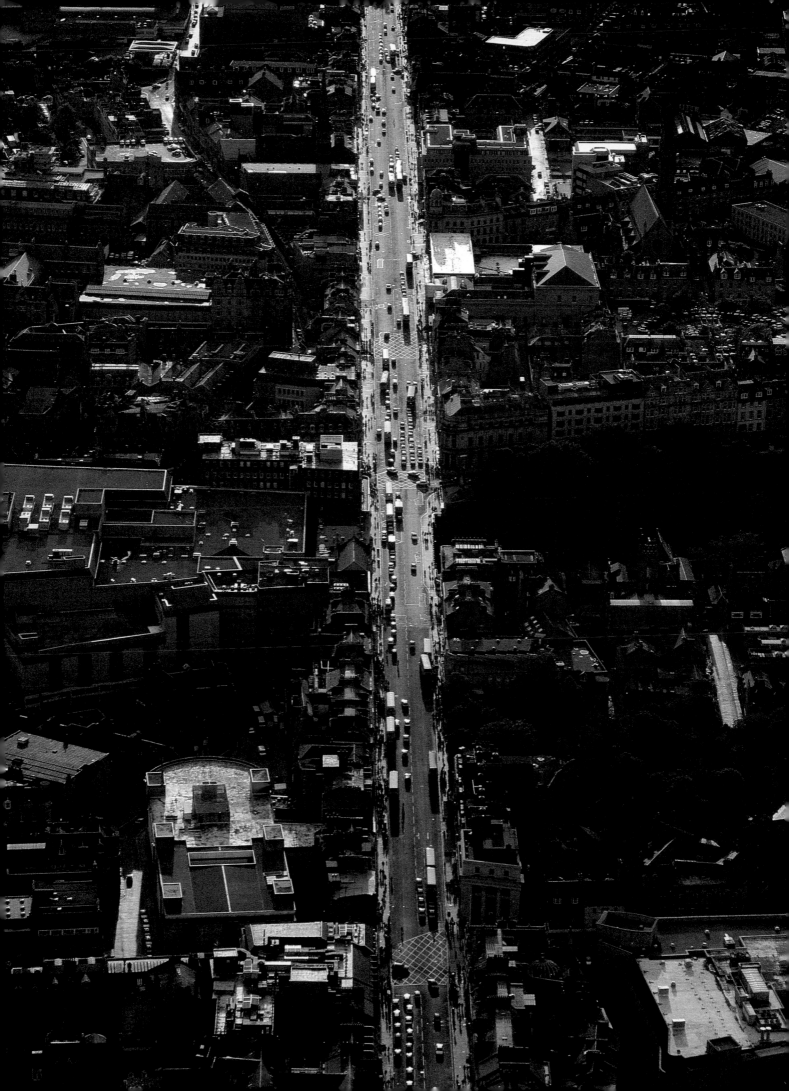

RUBISLAW QUARRY, ABERDEEN

Aberdeenshire granite is a very hard crystalline rock. It has good wearing properties and can be polished to a mirror-like surface. Hand-polishing of granite, surely a process which was invented for one of the circles of Dante's vision of Hell, was carried out in Aberdeen in the eighteenth century but the city's industry was mechanised in the nineteenth. At its height there were over ninety firms in Aberdeen connected with granite extraction and processing which together employed in total over 2,000 workers.

Rubislaw Quarry, now one of the largest artificial holes in Europe, is the most famous of Aberdeen's granite quarries. It supplied stone not only to build the Granite City itself but also to pave the streets and, in the cut and polished form, to ornament the buildings of cities throughout Europe and America. Rubislaw Quarry was opened in the early years of the nineteenth century and closed in 1971.

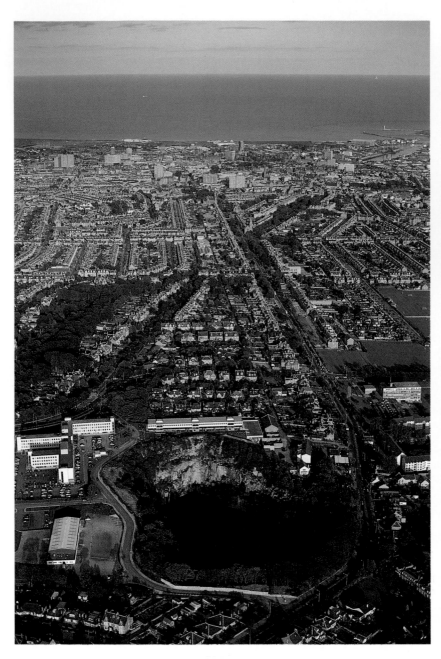

NINETEENTH-CENTURY SUBURB, ABERDEEN

It has been said that the grey granite of Aberdeenshire is fit only for banks and tombs. In the Granite City itself, however, it has been used to build extensive, well-mannered suburbs for the respectable middle-class.

Lewis Grassic Gibbon, on pondering the granite tombstones of an Aberdeen cemetery, said of its citizens: *Granite, grey granite in birth, in puberty, adolescence, grey granite encasing the bridal room, grey granite the rooms of blear-eyed old age . . . and even in death they are not divided.*

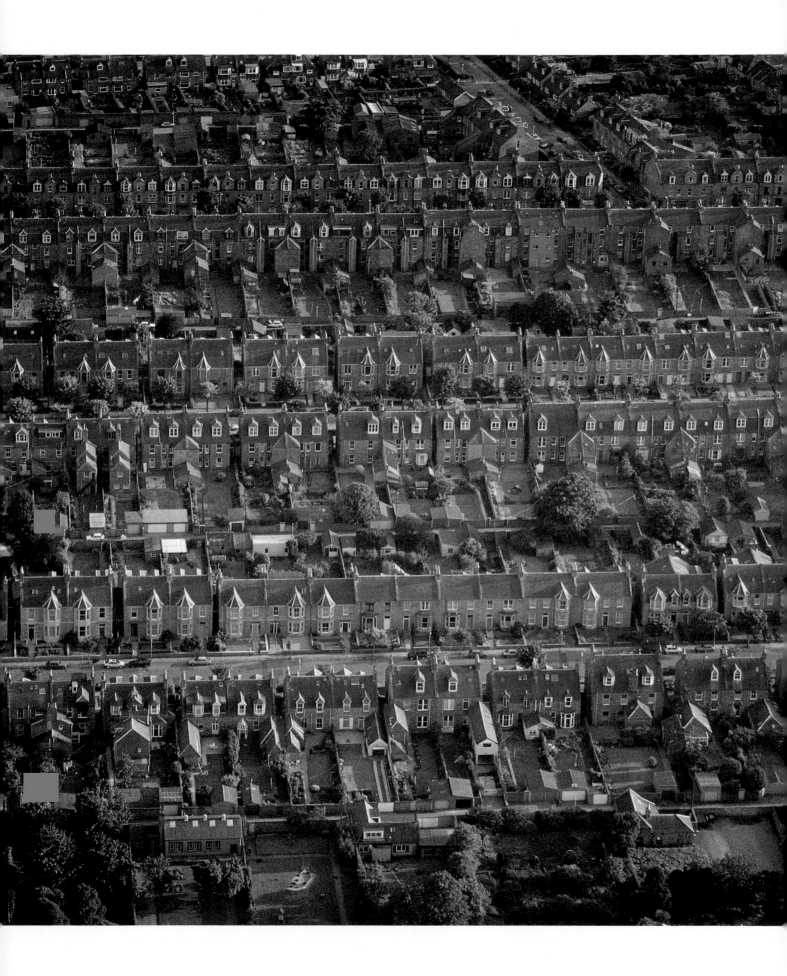

THE HARBOUR, ABERDEEN

Until the second half of the eighteenth century there were virtually no harbour works at Aberdeen. The ships which plied their trade to mainland Europe and the smaller vessels of the fishing fleet tied up to simple wharfs which had been erected on the banks of the Dee. The first major construction was begun in 1775, but the series of docks and breakwaters which constitute the harbour today were mainly built in the nineteenth century.

One of the most colourful eras in the maritime history of Aberdeen was that of the great nineteenth-century sailing clippers which voyaged to Australia and China in the tea and opium trades. The fastest of all of these magnificent vessels was the *Thermopylae*, which was Aberdeen-built and owned and which could reach Melbourne in sixty days and Foochow in ninety. It still holds the record for the greatest day's run by a sailing ship – 380 miles. Now the principal users of the harbour are the ships which service the oil platforms in the North Sea.

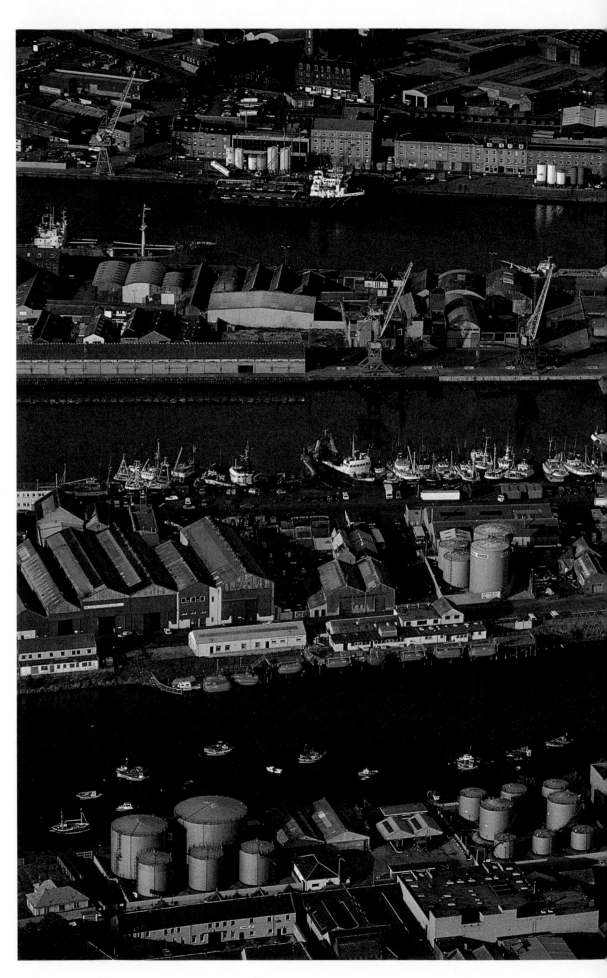

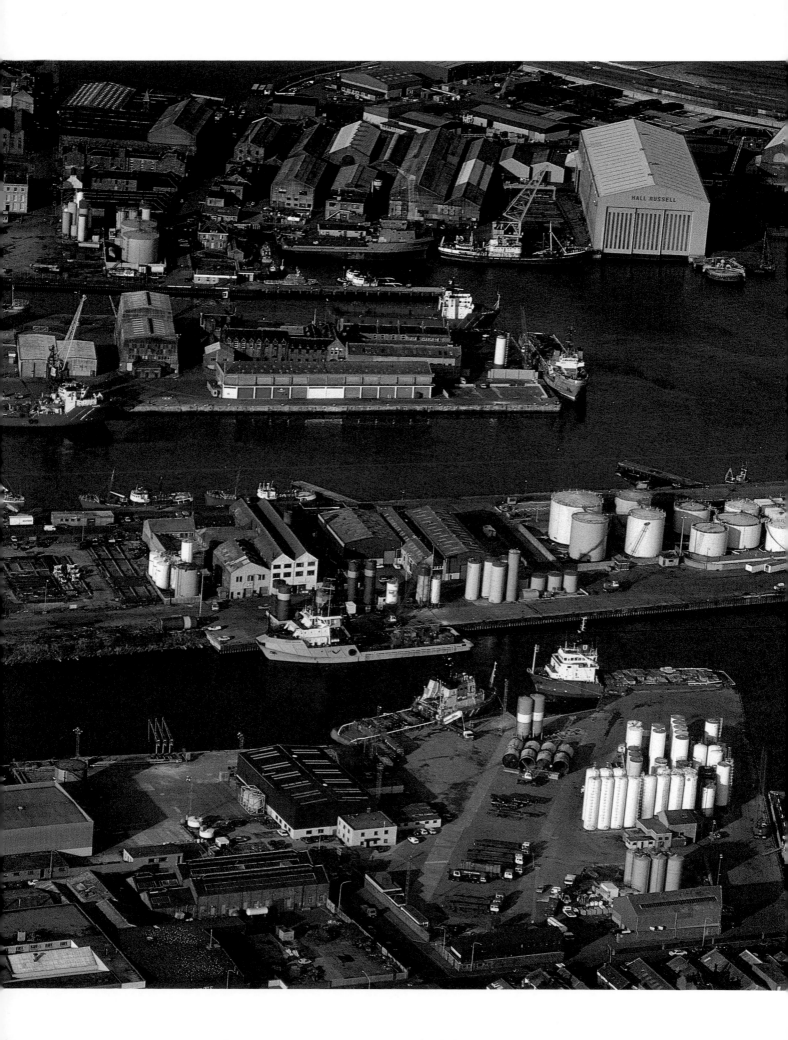

CAMPERDOWN JUTE WORKS, DUNDEE

The Camperdown Works was the largest jute works in the world and carried out every aspect of the jute-making process from the preparation of the raw fibre for spinning to the dyeing and finishing of the woven cloth. At its peak in the nineteenth century over 5,000 people were employed here in what was one of Britain's largest industrial complexes.

Cox's stack at the Camperdown Works, which is seen at the top right in this view, is one of Dundee's most distinctive landmarks. Modelled on the late medieval campaniles of northern Italy, this polychrome brick structure was constructed in 1865, when the boilerhouse complex at the works was rebuilt, and conducted into the atmosphere the smoke from the ninety tons of coal consumed daily by thirty-nine boilers.

Camperdown Works appeared in a recent television drama series as war-torn Berlin. Most of the original buildings have now been demolished and the site is being developed for alternative uses.

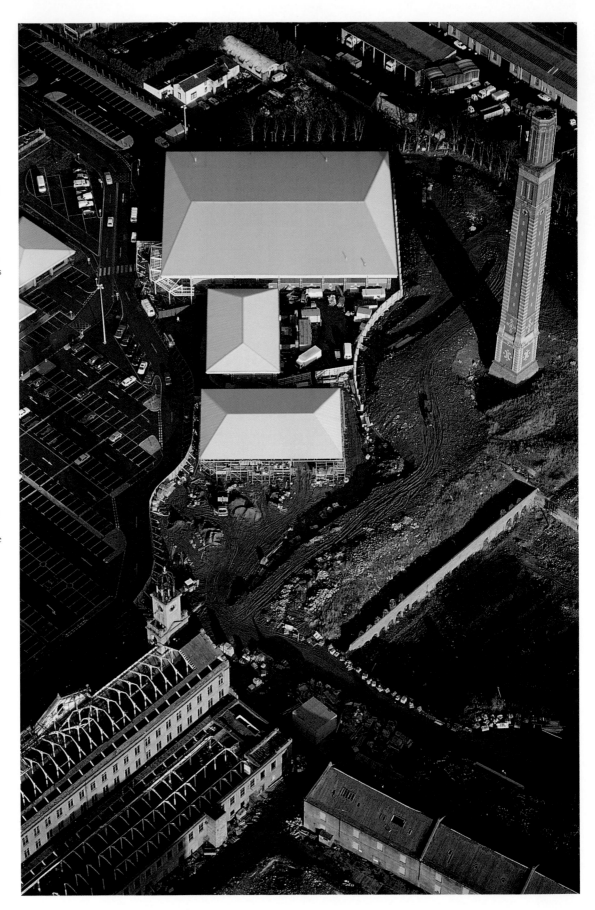

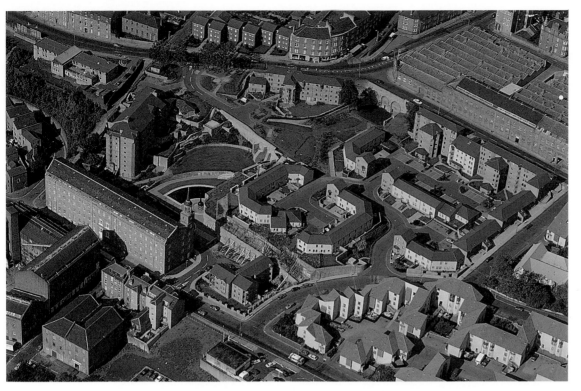

UPPER DENS MILL, DUNDEE

The tall mill building with elegant cast-iron spire at the bottom of this view is the Upper Dens Mill, a small fragment of the Dens Works of the Baxter Brothers, one of the great patrician families of the Dundee jute and flax industry. The Dens Works was a very large complex which at its peak in the 1870s employed 4500 workers. The Upper Dens Mill dates from 1833 and was the first Dundee mill to have all its structural members, including those in the roof, made of fireproof material – that is, of cast-iron or masonry. The Upper Dens Mill has been converted into houses and much additional new housing is seen here on the sites of other parts of the works. The Eagle Mill, also part of the Baxter empire, is seen at the top of the picture. Built in 1864, this was originally a foundry but was converted for jute spinning in 1930.

TAYBANK WORKS, DUNDEE

The Taybank Works, which consists of a series of buildings of nineteenth-and twentieth-century origin, all of which are now listed, was built for weaving and finishing jute. The Victorian school, church and tenements complete this historic scene. The Taybank Works is one of the few Dundee jute mills which is still in production.

COUNCIL HOUSING, ALLOTMENTS AND THE LAW, DUNDEE

The population of Dundee increased sixfold in the nineteenth century, mainly due to the immigration of workers to the expanding jute and flax industry, and, unlike their counterparts in many other growing industrial towns, the employers in Dundee made little provision to house their poorly paid workforce. However, the problem was addressed by the town council following the 1914–18 war and a programme of house-building was begun which lasted into the late 1970s. The rolling country north of the city became covered with buildings which had something of the appearance of self-contained villas but which were, in fact, blocks of flats. Some of the schemes incorporated ideas which were very advanced for the time such as district heating; they must still be considered 'advanced' in the present-day era of short-term political thinking.

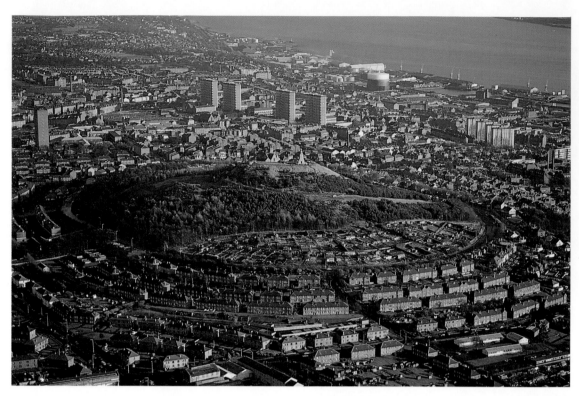

CRAIGIE HOUSING SCHEME, DUNDEE

The Craigie Housing Scheme was one of several which were planned immediately after the war of 1914–18 as the town council made a concerted effort to solve Dundee's chronic housing shortage. It was intended for artisans and was inspired by the theories of Ebenezer Howard of 'garden city' fame. The circus, the meeting point of two wide boulevards, is its focus. It is the location of the church and was initially intended to provide the sites for an institute, a school, shops, a bowling green and tennis courts. As in many similar idealistic schemes, though, financial constraints prevented the building of the full complement of amenities and the sites have been filled by housing of a later period. Electricity pylons, rather than mature trees, now grace the principal boulevard of this northern 'garden city'.

TOWER BLOCKS, DUNDEE

Connoisseurs of twentieth-century architecture and planning theory will find in Dundee examples of most forms of the products of the now discredited naïve idealism of Modernist architecture.

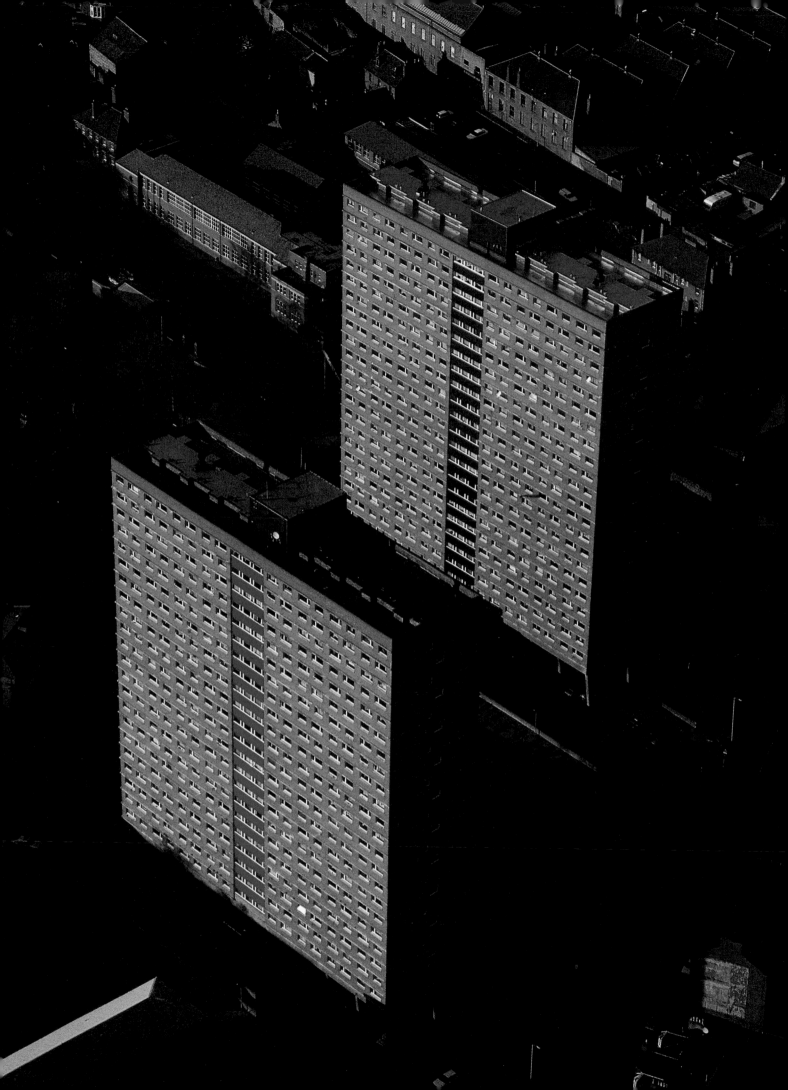

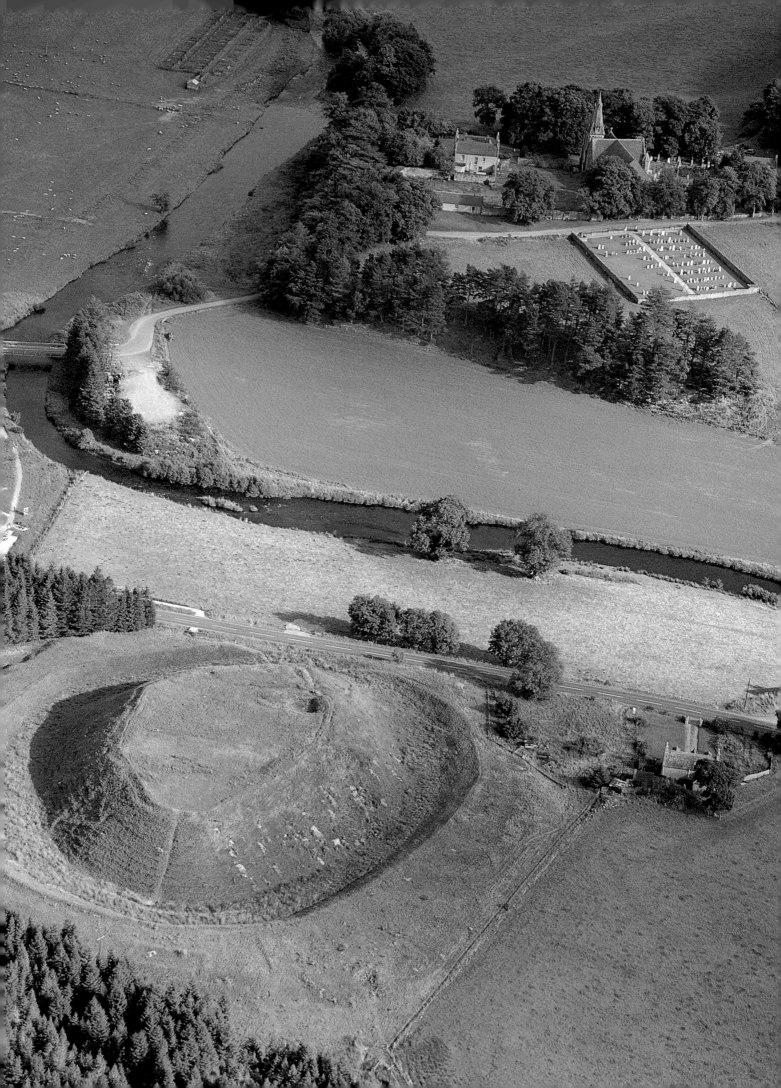

CHAPTER FOUR

CASTLE AND COUNTRY HOUSE

THE MEDIEVAL CASTLES OF NORTH-EAST SCOTLAND served many functions. At the most basic level they were simply the homes of people of wealth and influence. They were also the principal instruments of authority and, under the feudal system, were linked to areas of land, the primary source of wealth. They were the fortresses of the feudal barons, and the legal and administrative centres from which the king's dominions were governed and the king's laws enforced. They were also symbols of baronial, and ultimately of royal, authority.

Over the centuries, as the medieval world was gradually transformed into the post-renaissance and then the modern world, the castle metamorphosed into the large country house and the role of the building-type changed. It still functioned as the residence of the wealthy and the powerful, but the exercise of power became indirect and less overt, and the day-to-day administration of the legal and fiscal systems was gradually transferred to a professional class of lawyers and administrators, operating both inside and outside the public service. The land no longer remained the primary source of income. The wealth which had been extracted from it over the centuries by the landowners – the successors of the feudal barons – was gradually invested in industry and commerce elsewhere in Britain and throughout the world and the income from this wealth, rather than from the land itself, became the means of support of the large houses. The system has prolonged its existence into the present day and in the 1990s seven of the ten richest men in Scotland are members of the old landed aristocracy. The legacy of the feudal system, which elevated selected individuals into positions of power, concentrated into their hands the wealth which the land generated and the authority to administer it, and also allowed them to pass it on to their descendants, is very much part of modern Scotland. Hence, the study of the large houses of the Scottish landscape is also the study of the development of power and class.

The origins of the country house as a building owned by a local magnate and drawing revenue from surrounding lands dates in North-east Scotland from the imposition of feudalism in the late medieval period. The forerunners of country houses were the castles which the feudal lords were obliged to erect on the lands granted to them by the king. Feudalism was imposed on Scotland in the twelfth century by a monarchy which had close connections with Norman England and the earliest feudal strongholds were based on the Norman motte-and-bailey arrangement. These castles, which were constructed in earth and timber, consisted of a tower built on an artificial earthen mound (the 'motte') with an attached enclosure (the 'bailey') in which were placed

DOUNE OF INVERNOCHTY, GORDON

The Doune of Invernochty dates from the late twelfth century and is an example of a motte castle, which consisted of an artificial mound of earth and gravel on which was erected a timber palisade enclosing a range of timber buildings.

101

ancillary buildings such as kitchens, storerooms and stables. The bailey would normally be defended by a ditch and would be topped by a palisade.

The remains of several hundred motte-and-bailey castles survive in Scotland and their distribution indicates the extent to which feudalism penetrated into this northern land. Most are found in the rich lowlands of the Forth-Clyde valley but many were built on the coastal fringes of the North-east. Perhaps the most archetypal arrangement is seen at Duffus Castle, although this building is unusual because its superstructure is built in stone. The Doune of Invernochty, a variation on the motte-and-bailey theme, is also included here. This is a ring-motte castle consisting simply of a raised earthen platform defended by a ditch and rampart and providing a defensible enclosure for a group of buildings.

As the feudal system became established in Scotland and the power and wealth of its barons developed, castles came to be built in stone. The motte was abandoned since it would not support the weight of a stone structure, and new castles were built which relied on the impregnability of massive stone towers and walls for security. Stone tower-keeps, the epitome of the Norman castle, were never constructed in Scotland, however, and the stone castle-building tradition developed out of the shell-keep under the influence of European ideas on military architecture, thought to have been introduced by returning Crusaders. These are known as curtain-wall castles and their arrangement was similar to that of the motte-and-bailey type. They consisted of a massive 'donjon' (a tower containing the lord's hall and living accommodation) with an attached curtain wall forming an enclosure within which were situated ancillary buildings. Additional defensive towers were frequently placed at strategic points on the curtain wall such as at the gateway or the corners. In the earliest examples the donjon was placed opposite the gateway and was the last refuge of the defenders. Later, however, the gatehouse grew in size and ultimately had the functions of the donjon incorporated into it. Kildrummy Castle, illustrated here, is transitional; the lord's hall and chapel are placed to the rear of the courtyard enclosed by the curtain wall, but the gatehouse is massive. Establishments such as Kildrummy were very costly to build, and were maintained by only the wealthiest feudal barons, of which there were relatively few in Scotland. Lesser magnates built themselves fortified houses of a much smaller scale, known as hall houses, of which Rait Castle is a good example.

Nevertheless, the impoverishment of Scotland in the fourteenth century caused by the wars of independence against England, together with changing economic and social conditions, led to a discontinuation of the curtain-wall castle. The fashion for building tower houses began and the single massive tower would now become the most popular form of castle. This building-type was used throughout Europe but took on a unique character in Scotland, where in the course of the 400 years from around 1300 it was developed from a simple functional military structure into a distinctive architectural style.

The earliest tower houses, of which Drum Castle illustrated here is

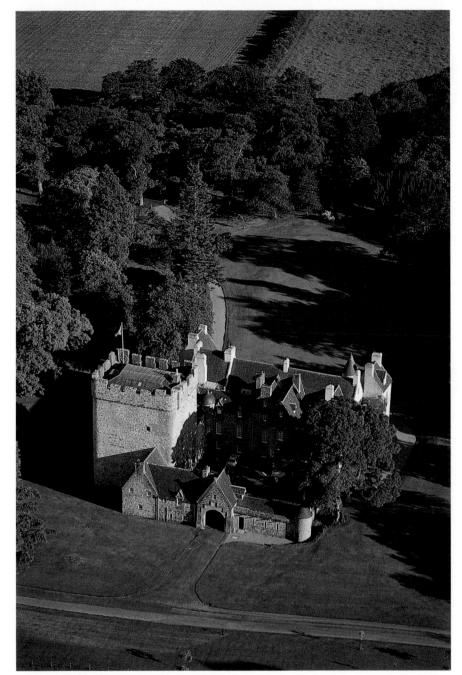

DRUM CASTLE, KINCARDINE AND DEESIDE

Drum Castle is one of the finest examples of an early tower house. Dating from the thirteenth century the original tower can be seen here dominating the group of buildings which includes a seventeenth-century palace wing fronted by a barmkin (a defensible cobbled courtyard) and gateway added in the nineteenth century.

The starkness of the original tower is obvious. It consists of a single rectangle in plan, with sheer walls pierced by small windows and topped by a machicolated and battlemented wallwalk. The original entrance was at first-floor level and was made accessible by a timber forestair which could be quickly dismantled in the event of trouble. The defensive strategy was passive and relied on the impenetrability of the walls, which are twelve feet thick at their base, active defence being confined to throwing missiles from the wallwalk.

typical, consisted of a series of vaulted rooms placed one on top of another on a rectangular plan. Frequently these spaces were subdivided horizontally by timber floors, and the uppermost vault was capped with stone flags to form a pitched roof. The walls were of immense thickness to support the vaults within and were pierced with very small windows, producing a building of forbidding appearance. Active defensive measures were confined to the wallhead where a parapet was provided from which stones or other missiles could be dropped on to any would-be attackers. Indeed, the tower house was particularly well adapted to the needs of the Scottish laird. It was secure, economical and could be

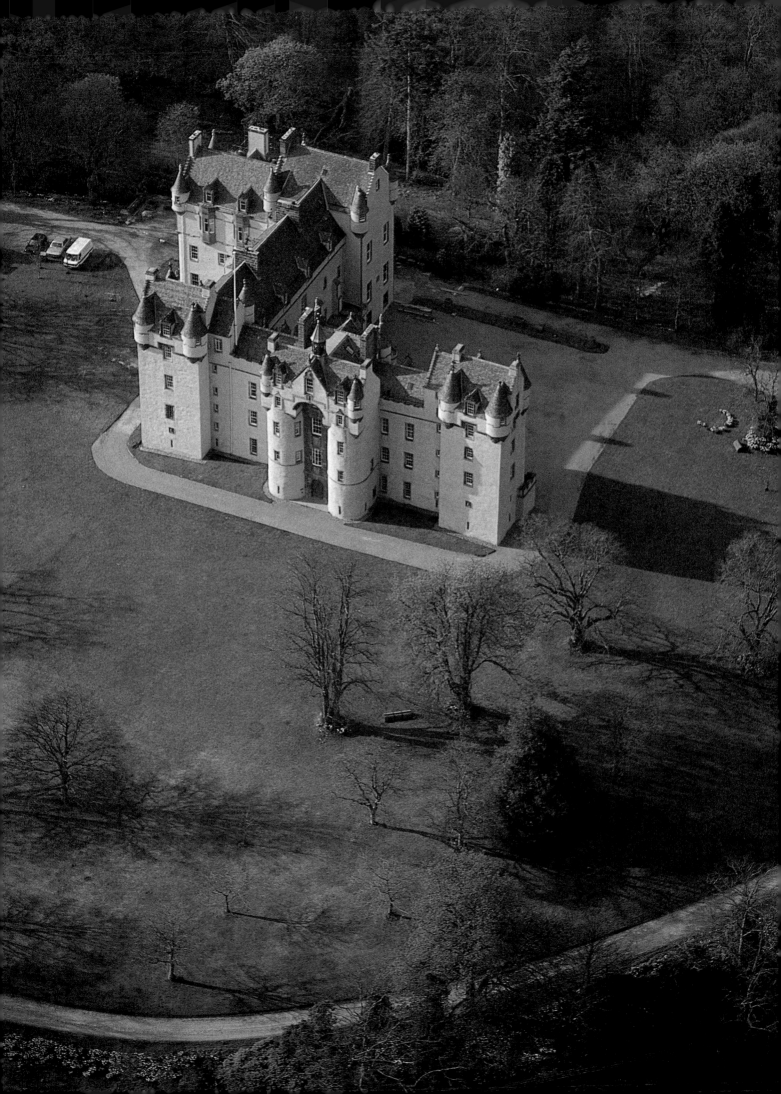

constructed almost entirely from local materials. The accommodation of the feudal establishment was organised vertically with storage vaults and kitchen on the ground floor, the laird's hall on the first and the laird's solar and other bedrooms on the upper levels, and it provided a reasonable degree of domestic comfort.

The tower house was to remain the most popular form of country house in Scotland for as long as a secure residence was considered necessary, although it was to undergo considerable development over the four centuries in which it remained in vogue. Most of the improvements to the basic form were connected to the standard of accommodation which was provided. Different planforms evolved, such as the L- and the Z-plan, and a further development was the placing of small rooms within the thickness of the walls, especially in the upper parts of the building where ancillary accommodation was provided. Access to these was often by wheel (spiral) stairs, also located within the wall-thickness and in many cases both the smaller rooms and the stairs were corbelled slightly beyond the perimeter walls. The tower house was developing to produce a tall building with plain lower walls which became more complex towards the top, where corbelled bulges would appear, topped with conical roofs. The roofscape was frequently very complex, with 'crow-stepped' gables and short stretches of straight ridge alternating with conical turrets and tall chimney stacks. By the beginning of the seventeenth century this vocabulary had developed into an architectural style and features originated for functional reasons were manipulated and juxtaposed for aesthetic effect. Its final flowering produced buildings such as Craigievar, Crathes and Fyvie which, though secure residences, had a minimal military function and were simply the houses of wealthy country magnates.

In parallel with the tower house, the hall house also evolved in the fifteenth and sixteenth centuries. In this less fortress-like but nonetheless fairly secure building-type the accommodation was spread horizontally and, as the wealth of the nation increased, became ever more palatial in character. This led to the appearance of the 'apartment', which was a suite of rooms for the occupancy of an important individual. The rooms were hierarchically organised and usually consisted of, in order of decreasing size, a hall, an outer (great) chamber and an inner chamber, sometimes with a very small room, called a 'cabinet', leading off. Such arrangements might be thought of as belonging to a royal palace but, in fact, several houses in the North-east were built or extended in this way, including Balvenie and Huntly Castles.

From the late sixteenth century, the need for a Scottish laird to live in a fortress had diminished. The idea of the castle as a stronghold had in any case been rendered obsolete by the invention of artillery and houses of a much more open aspect were being constructed. Old forms were adhered to, however, and Innes House in Moray is an example of the type of building which resulted. This replicated the traditional L-planform of the tower house but in practically every other respect it is a different type of building belonging to a post-medieval age. The ensemble is altogether more refined than the buildings of the previous

FYVIE CASTLE, BANFF AND BUCHAN

Fyvie Castle is an interesting example of French influence on the Scottish vernacular tradition. The vocabulary here is Scottish but the syntax is French. The history of the building is complex. It began life traditionally enough, in the thirteenth century, as a castle of enclosure. Fragments of the original curtain wall are contained in the two ranges of the present building and this explains the plan of the show-front: the projecting end towers and central gateway are founded on the original medieval walls. The upper levels, however, which were added in the seventeenth century, employ traditional tower-house motifs reshuffled in an imaginative fashion for purely visual reasons. The resulting arrangement resembles that of a French château.

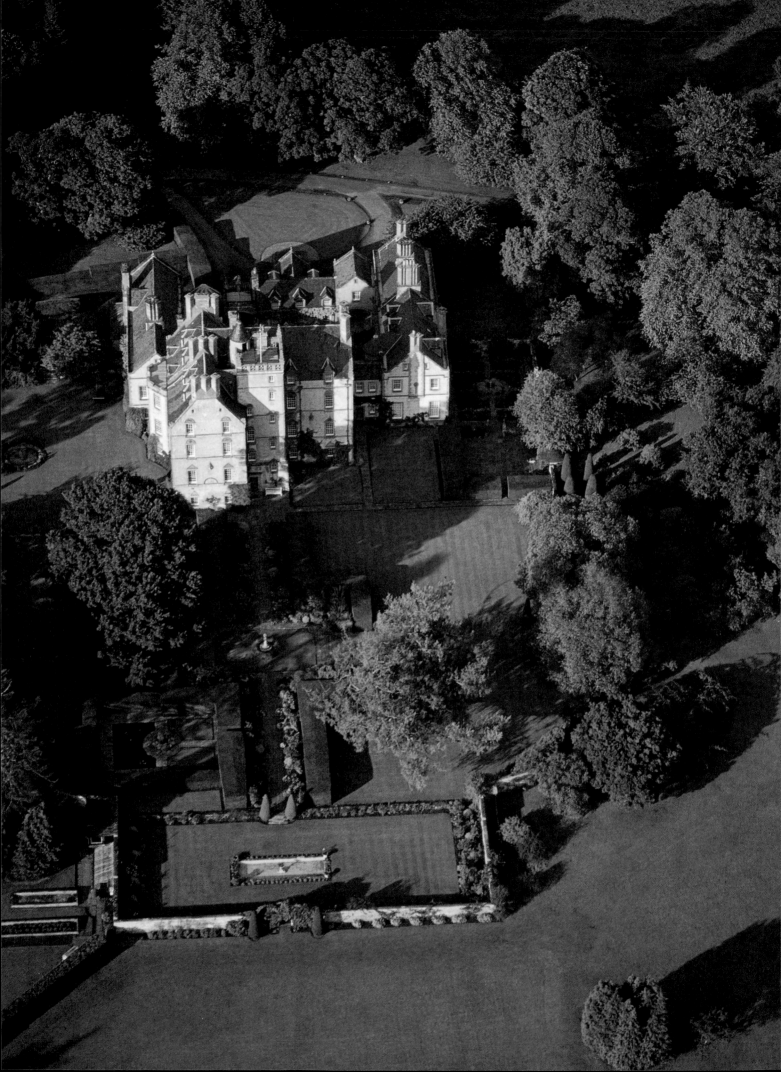

centuries and the composition much simpler than that of the later tower houses such as Craigievar.

Buildings like Craigievar, Huntly and Innes House may be regarded as examples of three separate types of development which were occurring in the building of large houses in North-east Scotland in the sixteenth and seventeenth centuries. This period is known as the Scottish Renaissance and is characterised by an absorption into the indigenous architecture of ideas which were spreading northwards from mainland Europe. A version of classicism unique to Scotland was slowly emerging, but its development was to be cut short by the cataclysmic events of the English Civil War of the 1640s, the Revolution Settlement of 1688 and by the union of the Scottish and English parliaments in 1707, which led to a tendency for the rich and the powerful in Scotland, who were the clients for large houses, to look to England for an architectural lead. This brought about the abandonment of the robust indigenous architecture in favour of the somewhat vapid neo-Palladianism which dominated English architecture in the first half of the eighteenth century.

It was in the North-east that the first country house, as opposed to castle, was actually built in Scotland. This was Panmure House in Angus which was begun in 1666; it was unfortunately demolished in 1955. The building had a classical plan, which may have been based on a design by the Italian architect Serlio. The architect William Bruce is said to have been involved in its design. It was to be in the Lowlands, however – where the land was rich enough to provide the wealth, either from fertile soil or from deep coal measures, with which to pay for large country houses – that most of the important classical country houses in Scotland were built. The tradition of small country house building, which had begun with the tower houses, nevertheless continued in the North-east and in the seventeenth and eighteenth centuries a large number of these were constructed. Amongst the earliest were Gallery House in Angus, which was completed in 1680 to a design by the Edinburgh master mason Thomas Wilkie, and Brechin Castle, by Alexander Edward.

The romanticism of the nineteenth century, with its preoccupation with the picturesque, the melodramatic and the mysterious, coupled with the introduction into British architecture of the notion of 'national styles', brought with it a revival of interest in Scotland in the indigenous architectural vocabulary. Many of the houses which were constructed or enlarged in this period, such as Blair Castle, took on some version of the Scots Baronial appearance, seen at its most successful in the hands of the architect David Bryce. This style was based on the motifs and devices of the tower house and thus did the wheel of fashion come full circle.

INNES HOUSE, MORAY

The original part of Innes House is the L-plan block seen in the foreground here, with a square stair tower in the re-entrant angle. This was built in 1640–53 to the design of the Edinburgh master mason William Aytoun. The building is an interesting mixture of tradition and innovation. The general arrangement and the layout of the accommodation are those of the traditional tower house, but aspects of the method of construction and of the architectural treatment are new. The building has timber floors rather than vaults, which has allowed the use of thin walls with large, regular window openings. This feature, together with the use of segmental and triangular window pediments, delicate string courses, and the absence of corbelling, is a significant departure from the traditional tower-house format. It is significant that William Aytoun worked on Heriot's Hospital in Edinburgh, which is the first building in Scotland to have a truly classical plan. Innes House cannot be considered a classical building, but it does represent a break with tradition as opposed to an extension of a tradition such as is seen at Fyvie, Craigievar and Glamis.

DUFFUS CASTLE, MORAY

As the feudal system gained ground in Scotland and the barons became richer, they required more imposing buildings, with better domestic arrangements than could be built of timber. This brought about a change to stone as the principal building material and with it the abandonment of the motte-and-bailey arrangement because the earthen motte could not support the weight of a stone keep. Duffus may be regarded as a transitional castle, being of the motte-and-bailey type, but built in stone. It is also a perfect demonstration of the reason why a change of format was required: major subsidence may be seen to have occurred here and one of the corners of the keep to have slid almost to the bottom of the mound.

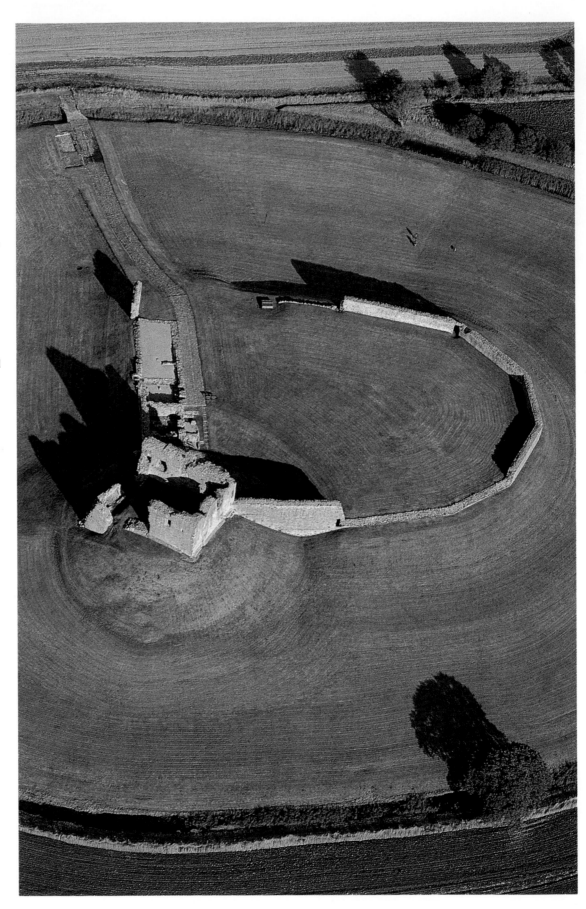

KILDRUMMY CASTLE, GORDON

Kildrummy Castle is situated on the direct route across the north-east corner of the Grampian Mountains between the fertile lands of Strathdon and those of the Moray coast. It played an important role in the feudalisation of North-east Scotland because, although the coastal areas were easily dominated by the new feudal masters, the Highlands, with their strong Celtic traditions and their long, steep-sided glens, were a different matter. Kildrummy, on the edge of the Highland zone, was therefore in a vital strategic location; successive kings of Scotland saw to it that a fortress was maintained here under the control of a reliable member of the baronage.

The building dates from the late thirteenth century and is an example of a curtain-wall castle consisting of an enclosure which is strongly fortified by towers at its corners and at the entrance. The principal buildings are placed at the rear and, unlike at Duffus, all of this massive structure is built directly upon firm substrata. The arrangement is typical of the second phase of feudal castle building.

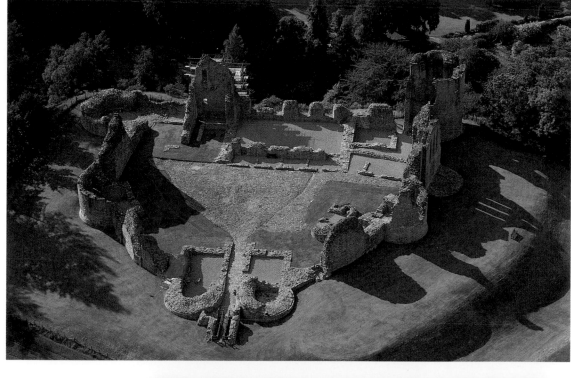

RAIT CASTLE, NAIRN

Rait Castle, near Nairn, is an example of a hall house, which is a defensible baronial residence of modest size. It is a two-storey structure which had a timber floor and a pitched roof. All the timber has disappeared but, with the exception of a breach in the end wall, the masonry has survived more-or-less intact. The interior of the building consisted of a single large medieval hall with a dais at the 'high' end and with a private room off, in the circular-plan tower. The single entrance was at first-floor level at the 'low' end of the hall, and the undercroft, for storage, was accessible from this by an internal stair. The fragment of masonry seen projecting from the side wall is the remains of a latrine tower.

Rait is a small building compared to a grand baronial residence such as Kildrummy but it was nevertheless the seat of a family which was close to the centre of power. In the early fourteenth century Sir Andrew de Rait was employed on the important task of surveying the royal lands of Scotland.

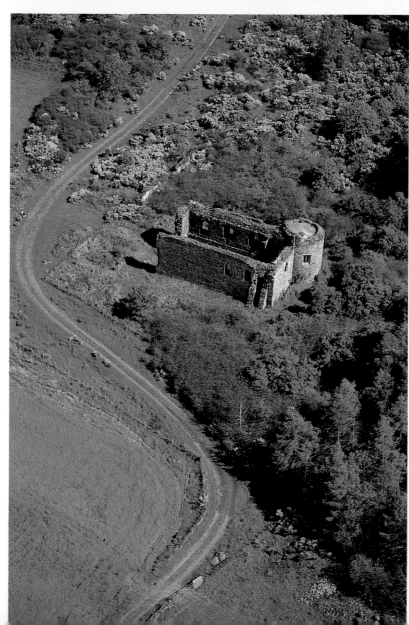

HALLFOREST CASTLE, GORDON

Like Drum Castle, Hallforest is a prime example of the highly utilitarian structures from which the later Scottish tower houses developed. The building consists of two barrel-vaulted cells, each subdivided by a timber floor, placed one above the other. This gave four spaces in all which served, in vertical order, as storage cellar, kitchen, hall and solar. The building is therefore virtually nothing more than a hall house set on end. A fifth room, probably the laird's bedroom, was placed under the roof and completed the principal accommodation. The walls were very thick, to absorb the thrust from the vaults, and fenestration was kept to a minimum. The tower was constructed from unshapen field-clearance boulders.

Hallforest, which dates from the late thirteenth century, is one of the earliest tower houses in Scotland and one of the most basic. It makes an interesting comparison with later derivatives such as Craigievar.

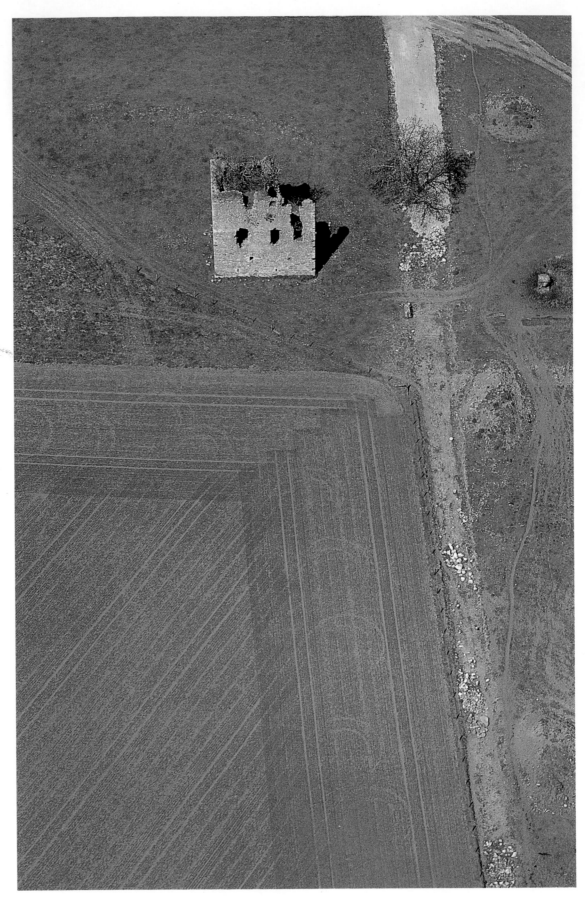

HARTHILL CASTLE AND BENNACHIE, GORDON

The hill of Bennachie overlooks the site of the Battle of Harlaw, the famous conflict in 1411 between the Highland army of Donald of the Isles and that of the lowlanders wishing to defend the burgh of Aberdeen. Several versions of this event, none of them factually accurate except in their emphasis on the scale of the slaughter on both sides, exist in ballad form.

Harthill Castle, seen in the foreground, is a simple structure rising to four storeys plus a garret and dates from the early seventeenth century. It is typical of the many tower houses which were being built in the North-east by minor lairds at this relatively late date.

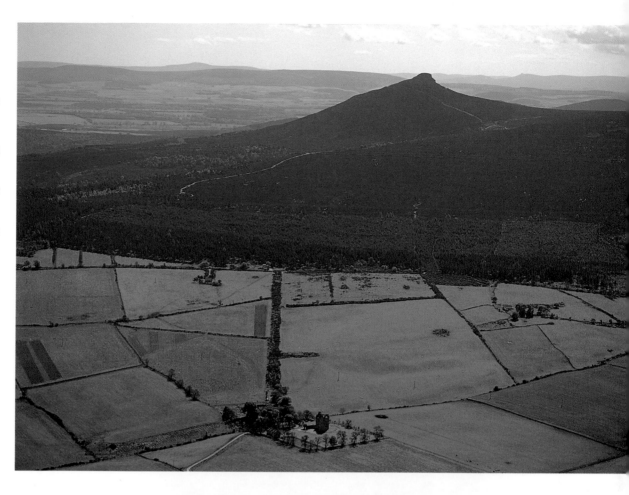

SPYNIE PALACE, MORAY

The tower at Spynie is surely one of the most gaunt and forbidding of all tower houses. It is the climax of the group of buildings which served as the palace of the Bishops of Moray, whose ecclesiastical seat was at Elgin Cathedral two miles to the south. It rises through six storeys and provides generous and luxurious accommodation within its large, rectangular planform.

The last Roman Catholic Bishop of Moray, Patrick Hepburn of the notorious Bothwell family, was sufficiently astute to realise, in the years before 1560, that the Reformation was inevitable, and so appropriated for himself the lands of Elgin Cathedral. When the Reformation finally occurred, he and his family were able to live on in this magnificent palace while the cathedral itself, deprived of its income, began slowly to decay.

The Palace of Spynie did become the residence of a bishop again, this time of the Protestant Episcopal Church, following the Restoration of the Monarchy in 1660. It was, however, to be a short-lived affair. The last bishop died in the palace in 1686, just two years before the 'Glorious Revolution', after which the building was allowed to decay.

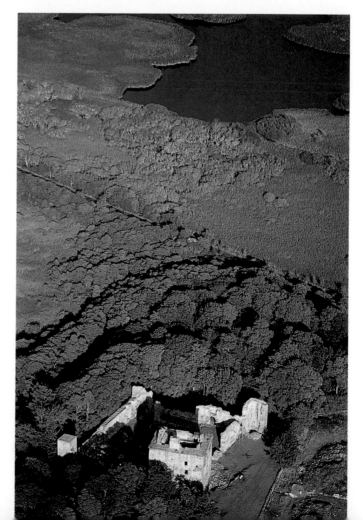

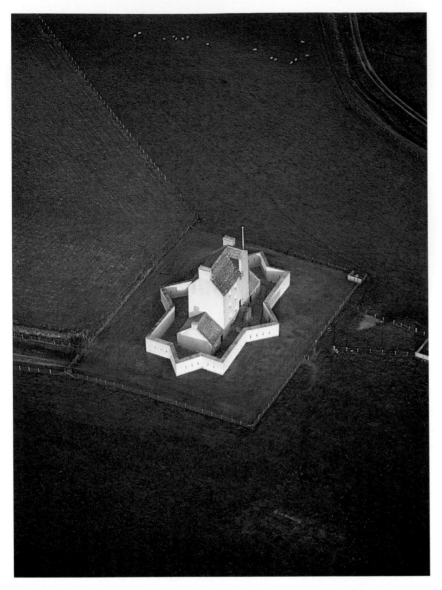

Burning of Auchindoun

'Turn, Willie Macintosh,
 Turn, I bid you;
Gin ye burn Auchindoun
 Huntly will head you.'

'Head me or hang me,
 That canna fley me;
I'll burn Auchindoun
 Ere the life lea' me.'

Coming down Deeside
 In a clear morning,
Auchindoun was in flame
 Ere the cock crawing.

But coming o'er Cairn Croom
 And looking down, man,
I saw Willie Macintosh
 Burn Auchindoun, man.

'Bonny Willie Macintosh,
 Whare left ye your men?'
'I left them in the Stapler,
 But they'll never come hame.'

'Bonny Willie Macintosh,
 Whare now is your men?'
'I left them in the Stapler,
 Sleeping in their sheen.'

head, behead *fley*, frighten
Stapler, hill in the Cabrach district
sheen, shoes

CORGARFF CASTLE,
GORDON

Corgarff Castle lies at the head of Strathdon in a position of strategic importance and has had an eventful history. In its earlier years, in the sixteenth century, it featured in the squabbles of the local lairds, in particular between the Gordon and Forbes families who were on either side of the Catholic-Protestant divide following the Reformation. The most infamous episode was the murder of twenty-seven people, including the laird's wife and members of her family, when the castle was burned in 1571 by Gordon raiders from Auchindoun Castle. This was commemorated in the famous ballad *Edom o' Gordon*.

The castle was occupied by Montrose in 1645 and also featured in the Jacobite wars of 1715 and 1745. It was commandeered by the Hanoverian government in 1746 in connection with the operation to suppress the Jacobites, and it was during this period that the star-shaped outer defensive works were added. It housed a garrison until 1831, involved with the control of the smuggling of whisky in the Highlands, after which it has remained virtually unaltered. It is, therefore, a rare example of a sixteenth-century tower house whose military function was prolonged into the nineteenth century.

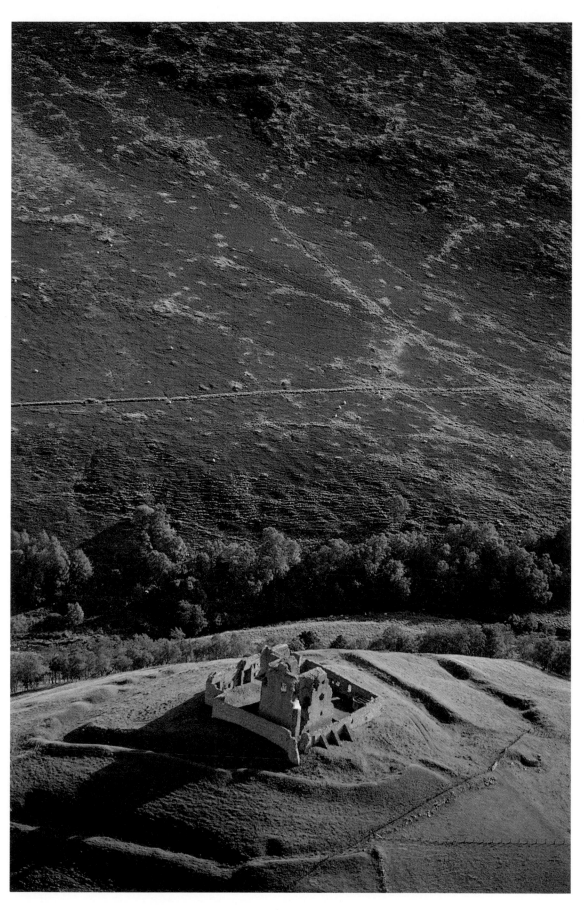

AUCHINDOUN CASTLE, MORAY

Auchindoun Castle, near Dufftown, was the stronghold of Adam Gordon, the infamous Edom o' Gordon, already mentioned in connection with Corgarff Castle. Although now ruined, it is, nevertheless, an impressive example of an L-plan tower house surrounded by a defensive barmkin. The remains are of some architectural interest because the hall vaulting is ornamented with Gothic ribbing which rises from fluted pilasters, a form of embellishment which is rare in tower houses.

Adam Gordon was the brother of the Earl of Huntly and therefore aligned with the Catholic Mary, Queen of Scots. Her opposer and successor, the Regent Earl of Moray, encouraged the Forbes family of Corgarff to suppress Gordon's activities, and this led to the burning of Corgarff in 1571. Auchindoun itself was burnt out in 1592, in the same conflict, to revenge the murder of another Earl of Moray, known as the 'Bonnie Earl', by the Marquis of Huntly. These events are commemorated in two other famous Scottish ballads, *The Burning of Auchindoun* and *The Bonnie Earl o' Moray*.

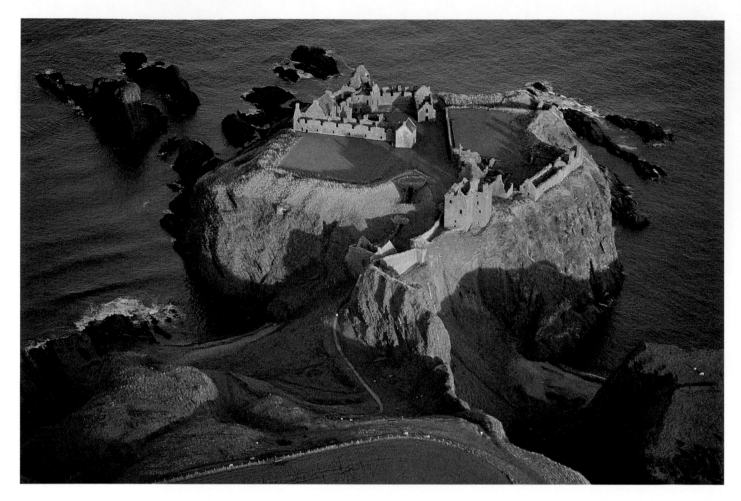

DUNOTTAR CASTLE, KINCARDINE AND DEESIDE

Dunottar is one of the most dramatically-sited of the Scottish feudal castles and was formerly the stronghold of the 'Great Marischal', one of the offices of state created under feudalism. The earliest building is the L-plan tower in the foreground here which contains two halls, a lower 'common hall' and an upper 'earl's hall'. The range of buildings in the background was added in the sixteenth and seventeenth centuries and constitutes a large courtyard house or 'palace' the plan of which was unusual at the time in Scotland. The building has featured in most of the armed conflicts which have occurred from the wars of independence to those of the Jacobites. Its occupants aligned themselves with the Stewart cause and the building was destroyed following the 1715 Jacobite rising.

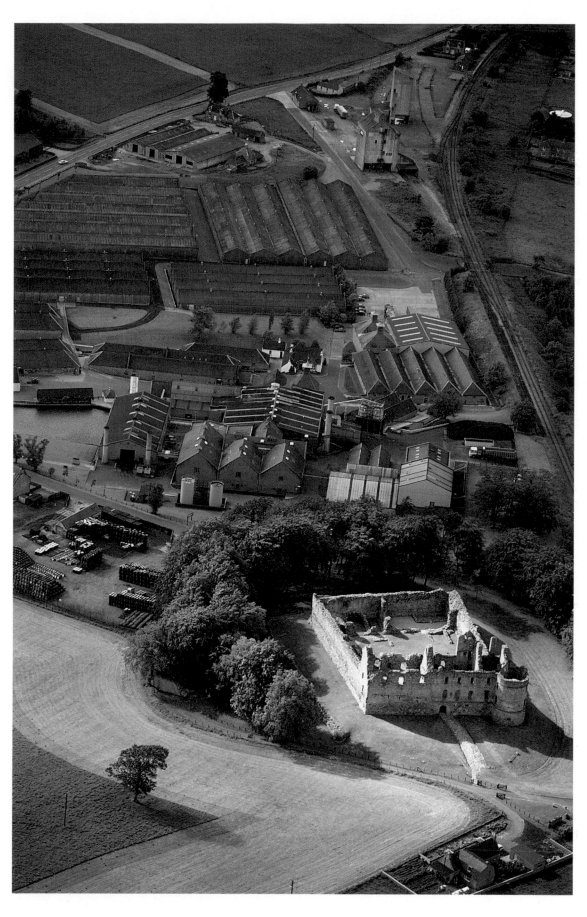

BALVENIE CASTLE, MORAY

Balvenie Castle, near Dufftown, was an important stronghold from the earliest days of feudalism. It was originally a rectangular-plan castle of enclosure, much of which remains in the outer walls of the existing building. The accommodation was subsequently extended to include the hall and chamber block, now much ruined, which is seen here against the furthest wall. Additional building took place in the mid-sixteenth century when the range nearest to the camera was added. This is based on a 'palatial' plan with apartments on the first and second floors, each with hall, outer chamber and inner chamber on a single level. These convenient, horizontal layouts provided sequences of rooms which were equivalent to those arranged vertically in tower houses and indicate the existence of a parallel tradition of castle building, which was enjoyed by those who had a taste for comfortable living and the means to indulge it.

The buildings in the background of this photograph are those of the Glenfiddich Distillery.

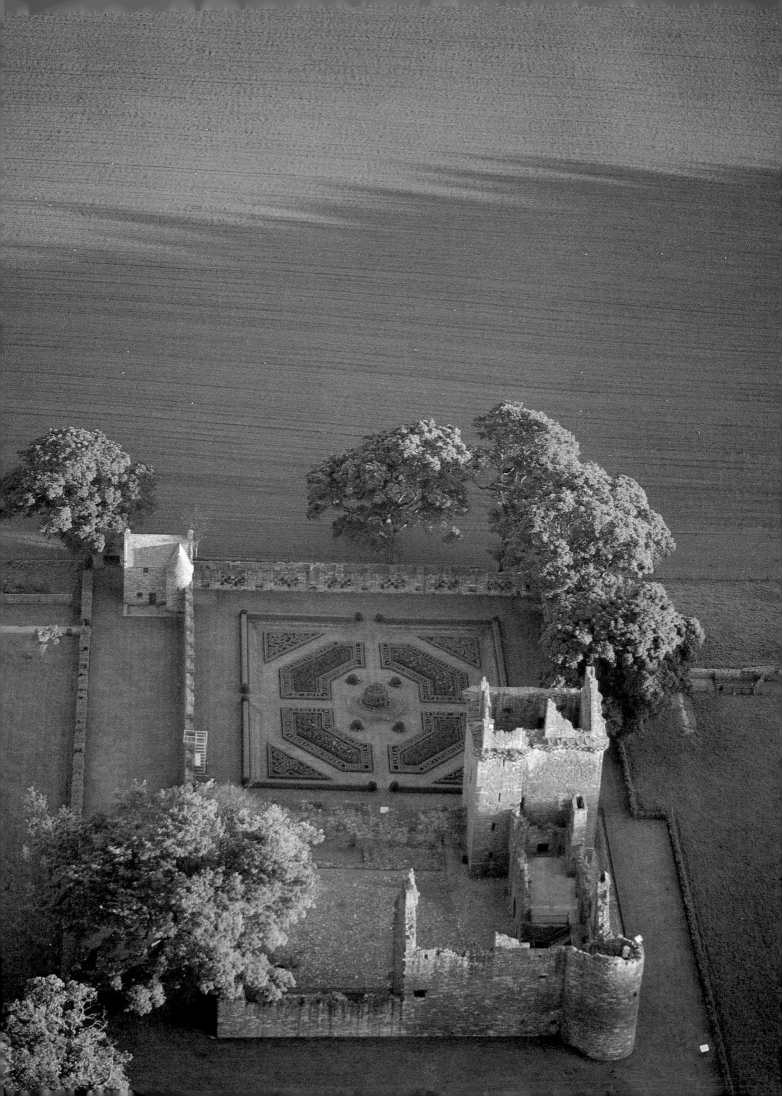

EDZELL CASTLE, ANGUS *(left)*

Edzell Castle dates from the late fifteenth century when an L-plan tower, which is the most prominent building in the complex, was constructed with an attached barmkin. The house was extended around the courtyard in the sixteenth century and finally, in the early seventeenth century, a pleasance with parterre, summerhouse and bath-house was added. No further building was carried out before the house was abandoned in 1764.

Edzell Castle is of significance as an example of the residence of a cultivated member of the Scottish aristocracy during the period following the Reformation and the Union of the Crowns. Of particular interest is the garden, which was built in 1604 for Sir David Lindsay, a well-educated individual of taste and scholarship who had travelled widely in Europe. The walls of this incorporate, within a classical framework, symbolic sculptured panels depicting the planetary deities, the liberal arts and the cardinal virtues, and give the castle a place in the history of European Renaissance art and architecture.

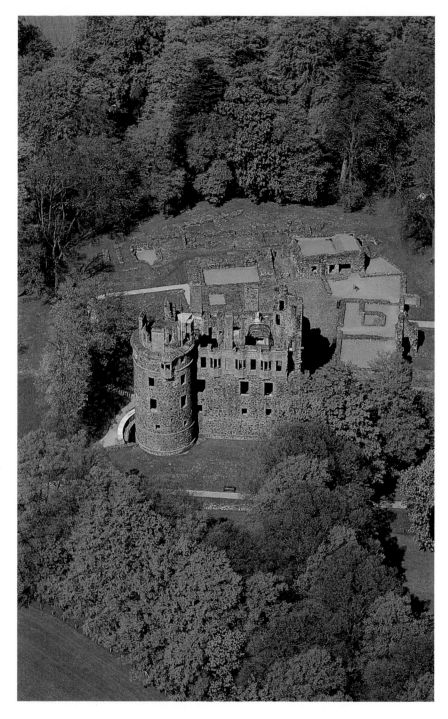

HUNTLY CASTLE, GORDON *(right)*

Huntly Castle is medieval in origin and underwent a series of metamorphoses from motte-and-bailey to tower house to 'palace' as the fashion in castle building changed. The most interesting part is the palace block, seen in the foreground here, which was begun in the sixteenth century. It is an example of horizontal planning in which apartments were provided on the two principal floors. Each chamber in the sequence would have been used as a reception room, graded according to the rank of those being received in relation to the occupant of the whole apartment.

The palace block was embellished in the early seventeenth century when the magnificent series of oriel windows was added to the upper apartment. The influence of foreign ideas, principally from France, is evident here. The occupation of the castle was brought to an end during the civil wars of the mid-seventeenth century in which the family sided with the royalist cause, after which the building fell into a state of decay.

CRAIGIEVAR CASTLE, GORDON

This view shows the imaginative combination at Craigievar of traditional features, such as corbelled turrets and crow-stepped gables, with ideas imported from renaissance Europe, such as the 'ogee' roofs, balustraded roof terraces and pedimented windows. Craigievar is perhaps the finest example of this genre in which the architectural vocabulary of the tower house was extended into an architectural style, unique to Scotland.

The castle was built for William Forbes, who was a well-travelled, cultivated individual with a degree from the University of Edinburgh. He was an example of a new kind of laird, a member of the bourgeoisie and very different to the feuding barons who had hitherto been the clients for tower houses.

The period in which the castle was built, between the Reformation of 1560 and the Covenanting wars of the 1640s, was something of a golden age in Scotland – a time of peace and relative prosperity in which art and architecture absorbed the ideas of the continental Renaissance. In the words of that distinguished antiquarian W. D. Simpson: *'Such a building as Craigievar . . . makes us wonder how our Scottish architecture would have developed were it not for the outbreak of the great Civil War and the victory of Calvinism which destroyed the building tradition inherited from the Middle Ages before it could assimilate the neo-classical elements, and so laid open the way for the triumph of pure classicism after the Restoration.'*

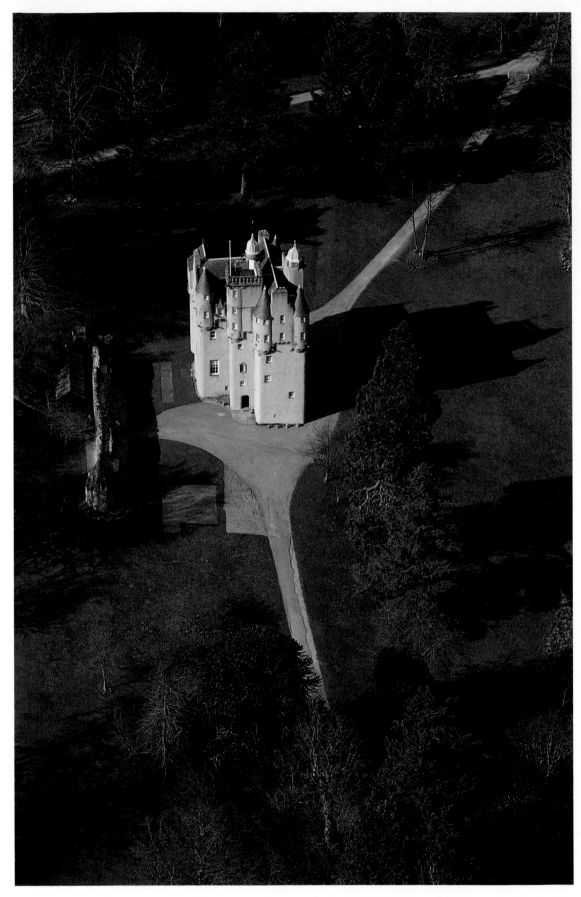

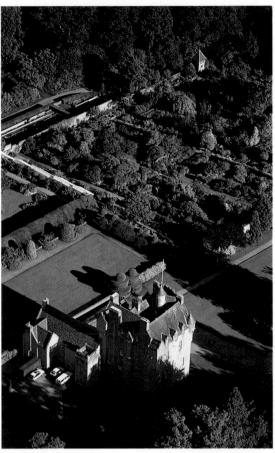

CAWDOR CASTLE, NAIRN

The central tower of Cawdor is one of a substantial number of Scottish houses which have remained in continuous occupation since medieval times. The present structure dates from the mid-fifteenth century and was probably built on the foundations of an earlier building. Like the massive tower at Drum, its external appearance is more or less original apart from enlargement of the window openings and the conical roofing of the original open corner rounds of the parapet. The surrounding courtyard palace which contains additional accommodation, stables and domestic offices, are mainly of seventeenth-century origin. By this time the castle had come, through marriage, to a branch of the Campbell family.

Of all the Highland clans, the Campbells were the most successful at adapting to the changing circumstances of the post-medieval world and they managed to be on the winning side in all of the subsequent troubles which affected the Highlands. It is perhaps for this reason that this magnificent medieval building has survived intact into the present day.

CRATHES CASTLE, KINCARDINE AND DEESIDE

Crathes Castle was built in the second half of the sixteenth century and externally is similar to Craigievar. It is probable that, like Craigievar, it was constructed by the famous Bell family of masons who were responsible for some of the finest of the late Scottish tower houses. Crathes is justly renowned for its topiary hedges of yew, which were planted at the beginning of the eighteenth century and which are clearly seen in this view.

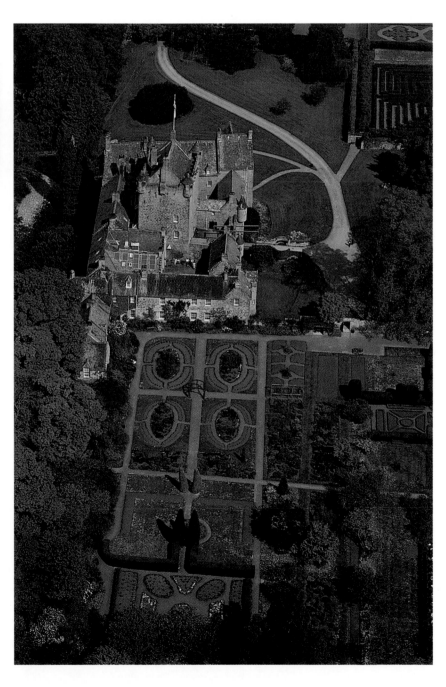

GLAMIS CASTLE, ANGUS

Although the core of Glamis Castle is much older, the external appearance of the building which is seen today is due to work carried out in the early seventeenth century. It therefore belongs to the same period as Craigievar and Fyvie, in which the architectural vocabulary of the tower house was the subject of much imaginative experimentation. The stylistic mannerisms here, however, are particularly eccentric and may have come about as a result of the second earl, who succeeded in 1615, acting as his own architect during the building of the west wing, seen on the left. Among the peculiarities of this design are a conical turret which rises out of a dormer window and a balustraded tower, with open belfry, which conceals the gable ends of the wings. The whole effect is extremely rich and, together with the scale of the additions, lends it a palatial aspect.

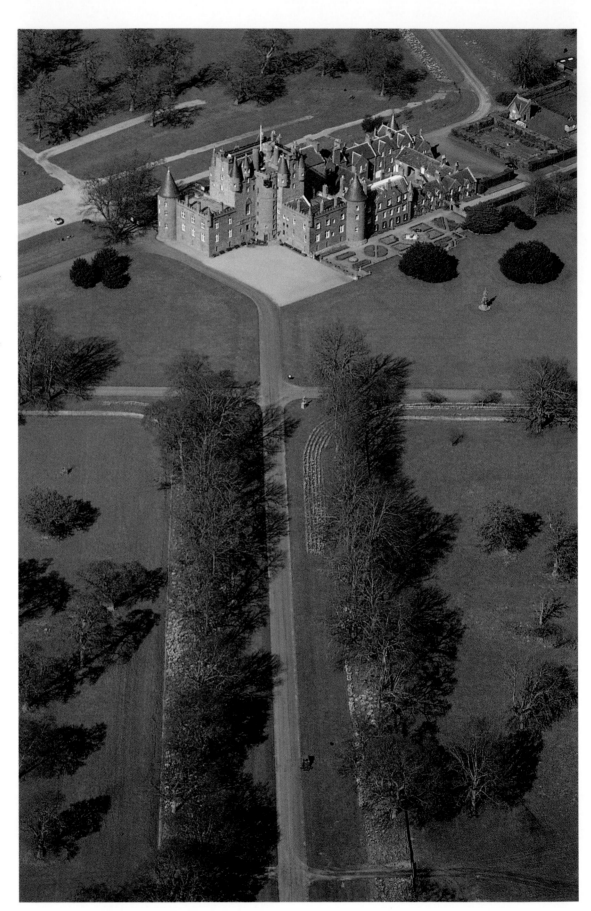

GALLERY HOUSE, ANGUS

Gallery House was completed in 1680. The plan is symmetrical with projecting towers topped by pyramidal roofs. The stair in this building is placed centrally and contained entirely within the main block, unlike in the typical tower house where the stairs are at the periphery of the plan and cause bulges or other excrescences in the external form. This building anticipates the classical houses of the eighteenth century and represents a complete break with the tower-house tradition.

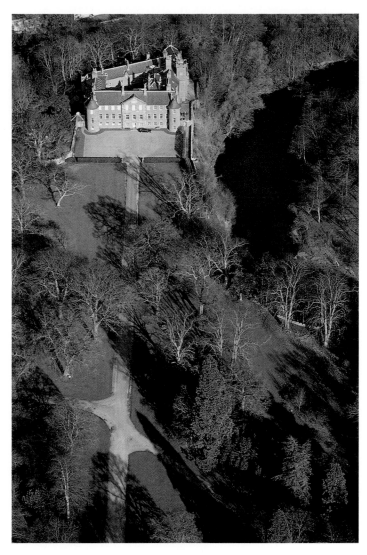

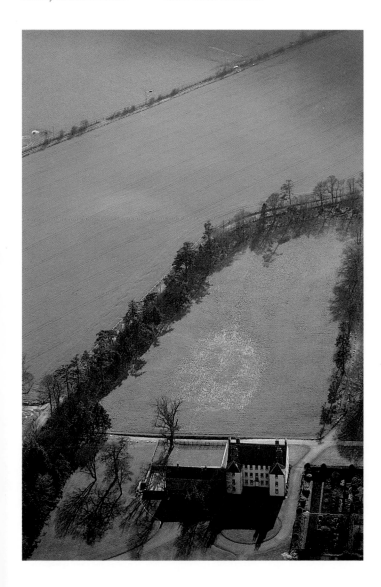

BRECHIN CASTLE, ANGUS

Brechin Castle was remodelled in the late seventeenth century to the design of Alexander Edward, who began his architectural career as an assistant of the great Scottish classical architect, Sir William Bruce. As at Gallery House, a symmetrical arrangement with end-towers has been adopted for its principal elevation. The architectural treatment here, with its round towers and conical roofs, is more traditional than at Gallery but the introduction of the pedimented frontispiece leaves no doubt that the arrangement is classically inspired.

DUFF HOUSE, BANFF AND BUCHAN

Duff House was William Adam's last country house commission and many consider it to be his finest work. It was built in 1735–40 but never completed; in the original scheme the main block was flanked by matching pavilions attached by curved colonnades in the manner of a Palladian villa. The design also owes much to John Vanbrugh but the vertical emphasis of the building, the presence of the attic storey and the way in which the ornamentation is handled are unmistakably Adamesque. The country houses of the eighteenth century were built for a gentry class which had abandoned the Scottish architectural tradition and looked southwards to England for inspiration. The verticality of buildings such as Duff and Gallery is not, however, found in the classical houses of England where, in the work of Inigo Jones and, later, Colen Campbell and Lord Burlington, the emphasis was horizontal. Perhaps the verticality which can be seen in the early Scottish classical houses originated in the penchant for vertical living which became established with the tower house and is the last vestige of tradition before the tide of Anglicised architecture swept all before it in the late eighteenth century.

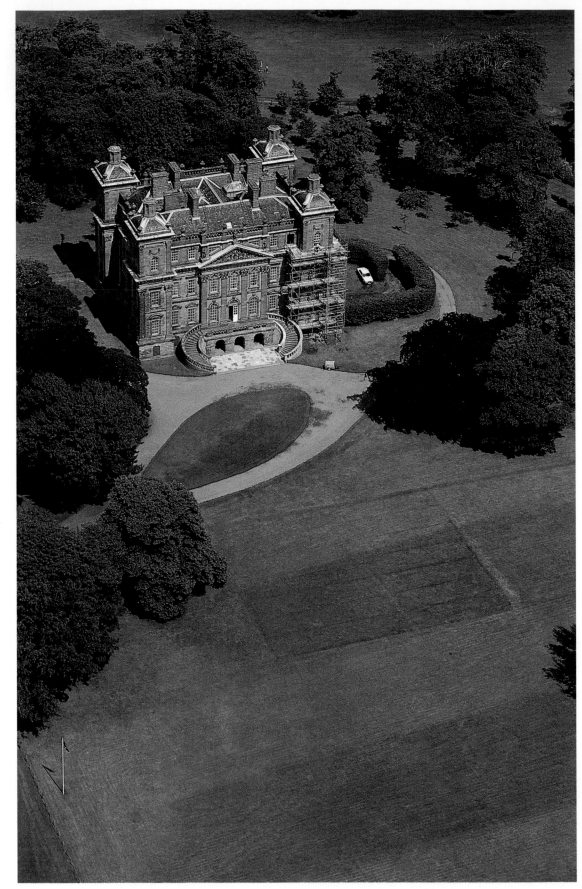

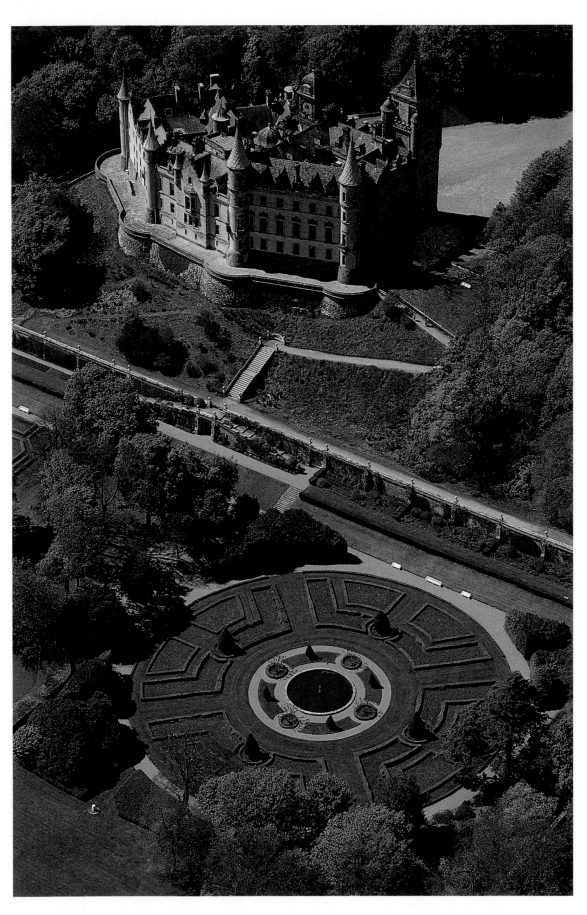

DUNROBIN CASTLE, SUTHERLAND

Dunrobin Castle, which is situated on rising ground at the edge of a bleak hinterland and overlooks the stormy waters of the North Sea, is the epitome of the nineteenth-century romantic pile. The present exterior was built mainly in 1835–50 to the designs of Sir Charles Barry who was, with A. W. N. Pugin, the architect of the British Houses of Parliament in London.

By this time the classical country house had fallen from grace, a victim of nineteenth-century romanticism which was a particularly powerful force in this land of Sir Walter Scott, Jacobitism, misty glens and illicit whisky. Dunrobin was built as the seat of the Dukes of Sutherland. The architecture is an Englishman's version of how a fantasy castle should look in Scotland and owes more to French than to Scottish tradition.

BRODIE CASTLE, MORAY

The Brodie family have been lairds of Brodie for 800 years and the core of the present building has stood on the site for almost exactly half of that time. It was erected in the second half of the sixteenth century as a Z-plan tower. Since then the Brodies have preferred to extend their house gradually, preserving its original character rather than embedding it within a shell which conformed to a later fashion or even replacing it entirely, as many other landowners did. The most recent addition was the east wing, seen on the right here, to a design by William Burn in the 1820s.

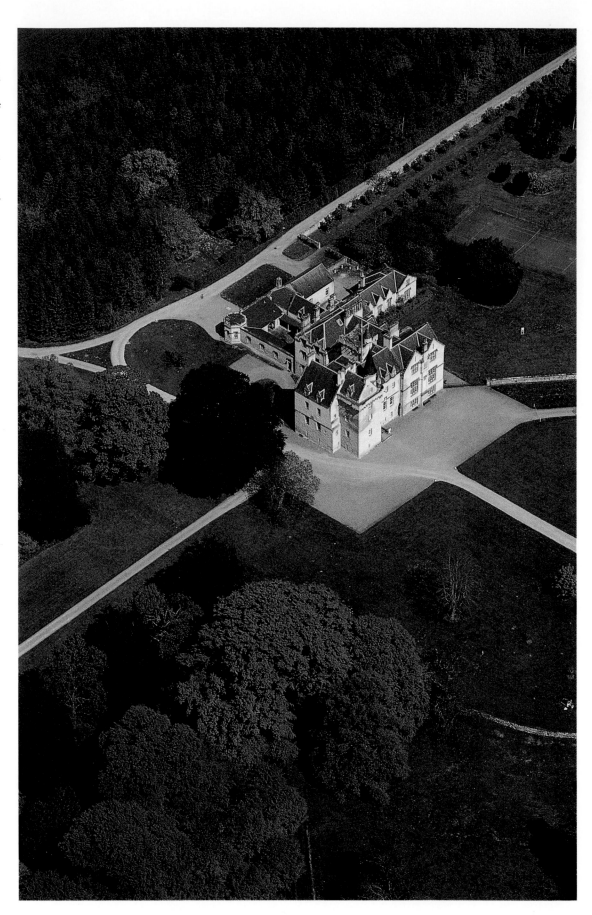

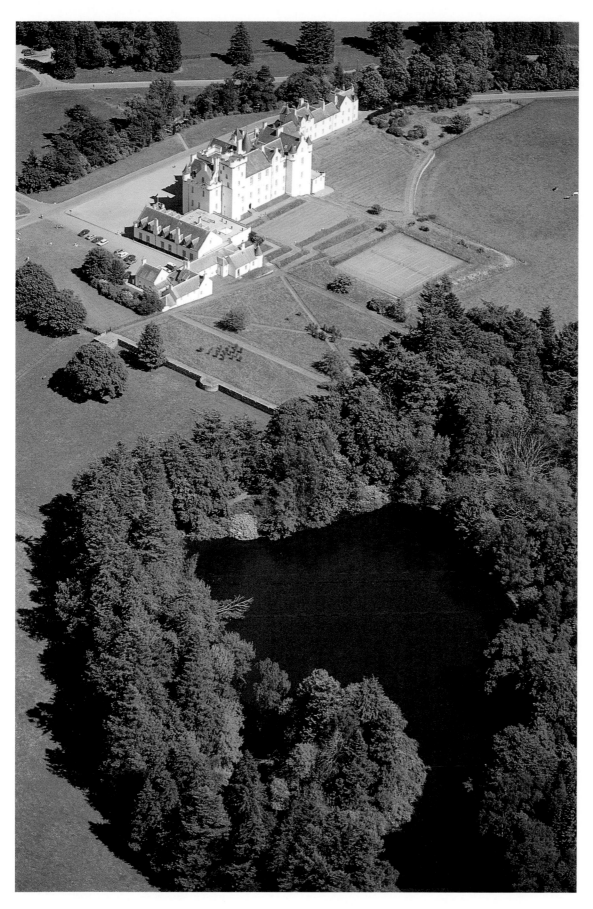

BLAIR CASTLE, PERTH AND KINROSS

The exterior of Blair Castle dates from the 1870s when the building was comprehensively remodelled by David Bryce. Bryce was famous as an architect of the Scots Baronial Revival and it is ironic that a medieval tower does actually exist at Blair beneath layers of later building. It was entombed in the eighteenth century when the house was enlarged into a Georgian mansion. The inner core, and the exterior of the building, are therefore traditionally Scottish and a layer of classicism is sandwiched between – an approach to the continuing requirement to enlarge a house which is quite different from that used at Brodie.

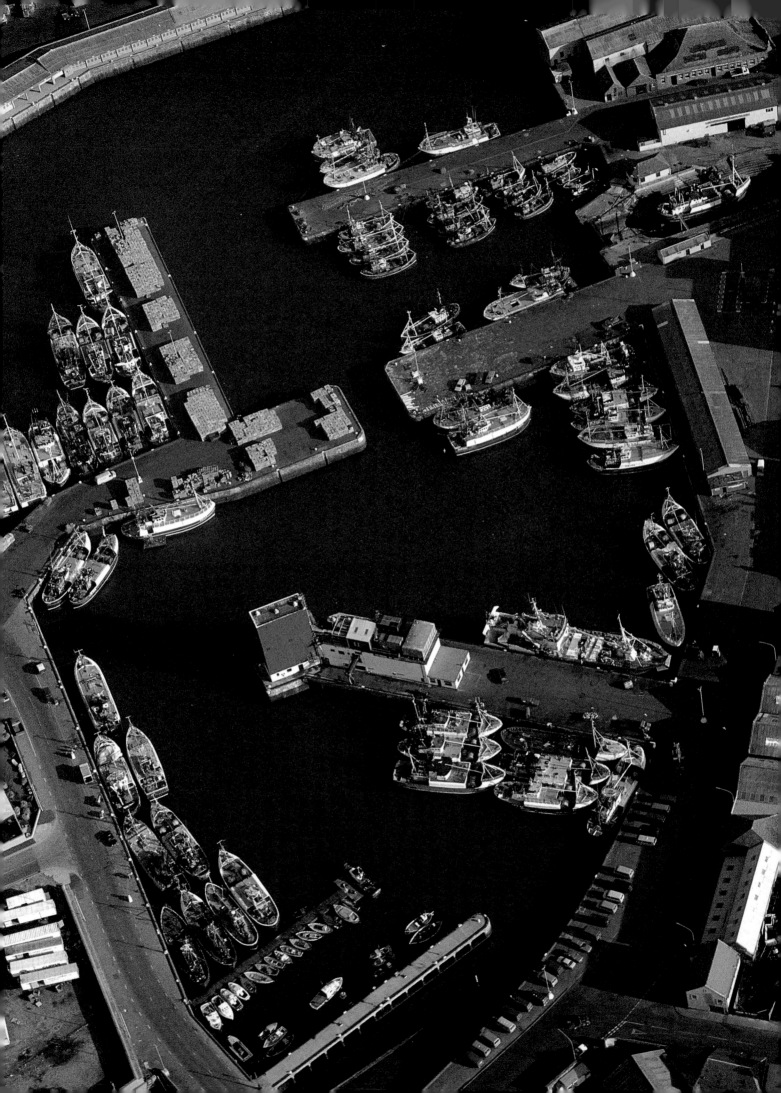

BY LAND AND SEA

THE GEOGRAPHY OF A COUNTRY AND IN PARTICULAR ITS climate, geology and geomorphology, determines to a very large extent its history, because the resources which the accidents of geography make available to a people strongly influence the type of society which they can establish. From the human point of view, North-east Scotland might be thought of as being in the middle range of environments on the planet Earth. There is not here the harshness of an arctic or sub-tropical desert but nor is there abundantly lush vegetation or easily-winnable mineral resources. There is a temperate climate with relatively high levels of rainfall and a geomorphology which allows a reasonable living to be made from the land. The coastal waters have also been capable of providing a livelihood to those with the skill and determination to extract it.

The lowlands of the North-east are amongst the most productive of any agricultural land in Britain. They are favoured by their soil types and climate, the conditions being particularly good in the inner Moray Firth, where is found the most northerly land designated Class 1 in Britain. Over the centuries surpluses of agricultural produce, which were won from the soil at the cost of much human effort, formed the basis of trade and rural industry. These were conducted in the burghs and, in time, allowed the modern system of capital and industry to come into being. Thus, as elsewhere in Europe, these fertile areas of the North-east made possible the development of civilisation and of a reasonably comfortable standard of living.

The appearance of these lowland areas is almost totally artificial and the landscape as we know it today was formed principally in the late eighteenth and early nineteenth centuries as a result of the ideas of the enclosure movement. Agricultural interests dominate in these areas today and in recent years the level of tree cover has diminished as hedgerows and shelter belts have been removed to create the very large fields favoured by modern methods of intensive cultivation. The resulting aesthetic impoverishment of the landscape must be set against the necessity for fertile areas of the world to produce sufficient food for its population, and also with the need, in the present day, for agriculture to be economically viable. A vital factor which is often overlooked, however, is that much of this intensive farming is damaging to the environment and is not sustainable in the long term. This would seem to indicate the vital necessity of relating the economics of farming to the realities of biology and ecology rather than to artificial systems of accounting and economics, as is the current practice.

In the extreme north most of the lowlands are of poor agricultural

PETERHEAD, BANFF
AND BUCHAN

Like Fraserburgh, Peterhead developed as a fishing port in the nineteenth century at the time of the herring boom and provided all of the facilities required to process the catch and to maintain the vessels of a large fleet of herring boats. It is today the principal fishing port of Europe. Through the 1980s a fleet of around 400 boats of the medium-sized purse- and seine-net trawler types, a quarter of which were actually registered in Peterhead, regularly worked from the harbour. Like all of the fishing ports of the North Sea, it now faces an uncertain future due to the stringent conservation measures being imposed by the EEC in response to dwindling fish stocks.

quality. Subsistence farming was practised in these areas until the 'age of agricultural improvement', but when, in the nineteenth century, landowners attempted to generate cash income from their estates, this proved possible only by evicting the indigenous population and turning the land over to sheep. The infamous 'Highland Clearances', though mostly a phenomenon of the western Highlands, affected parts of the North-east, in Caithness and Sutherland, and the legacy of this today is a depopulated landscape.

Most of the landmass of the North-east is, in fact, upland and of a type which makes self-sustaining agriculture difficult to achieve. Today the parts which serve agriculture are used as rough grazing for sheep or are being turned over to commercial forestry. The principal use of this land is for recreation, however, either in the form of shooting for sport or for climbing, hillwalking and skiing. The visitors who come to the Highlands to participate in these activities can be regarded as the clients of a multi-million-pound industry which forms a significant component of the Scottish economy. Here again a resource is being exploited, in this case a set of landscape forms which, in the culture of the West, has, since the romantic movements of the nineteenth century, been considered to be the epitome of natural beauty.

From the eighteenth century manufacturing industries based on agriculture have assumed increasing importance in the North-east, as elsewhere in Scotland. In the eighteenth century the most important of these was the textile industry, principally the linen industry based on locally-grown flax. Today the largest local industrial consumer of agricultural produce, at least in terms of revenue earned, is the whisky industry.

Scotland's national drink has, in fact, been one of the mainstays of the Highland economy for almost 200 years. It is, in the popular imagination, as inseparable from the idea of Scotland as kilted Highlanders, purple heather and oatmeal porridge. In the form in which we know it today, however, it is a comparative newcomer to the Highland scene. Legend has it that the 'secret' of making whisky was brought to western Scotland by St Patrick in the fifth century but it is more likely that a knowledge of the techniques of distillation travelled to this north-western fringe of Europe with returning Crusaders in the twelfth century. The essential ingredients are barley and suitable water so it is likely that the making of whisky did not become widespread until reasonable surpluses of barley became available in the eighteenth century as a result of the Agricultural Revolution. The water which drains from the peat-clad granite rocks of the Grampians is considered to be particularly suitable for the whisky process and is responsible for making the Speyside area of the North-east in particular one of the classic whisky-producing parts of Scotland.

In the early days of the popularity of whisky in Scotland, it was made privately on farms and crofts for local consumption. This fiery liquid was 'malt' whisky – that is, whisky which was made from malted barley in a relatively small pot still, and which had a distinctive flavour mainly dependent on the character of the barley and on the shape of the still. The resulting spirit was frequently somewhat rough and was

sweetened with honey or herbs. As the eighteenth century progressed and the ideas of a cash economy were introduced into the Highlands there was an ever-increasing interest in commercial manufacture, and from the middle of the century a growing number of commercial distilleries were set up from which whisky was exported, mainly southwards to the Lowlands and to England, but also abroad.

By the twentieth century the Scotch whisky industry had consolidated its position as a valuable contributor to the Scottish economy and to UK exports. Production reached peak levels in the early 1970s after which the industry declined somewhat due to difficulties in the world economy and to changes in consumer preferences in alcoholic drinks. The 1980s saw a period of retrenchment and consolidation from which the industry has emerged as a producer of lower volume but higher status products, similar to the French brandy industry.

The land of North-east Scotland has therefore produced three industries which make significant contributions to the present-day economy of Scotland. The lowland fringes contain some of the most intensively farmed land in the British Isles and therefore support a capital-intensive and cash-earning agricultural industry; the Highlands, through their incomparable scenery, their challenging mountain ranges and their grouse moors, support a multi-million-pound tourist industry, and the Highlands and Lowlands together create the conditions which are necessary for the manufacture of the greatest single earner of foreign currency in Scotland, the whisky industry.

The North Sea too has, over the centuries, provided resources on which the population of North-east Scotland has always depended for its well-being: since earliest times, fish and, more recently, oil.

Fishing is an activity which has been carried out from the east coast of Scotland since humans first arrived upon it. The earliest recorded references to it in this part of the world, however, occur in burgh records and Acts of Parliament dating from the medieval period. It is clear from these that, as for Scotland's prehistoric inhabitants, fish formed an important component of the diet and was probably the only protein eaten regularly by many. Fish curing (salting and smoking) developed as a means of preserving fish caught in the summer for use in winter when other food supplies were likely to be short, and this practice also allowed surplus fish to be exported.

The fish which were caught were salmon and white fish such as cod, haddock and ling. Salmon fishing was concentrated at the mouths of rivers where the fish were taken as they migrated to their spawning grounds. From earliest times they were much-prized fish and this activity was closely supervised by the Crown and nobility. White fish, on the other hand, were caught at sea on lines, these being very long with many individually-baited hooks. The boats were open-decked, usually no more than twenty feet in length, and were launched directly from beaches as there were few natural harbours along this coast. It was the principal fishing method in eastern Scotland until well into the nineteenth century and the fact that harbours were not a necessity meant that from medieval times onwards small communities dedicated to fishing grew up along the entire east coast of Scotland, from Wick

to Berwick upon Tweed. Many new settlements were also established in the late eighteenth and early nineteenth centuries as part of the planned village movement.

The nineteenth century saw the development of commercial herring fishing on a very large scale and this brought what was perhaps the period of greatest prosperity to the east coast fishing villages. Herring fishing was altogether different from traditional line fishing. It was carried out further from the shore from larger vessels using drift nets, and, as the investment in boats and gear was considerable, it was frequently financed by the curers and merchants – the middle-men who were to be the principal financial beneficiaries of the 'herring boom'. Most fishermen simply became employees of the boat owners and work was seasonal as the boats had to follow the shoals of herring. It began in April in the Hebridean seas, principally the Minch, and then moved gradually clockwise around the coast of Britain, finishing in the late autumn in East Anglia. Often the fishermen would be away from home for the entire summer. The activity gave employment to many shore workers, who were also forced into a migratory life – people like coopers, net-makers and all of those associated with the maintenance of a fleet of boats. Perhaps the liveliest group, however, were the herring girls – young women, mostly unmarried, who gutted and packed the herring in prodigious quantities and who sent their earnings home to supplement the family budget.

The herring fishery increased in volume throughout the nineteenth century and reached its peak in 1913 when the largest catches were landed; it then collapsed and all but disappeared during the following twenty years. The reasons for the failure of the industry were various and included the loss of a large part of the market following the upheaval of the Russian Revolution, and the development of home-based fishing industries in Eastern Europe. The depletion of the herring stocks was another factor, although whether this occurred principally as a result of overfishing, or of a natural decline in the population of the elusive herring, or both, is a matter for conjecture.

One of the effects of the herring boom was to concentrate fishing into the larger ports where the herring drifters could be docked and serviced and where the enormous catches could be landed and processed. Many villages decreased in importance as places from which fishing was actively carried out, although most retained both a connection with the industry and a few local boats working by traditional methods. This process of concentration was given further impetus by the development of trawling in the late nineteenth century.

As with the herring boom which preceded it, trawling required large powerful boats and was a capital-intensive industry which operated out of large harbours such as Aberdeen, Peterhead and Fraserburgh. Following the collapse of the herring industry, deep-sea trawling for cod, haddock and ling became the mainstay of the Scottish fishing industry but this too underwent a cycle of 'boom and bust' and from its period of greatest success in the early twentieth century has declined to a fraction of its former size. Today the fishing industry in the North-east is greatly threatened in the short term by EEC-imposed

RAPE FIELD NEAR AUCHMITHIE, ANGUS

The fields here have the rectangular precision of a machine-made product or a geometric abstract painting by Piet Mondrian. We catch a glimpse of agriculture as a series of industrial processes controlled by a centralised bureaucracy. The limited range of colours is caused by the effect of government policy on the economics of agriculture, which determines the types of crop which are grown. The evenness of the colours is due to the application of pesticides and fertilisers. No plant here grows naturally and even the farm steading has a clinical tidiness.

In 1917 Piet Mondrian wrote, 'The life of today's cultivated humanity is gradually turning away from natural conditions; it is becoming more and more an abstract life.' The geometric visual vocabulary of modern art and architecture proclaims a belief in the complete control of nature by human beings. The landscape of modern agriculture, which conforms to the same visual vocabulary, could have been taken to justify this view had not the events of the late twentieth century so effectively demonstrated its falsity.

conservation measures designed as a long-term strategy in response to catastrophic declines in fish stocks.

As the fishing industry in the North Sea has declined a new source of wealth from the sea has appeared to replace it, if a mineral, albeit of biological origin, can ever be said to replace the renewable resource of a living harvest. The extraction of oil and natural gas from offshore the east coast of Scotland is frequently billed, especially by government agencies anxious to convince the world that the Scottish economy is facing a bright future, as a story of great economic success for North-east Scotland. The reality is somewhat different and, as was so eloquently pointed out by John McGrath in his play *The Cheviot, The Stag and the Black, Black Oil*, the true story has a slightly familiar ring to it, especially to Highland ears:

TEXAS JIM:

So leave your fishing, and leave your soil,
Come work for me. I want your oil.
Screw your landscape, screw your bays
I'll screw you in a hundred ways –

WHITEHALL:

We didn't charge these chaps a lot of money, we didn't want to put them off.

The essential facts of the North Sea petroleum industry, simply stated, are undoubtedly impressive. Exploration for oil in the northern North Sea began in the late 1960s following the successful discoveries of natural gas in the southern sector in the vicinity of East Anglia. In 1974 Britain was still importing all of the oil which it required. The first North Sea oil came ashore in 1975 and by 1980 the country was self-sufficient in the commodity. Oil exports began in 1981 and by 1983 there was a 50 per cent surplus. The rate of development of the North Sea oilfields was, therefore, very rapid and there is no doubt that, given the difficulties of operating in the extremely hostile waters of the northern North Sea, this was a very remarkable technical achievement.

The cash benefit to the UK economy was equally remarkable. Throughout the 1980s the annual balance of payments benefit to the UK economy was of the order of £10,000 million although the economic benefit of the oil to Scotland was only an indirect one. None of the income generated by the oil and gas which comes ashore in Scotland is credited to the Scottish economy, because the Westminster government created a new region of Britain known as the UK Continental Shelf, to which it has all been assigned. The benefit of the balance of payments value of North Sea oil to Scotland must, therefore, be seen in the context of its benefit to the UK economy as a whole.

The oil industry has, of course, provided employment in the Highlands of Scotland but this is an industry which is not labour-intensive. Wages and salaries account for only around 3 per cent of the value added to the product compared to 70 per cent in manufacturing

industry, and it is likely that many of the jobs will be of a temporary nature. Other facts which should not be ignored are that most of the jobs are offshore and that many of the workers have their homes outside Scotland.

The most obvious employers of local labour by the oil industry have been the yards which have fabricated the rigs and production platforms, but several of these have already closed down since the late 1970s. The supplying of materials and provisions to oil rigs and platforms has also stimulated the local economies – the centre of this activity being Aberdeen. Nevertheless, the direct benefit to the Scottish economy of the oil boom of the 1980s has been small in relation to the vast income which it has generated for the UK as a whole, and also to the claims which were made for it in the heady days of the 1970s.

And what of the future? How much of this income has been invested in Scotland to benefit succeeding generations of local people? The answer is, very little indeed. Instead, it has been used (many would say squandered) to support the dogmatic economic policy of a Westminster government so as to bring about an insignificant and temporary economic 'miracle'. Much of it has, in other words, disappeared in financing the desires for imported consumer 'toys' by the high-salaried inhabitants of southern Britain, who were the principal beneficiaries of the short-lived economic booms of the 1980s.

It is impossible to tell the full story of the relationship between people and natural resources through the medium of aerial photographs. In the case of North-east Scotland, the overview does, however, provide an opportunity to reflect on the sustained effort which has always been required to maintain, and slowly improve, the material standard of living of the people who dwell there. It does not show, however, the effect which this effort has had on the character of the population, which is typified by resourcefulness, sternness of manner, forthrightness and respect, albeit grudging, for the mysteries of Nature. Neither does it show the strong sense of community and of mutual support generated by the continuous task of wresting a living from a difficult environment.

DRILLING (SOWING) A FIELD NEAR FORFAR, ANGUS

In the days before tractors, the ploughing, preparation and sowing of a field was an operation which required several days, spread over a number of weeks. It was labour-intensive and depended on the muscle power of horses and men. A high percentage of the land under tillage, sometimes as much as 50 per cent, was required to provide fodder for the draft animals, but, and here is a vital comparison with the present day, the system was sustainable in the long term.

Mechanisation has eliminated the need for draft animals and greatly reduced the number of people required to work the land. It has also allowed the preparation and sowing of a field to be carried out in a matter of hours, as is happening in this photograph. It would be interesting to know what percentage of the farm acreage today is required to generate the revenue needed to pay the bills for tractor fuel. This would provide a direct comparison with that which was formerly needed to grow oats to feed horses. No doubt this would appear to show how much more efficient modern farming has become, but it might equally be simply a demonstration that the price of oil is artificially low; in this case, the present 'high efficiency' would be seen to be simply an illusion, dependent on a non-renewable resource, and not sustainable.

Rhynie

At Rhynie I sheared my first hairst,
Near tae the fit o' Bennachie.
My maister was richt ill tae sit,
But laith was I tae lose my fee.

 Linten addie tooring addie,
 Linten addie toorin ee.

Rhynie's wark is ill tae wark
An' Rhynie's wages are but sma'
An' Rhynie's laws are double strict
An' that does grieve me warst ava'.

Rhynie, it's a cauld clay hole,
It's far frae like my faither's toon,
An' Rhynie it's a hungry place,
It doesna suit a lowland loon.

But sair I've wrocht an' sair I've focht
An' I hae won my penny fee
An' I'll gang back the gait I cam
An' a better bairnie I will be.

hairst, harvest *ill tar sit*, hard to please
laith, unwilling *gait*, way

PLOUGHING, ANGUS

It should not be thought that because farming has become highly mechanised there is no longer any tradition of craftsmanship. Ploughing is still regarded as an art and taken very seriously. Here the ploughman is achieving a straight furrow line over a field which is undulating, although the unevenness of the ground is not obvious in this nearly vertical view.

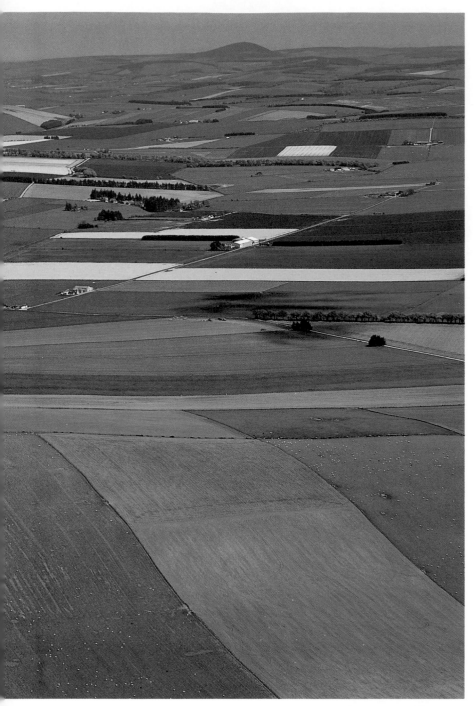

O Lord Look Doon on Buchan

O Lord look doon on Buchan
And a' its fairmer chiels!
For there's nae in a' Yer warld
Mair contermashious deils!

Yet tak a thocht afore Ye lat
Yer wrath and vengeance fa',
For sic weet and clorty widder
Wid gar ony human thraw!

But still an' on Ye ken richt weel
Their sowls are unca teuch,
And Lord fin a' is said and dane
Ye've tholed them lang aneugh.

And yet gin Ee'd come doon and tak
A dauner roon aboot
Ye'd sweir there wisna better han's
At garrin a'thing sproot.

So coontin up and coontin doon
The richt o't and the wrang,
Ye'd best hae patience, Lord, a fyle,
But Lord, O Lord, foo lang?

J. C. MILNE

chiels, lads *contermashious*, perverse
clorty, dirty *widder*, weather
thraw, twist
unca teuch, extraordinarily tough
tholed, suffered *Ee'd*, You would
dauner, stroll

POST-IMPROVEMENT LANDSCAPE

The southern fringes of the Moray Firth, in Banff, Buchan and Moray, contain the most northerly areas of extensive arable farmland in the British Isles. The field patterns here have been determined by the land surveyors of the age of agricultural 'improvement' in the late eighteenth and early nineteenth centuries, who have laid out a system of enclosed fields, shelter belts and farm steadings which allow the land to be intensively worked according to the principles of commercial agriculture.

In an earlier age this rich land attracted the Anglo-Norman barons of the feudal period to northern Britain and caused the displacement of the Celtic culture into the Highlands. To this day, the North-east of Scotland lies on a cultural boundary between post-renaissance commercial Europe and a fringe which owes allegiance to a more ancient belief system.

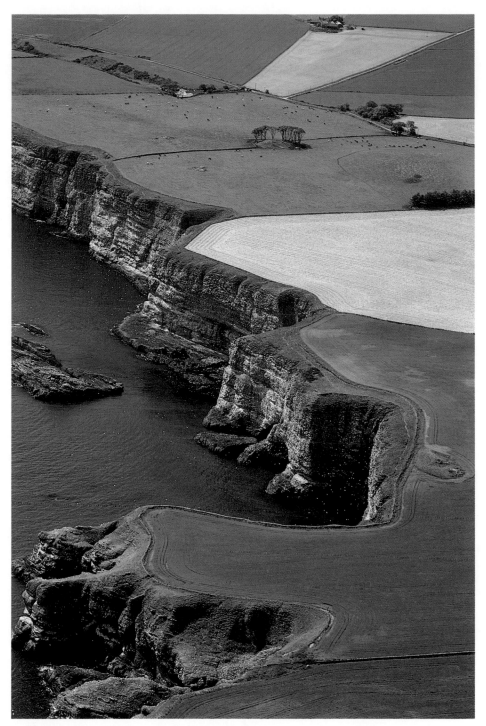

Taxman

Seven scythes leaned at the wall.
Beard upon golden beard
The last barley load
Swayed through the yard.
The girls uncorked the ale.
Fiddle and feet moved together.
Then between stubble and heather
A horseman rode.

GEORGE MACKAY BROWN

CLIFFS NEAR
STONEHAVEN,
KINCARDINE AND
DEESIDE

Much of the arable land in
the North-east is devoted to
the rearing of livestock. The
most common cereal crop is
barley and, although the
best-quality grain is used for
malting and distilling, most
of it is grown for animal feed
and much is retained on the
farm on which it was grown.
A combination of grazing
land and cereal crop is seen
here extending almost to the
edge of the cliffs.

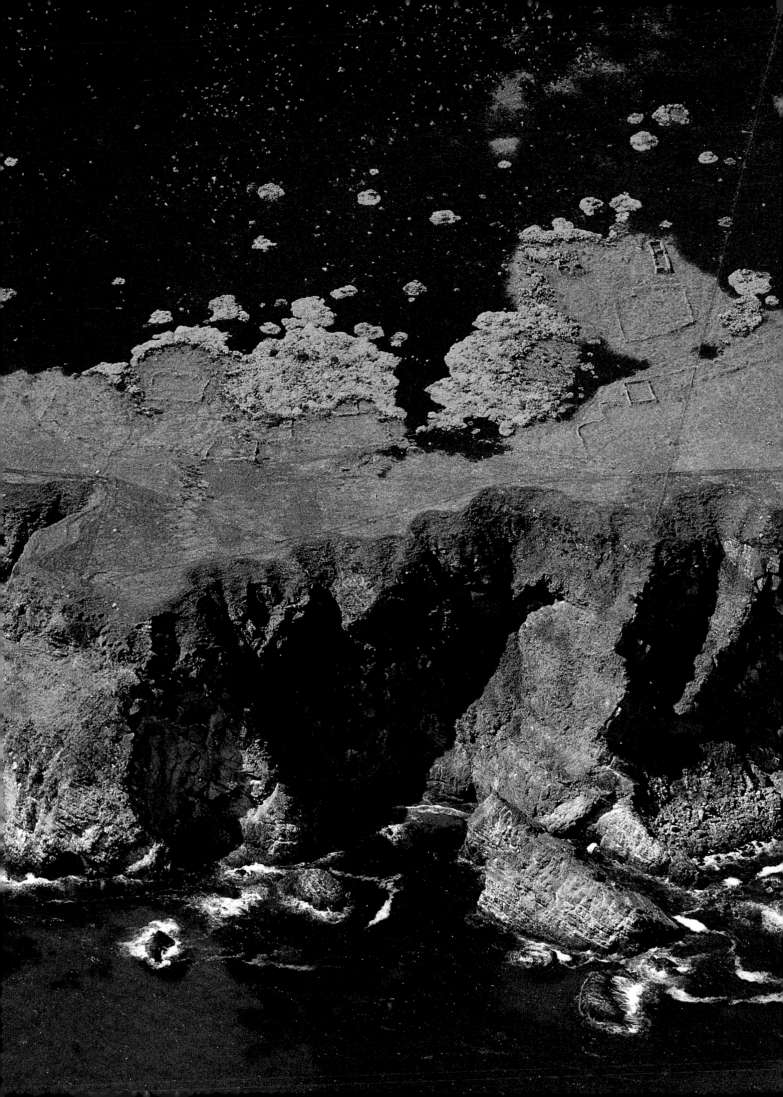

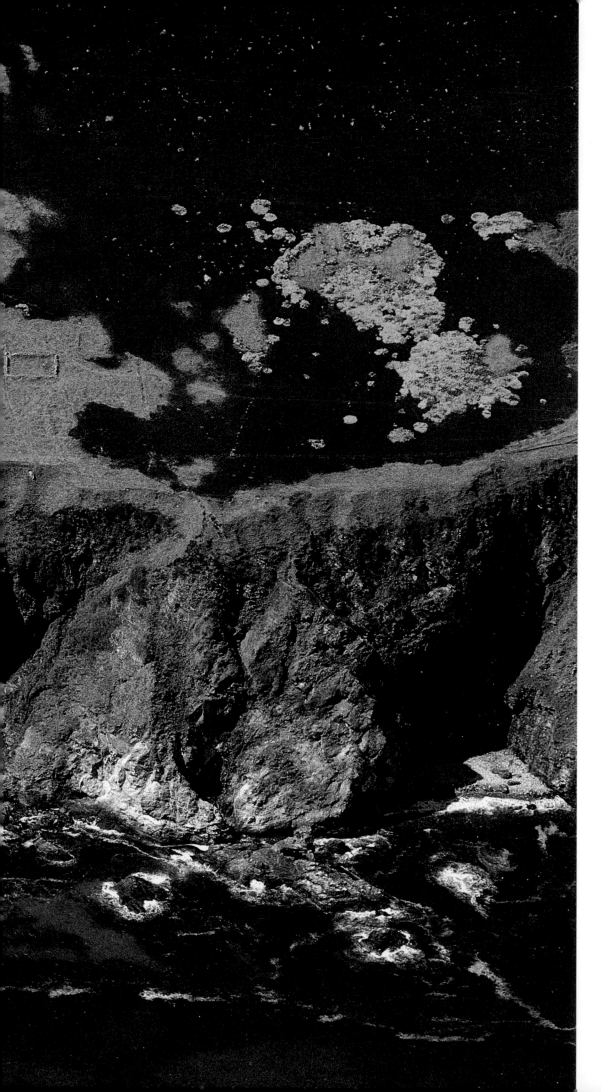

COAST NEAR BERRIEDALE, CAITHNESS

North of the Great Glen and the Black Isle, the pattern of land use in the north-eastern fringe of Scotland is similar to that of the north-western Highlands. Much of the land is of poor quality for agriculture but nevertheless once supported a large population of subsistence farmers. The people were cleared from their land in the nineteenth century by landowners who wished to generate a higher cash income than was possible from the traditional methods of working, and it was turned over to rough grazing for sheep. Some of the dispossessed were resettled in inadequate coastal holdings. Except in a few locations, the sole reminders of a once-thriving culture in the extreme north of the Scottish mainland are the ruined remains of domestic buildings.

HEATHER BURNING, SOUTH OF ABOYNE, KINCARDINE AND DEESIDE

Much of upland Scotland has been given over to deer forest and grouse moor. In its present form, this usage dates from the late nineteenth century when the economics of sheep farming declined following the emergence of competition in wool production from Australia and New Zealand.

Deer forests are mainly confined to the western Highlands, but, with the exception of an area around the Cairngorms, the uplands of the eastern Highlands, where the climate is drier, are mainly devoted to grouse. The moors are managed by burning limited areas on a twelve-to fifteen-year cycle so as to produce new growth on which the birds feed. Approximately 300,000 grouse are shot annually on the hills of Scotland, compared to 65,000 deer and 1,000,000 pheasant, these last being taken mainly in the Lowlands.

HEATHER BURNING, SOUTH OF ABOYNE, KINCARDINE AND DEESIDE

Shooting rents represent the main source of income on many estates in the eastern Highlands and sporting estates are actually valued by the amount of game which can be taken from them annually: in 1990 the valuation was £1,000 per brace of grouse. It is difficult to believe that this is the best way of using this land, but many landowners can see no alternative. As Lady Phosphate and Lord Crask sing in John McGrath's *The Cheviot, the Stag and the Black, Black Oil*:

'Oh it's awfully, frightfully, nice,
Shooting stags, my dear, and grice
And there's nothing quite so right
As a fortnight catching trite:
And if the locals should complain,
Well we can clear them off again.'

COMMERCIAL FORESTRY PLANTATION, KINCARDINE AND DEESIDE

In the last three decades an increasing amount of the uplands of Scotland which were formerly used for rough grazing or shooting for sport have been turned over to forestry, largely as a result of the creation by the government of attractive financial incentives. This has caused an increase in tree cover from a figure of around 5 per cent at the beginning of the century to 13 per cent today.

The recent activity has caused much controversy between the forestry and conservation lobbies. Conservationists argue that the planting of large areas with monocultures of alien coniferous species, such as are seen here, is detrimental to the landscape: it has not improved its appearance and it has significantly reduced the diversity of the natural environment by depriving many species of birds, animals and plants of a suitable habitat. The forestry interests point out that Britain at present imports 90 per cent of the timber which it requires at a cost of around £4.5 billion. It is possible that a reconciliation could be brought about by measures designed to make indigenous species of timber more attractive commercially to the growers and landowners.

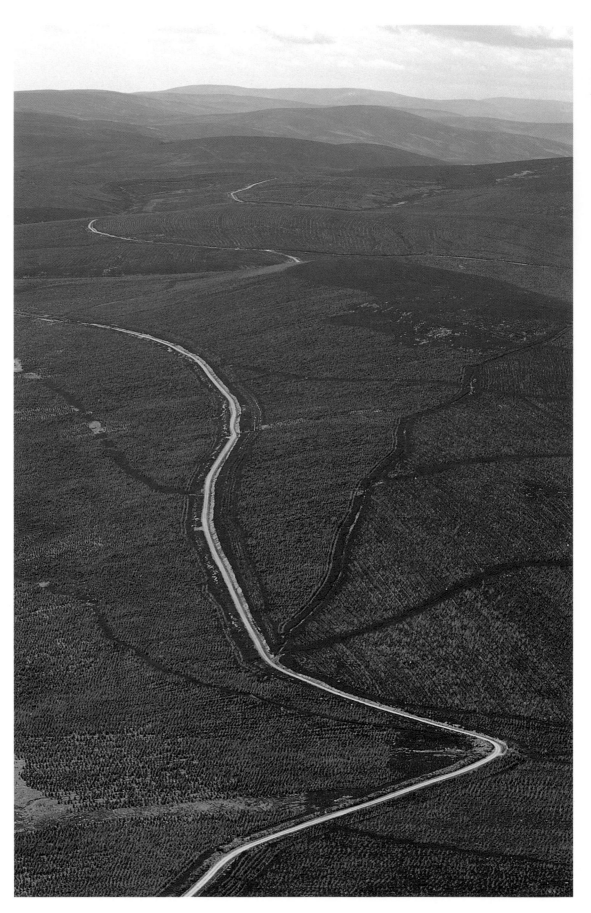

'THE GLENLIVET' DISTILLERY, MORAY

R. J. S. McDowall, in his book *The Whiskies of Scotland*, refers to 'The Glenlivet' as 'the prince of whiskies'. The River Livet is a tributary of the Avon, which in turn flows into the Spey; the distillery is therefore situated in one of the classic whisky-making areas of Scotland. It enjoys water running northwards from the peat-clad granite rocks of the Grampian Mountains and is within easy reach of the barley-growing areas of the Moray Firth coast.

In the early nineteenth century there were said to have been 200 illicit stills around Glenlivet which supplied flourishing smuggling operations southwards through the Grampians to the rugged, cave-strewn coast around Montrose and Auchmithie. The Glenlivet was the first whisky to be licensed in 1823 under the Act of Parliament which led to the establishment of the legitimate whisky industry in the latter half of the nineteenth century.

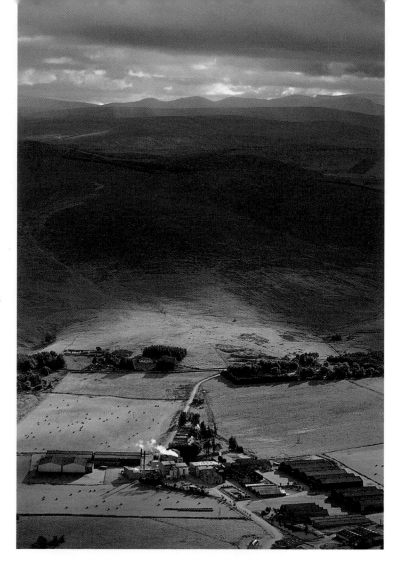

GLENFIDDICH DISTILLERY, DUFFTOWN, MORAY

Glenfiddich is another of the great single malts from a tributary glen of the Spey. Like all Scotch whiskies, it must be matured for a minimum of three years in oak casks before it may legally be given the name, and the large ranges of sheds in this photograph are the bonded warehouses in which the maturation process is carried out. Ben Rinnes, in the background, is the heart of this whisky-making area.

SPEYMOUTH, MORAY

The Spey is 107 miles in length and is the second-longest river in Scotland. Like the other great rivers of the eastern Highlands, it has been an important factor in shaping the economy of the area. It carried the felled timber of the Old Caledonian Forest to the sea for export, and the greatest concentration of malt whisky distilleries in Scotland occurs along its banks and those of its tributaries. It is also one of the great salmon rivers of Scotland. In the present day the fish are taken for sport but in former years commercial fishing was an important activity. From the Middle Ages the fish, in pickled or smoked form, were a valuable export commodity. Later, packing in ice allowed exported fish to be sold fresh. On the left of this picture, close to the river mouth, can be seen three turf-covered vaults which were ice-houses built in the late eighteenth century. These were filled with ice collected from ponds in the winter and used for packing salmon prior to its being shipped by fast sailing packet to Billingsgate.

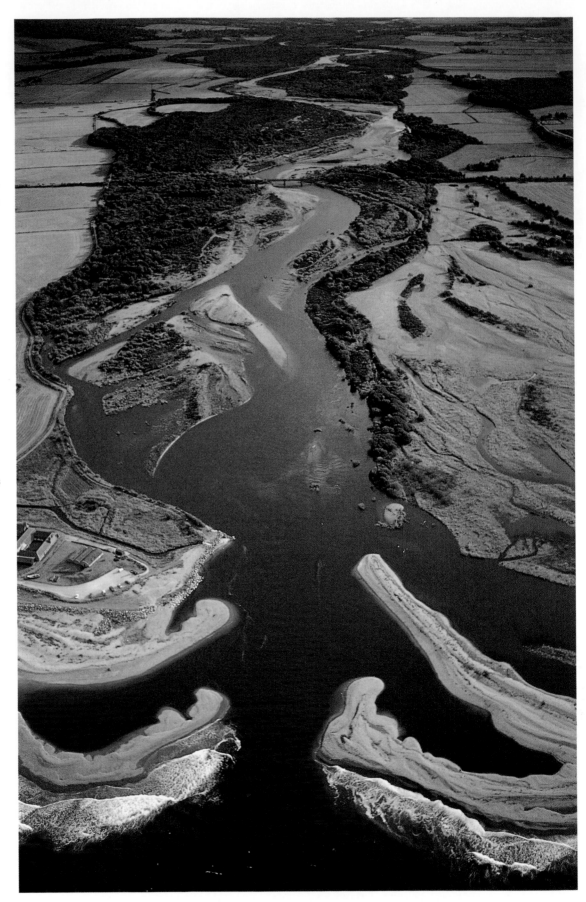

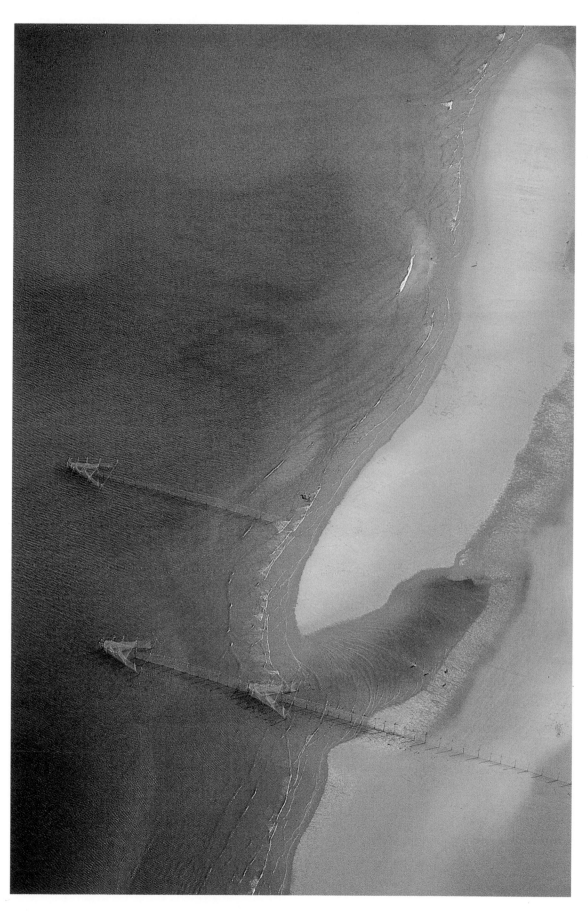

SALMON STAKE NETS, LUNAN BAY, ANGUS

Salmon are migratory fish which spend most of their lives at sea but which return to the rivers of their origin to spawn. They are found in large numbers moving along the North Sea coast of Scotland seeking out the rivers which flow eastwards from the Highlands. In medieval times and throughout the Stewart period they were a valuable export commodity, especially to the Low Countries, where salted Scottish salmon were regarded as a delicacy. They became almost a form of currency and were exchanged for the luxuries which came to Scotland from Europe, particularly wine, and were even used to pay the king's debts. The three main centres of the trade were Banff, near the mouth of the Spey, Aberdeen on the Don and the Dee, and Montrose, close to the rivers North and South Esk.

Lunan Bay, which is near Montrose, remains one of the most active salmon fisheries today. The fish are caught in nets which have the characteristic shape shown here.

AUCHMITHIE, ANGUS

Auchmithie is typical of the many small hamlets which are to be found on the coast of North-east Scotland. Line fishing for white fish has been carried out from here for thousands of years, but the period of greatest activity was in the nineteenth century. The small harbour was built in the 1890s; before that time the boats were launched from the shingle beach. They would have set out in the early morning and returned by midday to allow the fish to be gutted, cured and transported to Dundee or Montrose. Fresh fish were carried in creels to the hinterland for sale. In the afternoons the lines, each with around a thousand hooks, would be baited with shellfish collected from the shore in preparation for the next day's fishing.

In the present day the few remaining boats are engaged in fishing for lobsters and crabs close to the shore. Many of the houses are now holiday cottages or commuter homes.

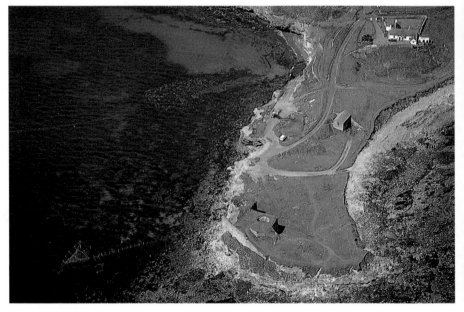

SALMON FISHING STATION, BODDIN POINT, ANGUS

The salmon fishing station at Boddin Point lies at the north end of Lunan Bay. Nets can be seen in the water and hanging on the foreshore where they are dried and repaired.

Commercial salmon fisheries such as this were once common along the entire east coast of Scotland but are now rare, due mainly to the activities of the Atlantic Salmon Trust. This is a charitable body which was set up to promote good fishery management and, in particular, to conserve stocks for anglers. It has bought up and closed down many commercial salmon fisheries to the detriment of the families which have depended for generations on this traditional activity. In fact, recent research has indicated that only 15 per cent of returning salmon were trapped by the net fisheries and 4 per cent caught by anglers. Around 80 per cent of the fish were, therefore, untouched by either of these activities, indicating that reductions in numbers are more likely to be due to other factors such as large-scale commercial fishing in the Atlantic off Greenland, pollution of home rivers by acid rain and industrial waste, and disease, which may also be related to pollution.

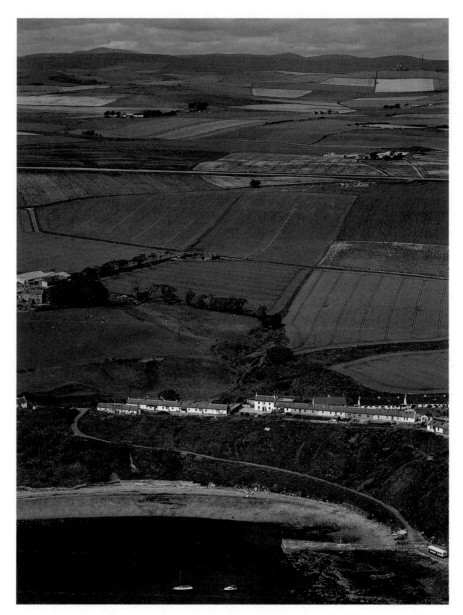

CATTERLINE,
KINCARDINE AND
DEESIDE

Catterline, like Auchmithie,
is a 'heugh-heid' (clifftop)
fishing village. First recorded
in the twelfth century, it was
never a major fishing station
but did, in the nineteenth
century, acquire something
of a reputation for
smuggling. It became famous
in recent times as the home
of the artist Joan Eardley.

The landscape in the
background here was the
boyhood home of the author
James Leslie Mitchell (Lewis
Grassic Gibbon) and formed
the setting for the *Scots
Quair* trilogy, a series of
novels in which the life and
attitudes of the farming
communities of the North-
east are depicted with great
perception and
understanding.

Right opposite Peesie's Knapp, across the turnpike, the land climbed
red and clay and a rough stone road went wandering up to the
biggings of Blawearie. *Out of the World and into Blawearie* they said in
Kinraddie, and faith! it was coarse land and lonely up there on the brae,
fifty-sixty acres of it, forbye the moor that went on with the brae high
above Blawearie, up to a great flat hill-top where lay a bit loch that
nested snipe by the hundred; and some said there was no bottom to it,
the loch, and Long Rob of the Mill said that made it like the depths of
a parson's depravity. That was an ill thing to say about any minister,
though Rob said it was an ill thing to say about any loch, but there the
spleiter of water was, a woesome dark stretch fringed rank with rushes
and knife-grass; and the screeching of the snipe fair deafened you if you
stood there of an evening.

LEWIS GRASSIC GIBBON, *Sunset Song*

INVERALLOCHY AND CAIRNBULG, BANFF AND BUCHAN

The regularly arranged houses in the foreground here are the combined villages of Inverallochy and Cairnbulg. As with most of the small fishing villages on the east coast, the harbour is a relatively recent addition. For centuries the craft from which line fishing for white fish was carried out were simply launched from the shingle beaches. No great feat of the imagination is required to picture the scene as boats up to thirty feet in length and four tons burthen were launched and recovered through the hazardous breakers of the North Sea.

This photograph also shows a typical stretch of the coastline between Aberdeen and Inverness, which is characterised by alternating sandy and rocky stretches, with some of the latter occurring in the form of cliffs rising to heights of around 70m. Normally the rocky stretches were preferred for fishertowns because they gave better ground on which to build houses and a more stable beach from which to launch boats. The town in the background here, which has grown into a large fishing port, is Fraserburgh.

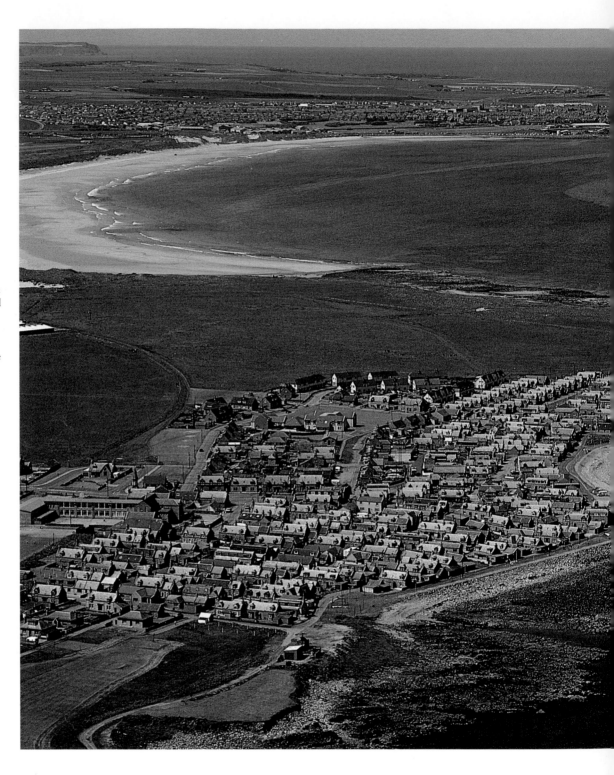

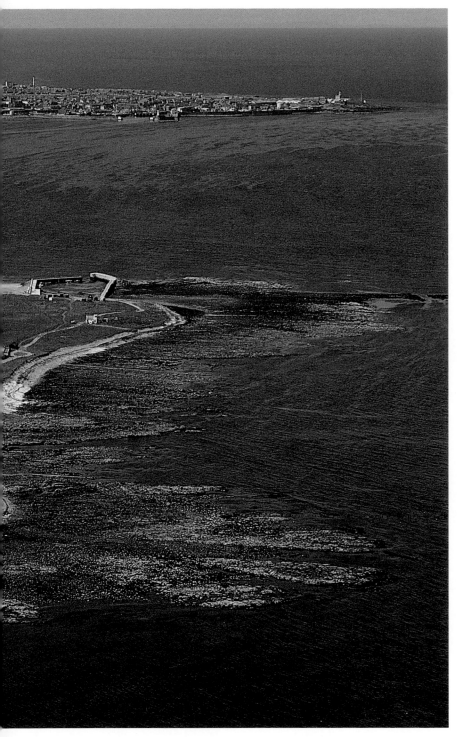

INVERALLOCHY, BANFF AND BUCHAN

The remains of poles on which salmon nets would have been hung to dry and for repair, and of a channel on the foreshore which would have aided the launching and recovery of boats, are clearly seen in this photograph. The houses here date from the late nineteenth century when, following an outbreak of cholera, they were built to replace the irregular clusters of older clay-walled buildings. The arrangement, in which parallel rows of houses present gable ends to the winds and waters of the sea, is typical of the many small fishing towns which were built along the Moray Firth coast in the eighteenth and nineteenth centuries.

NAIRN

Nairn is one of Scotland's ancient royal burghs and has been a fishing and trading port since at least late medieval times. Its fishertown is perhaps the most irregular of those which underwent considerable expansion in the nineteenth century during the boom in herring fishing. Its prosperity increased steadily throughout the period: by 1881, ninety-one boats were working from its harbour, and it was the third busiest herring port in the Moray Firth after Buckie and Portknockie. Like the others, it suffered from the collapse of the herring fishery in the early twentieth century and few boats work from Nairn today.

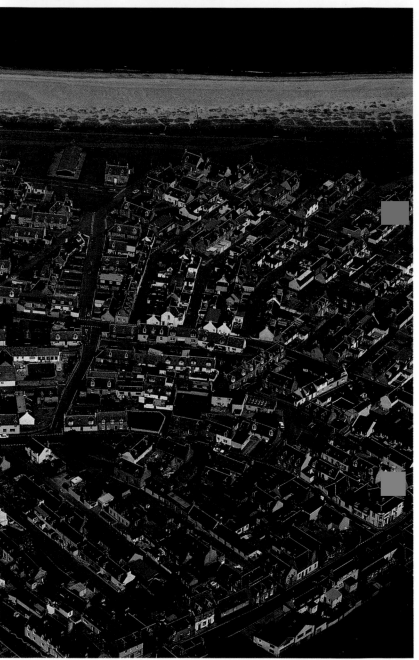

Inheritance

This which I write now
Was written years ago
Before my birth
In the features of my father.

It was stamped
In the rock formations
West of my hometown.
Not I write,

But, perhaps William Bruce,
Cooper.
Perhaps here his hand
Well articled in his trade.

Then though my words
Hit out
An ebullition from
City or flower,

There not my faith,
These the paint
Smeared upon
The inarticulate,

The salt crusted sea-boot,
The red-eyed mackerel,
The plate shining with herring,
And many men,

Seamen and craftsmen and curers,
And behind them
The protest of hundreds of years,
The sea obstinate against the land.

GEORGE BRUCE

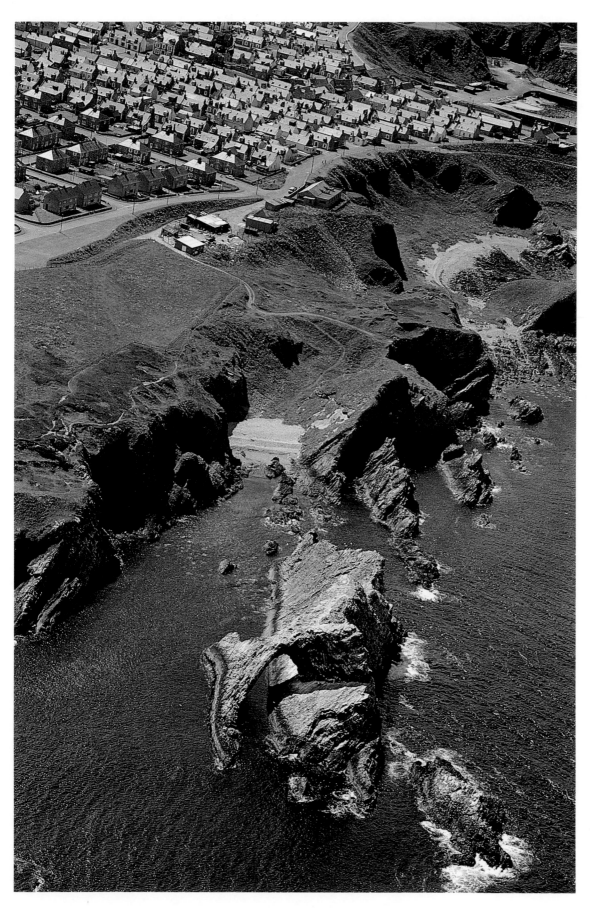

PORTKNOCKIE, MORAY

Where the preferred rocky stretches of coast took the form of cliffs and there was insufficient space near the shore, villages were built on the higher ground at the clifftop, as here at Portknockie. The part illustrated was built in the nineteenth century. Clifftop sites were inconvenient: not only had the catch to be carried up from the shore but, because the work of baiting and preparing the lines was carried out in the houses, the gear too had to be transported up and down the precipitous pathways.

The famous natural arch in the foreground of this photograph is the 'Bow-fiddle', so called for obvious reasons.

FRASERBURGH, BANFF AND BUCHAN

By the end of the nineteenth century fishing for herring was carried out on a very large scale. The industry was dependent on an export trade, principally to Russia and Eastern Europe, and this required that the catch be cured, which was done by packing the fish in barrels between layers of salt. The need for a large-scale curing capacity and, following the introduction of steam-powered boats, for sophisticated repair and maintenance facilities, caused a concentration of activity into a few large centres, of which Fraserburgh was one.

Fraserburgh was founded in 1546 and, until the beginning of the nineteenth century, was similar to other settlements on the Moray Firth coast with a small number of vessels engaged in line fishing, operating from the foreshore. The harbour was begun in 1814 and building work was destined to continue for most of the nineteenth century as more and more basins were added to accommodate the expanding herring fleet which came to be based there.

Fraserburgh remains a major fishing port in the present day with facilities for curing and for ship repair. The vessels in the photograph are a mixture of seine-netters and purse-netters.

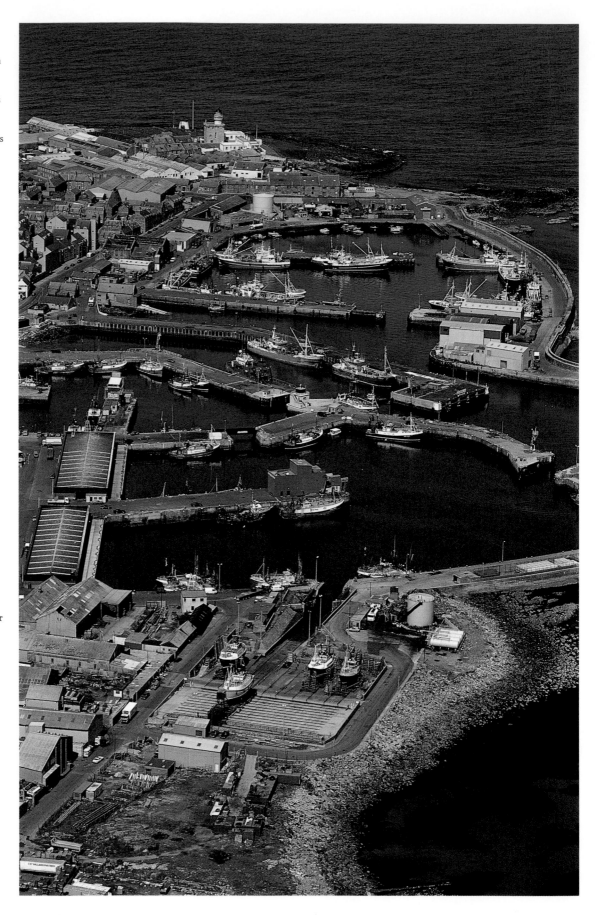

Clann-nighean an Sgadain

An gàire mar chraiteachan salainn
ga fhroiseadh bho 'm beul,
an sàl 's am picil air an teanga,
's na miaran cruinne, goirid a dhèanadh giullachd,
no a thogadh leanabh gu socair, cuimir,
seasgair, fallain,
gun mhearachd,
's na sùilean cho domhainn ri fèath.

B'e bun-os-cionn na h-eachdraidh a dh'fhàg iad
'nan tràillean aig ciùrairean cutach,
thall 's a-bhos air Galldachd 's an Sasuinn.
Bu shaillte an duais a thàrr iad
às na mìltean bharaillean ud,
gaoth na mara geur air an craiceann,
is eallach a' bhochdainn 'nan ciste,
is mura b'e an gàire
shaoileadh tu gu robh an teud briste.

Ach bha craiteachan uaille air an cridhe,
ga chumail fallain,
is bheireadh cutag an teanga
slisinn à fanaid nan Gall –
agus bha obair rompa fhathast
nuair gheibheadh iad dhachaidh,
ged nach biodh maoin ac':
air oidhche robach gheamhraidh,
ma bha siud an dàn dhaibh,
dhèanadh iad daoine.

<div align="right">RUARAIDH MACTHOMAIS</div>

The Herring Girls

Their laughter like a sprinkling of salt
showered from their lips,
brine and pickle on their tongues,
and the stubby short fingers that could handle fish,
or lift a child gently, neatly,
safely, wholesomely,
unerringly,
and the eyes that were as deep as a calm.

The topsy-turvy of history had made them
slaves to short-arsed curers,
here and there in the Lowlands, in England.
Salt the reward they won
from those thousands of barrels,
the sea-wind sharp on their skins,
and the burden of poverty in their kists,
and were it not for their laughter
you might think the harp-string was broken.

But there was a sprinkling of pride on their hearts,
keeping them sound,
and their tongues' gutting knife
would tear a strip from the Lowlanders' mockery –
and there was work awaiting them
when they got home,
though they had no wealth:
on a wild winter's night,
if that were their lot,
they would make men.

<div align="right">DERICK THOMSON</div>

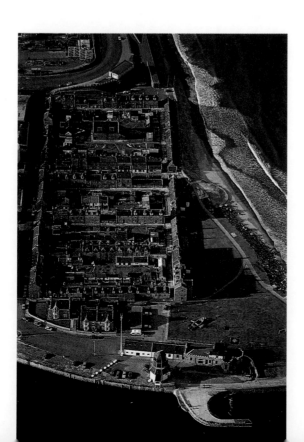

FOOTDEE, ABERDEEN

Footdee (locally pronounced 'Fittie' or 'Futtie') was rebuilt by the town council for Aberdeen's fishing community at the very beginning of the nineteenth century. The arrangement, based on three squares, was inward-looking. Initially the houses had no windows in the walls which formed the perimeter of the development. In the first half of the nineteenth century most of the crews which worked from Aberdeen were engaged in line fishing for white fish. The scale of the activity was modest, with only forty boats by the middle of the century, but it then expanded rapidly and by 1868 there were over a hundred line boats and a slightly larger number engaged in herring fishing. The real expansion of fishing in Aberdeen came in the 1880s following the development of trawling, which became possible after the introduction of powered vessels.

ABERDEEN

Despite its obvious suitability, Aberdeen did not become one of the major herring ports of the North-east during the phenomenal growth of the herring fishing industry in the nineteenth century. It does, however, warrant a place in the history of the development of North Sea fisheries because the fishermen of Aberdeen were pioneers of trawling. This technique of dragging a bag-net behind a boat was not feasible before the days of powered vessels, but once developed, it revolutionised the white-fish industry which was concerned with the relatively deep-swimming species such as cod and halibut, formerly only caught by the laborious line-fishing method.

Trawling was first carried out from Aberdeen in 1883 and, like the herring industry before it, it rapidly underwent phenomenal expansion. The boom years were those before the 1914–18 war following which Aberdeen lost its place to Hull and Grimsby as the premier trawling port. The last three decades have seen a rapid decline in trawling as fish stocks have dwindled and fishing grounds have been closed.

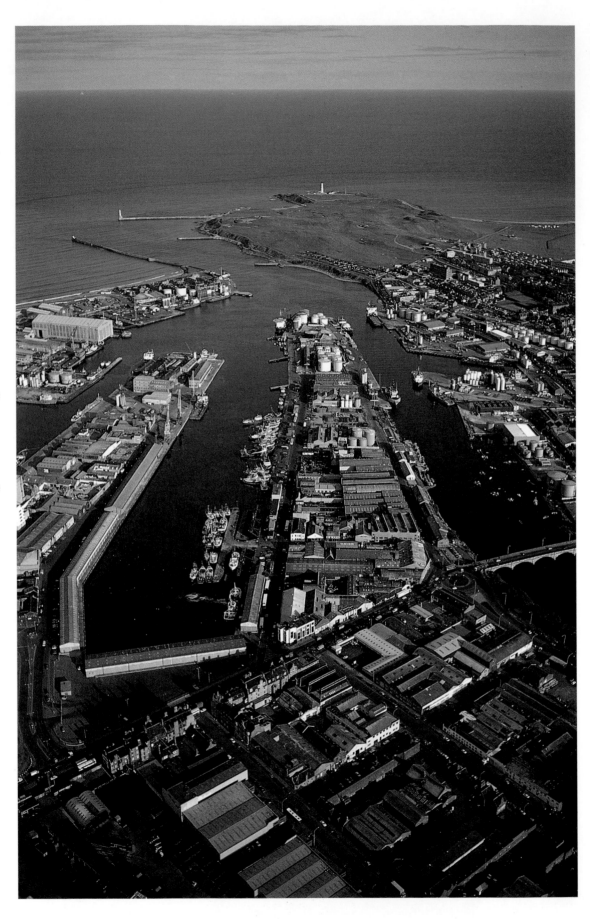

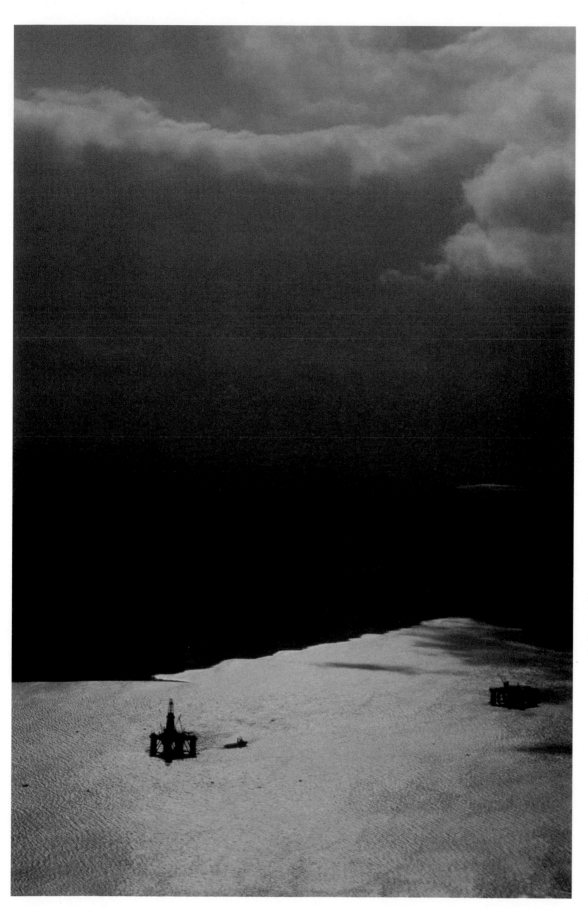

OIL RIG, CROMARTY FIRTH, ROSS AND CROMARTY

Oil rigs and platforms, those classic images of the offshore petroleum industry, have been seen in increasing numbers around the Scottish coasts since the early 1970s. They are the most visible reminders of the presence of a very large extraction industry which operates, out of sight of land, in the extremely inhospitable waters of the North Sea. In the northern sector there are around 160 platforms and other installations concerned with the extraction of oil and gas, and many rigs engaged in exploration. Each one of these is a highly complex, multi-million pound structure.

Although the value of the oil and gas extracted from the North Sea since production began in 1975 can be stated in figures, the effect of it on the British economy, and therefore on the lives of the British population, is incalculable. It will remain to be seen how the disappearance of this earner of prodigious amounts of foreign currency will affect the wellbeing of subsequent generations once the oil and gas fields are finally exhausted. There is little evidence in Britain that the huge benefit of this 'windfall' is being used to make provision for the future.

CONSTRUCTION YARD, ARDERSIER, INVERNESS

The direct effects of the petroleum industry on Scotland's economy have occurred through the construction of rigs, platforms and installations, through the processing of a proportion of the crude oil and gas, and through the servicing of the industry. The sector which has created the greatest number of jobs has been that of construction. McDermott's yard at Ardersier, near Inverness, which manufactures components for platforms and other installations, was established in 1972 and is the largest in Scotland. Although the bulk of its work has been for the North Sea, it has also fulfilled contracts for Norway, Denmark, the Netherlands and Brazil. It currently employs around 2,000 people.

The extent to which any of the jobs which have been created by the North Sea petroleum industry will survive in the long term is uncertain. This will only happen if the accumulated expertise becomes permanently involved with the supply of oil goods to an international market and therefore independent of the state of the reserves of oil in local waters. The fact that most of the companies involved with large-scale oil-related industry, such as that at Ardersier, are owned and controlled from outside Britain does nothing to relieve the degree of uncertainty concerning its long-term prospects on Scottish soil.

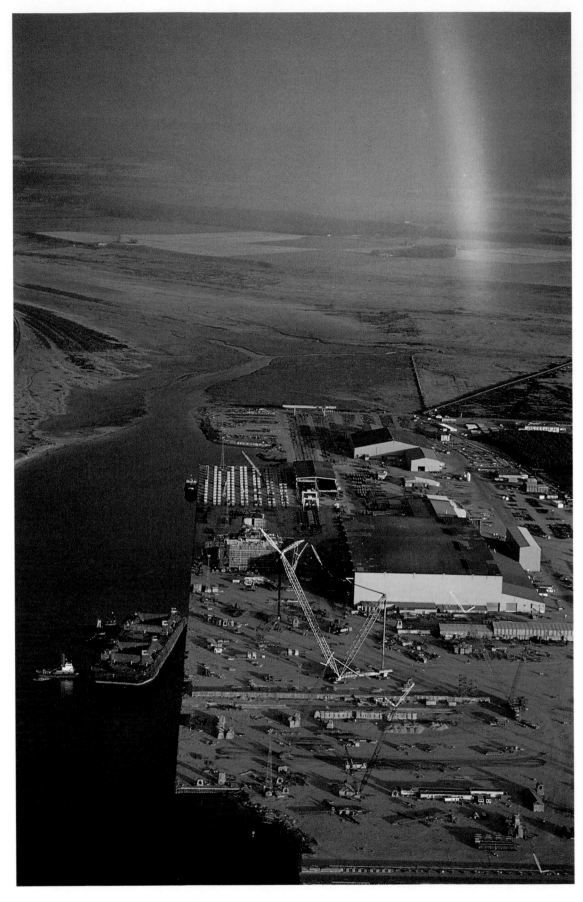

PIPELINE LANDFALL,
ST FERGUS GAS
TERMINAL, BANFF AND
BUCHAN

Since the beginning of the
1980s Britain has been
totally dependent on the
North Sea for its gas supply.
St Fergus is the major
terminal and is linked to the
Brent, Frigg, Alwyn, Tartan
and Ivanhoe/Rob Roy Gas
Fields as well as to several
other smaller fields. It is also
an important link in FLAGS
(Far-north Liquid and
Associated Gas System)
which pumps liquid gas to
the processing plant at
Mossmoran in Fife. A £650-
million expansion
programme, in several
phases, is currently (1992)
taking place at St Fergus.

The level of investment
which is involved in winning
and distributing oil and gas
from the North Sea is
staggeringly large. The
technical skill and ingenuity
which is displayed by the
industry is also of a very high
order.

The profligacy with
which the precious
commodities extracted from
the sea bed are being
consumed, when it is
considered that millions of
years were required to lay
down what will be used up in
a few decades, casts a
shadow over this impressive
endeavour.

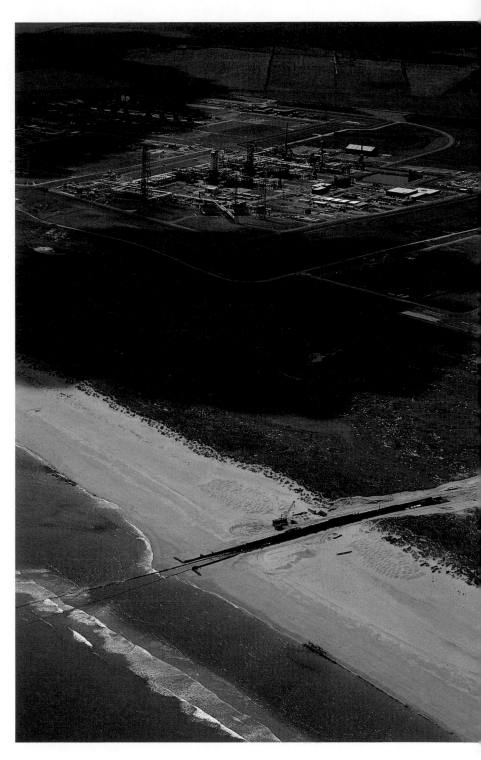

Oilmen

It wasn't the Springtime or the Autumn.
It was the winter that the strangers came
and offered money for our lives.

We are the people who were never fooled
or swung off balance like the others.
We saw through many a kilted boast.
We held back from the iron raiders.

I told them this, and I said –
you have no notion how they'll use us.
But their necks stretch to suck the sea,
their ears are full of the black
wealth chocking.

From all this, I make a song.
The power will always be the gold
and the barrel of the gun.
Poetry is the report
in whatever space is left.

ROBIN MUNRO

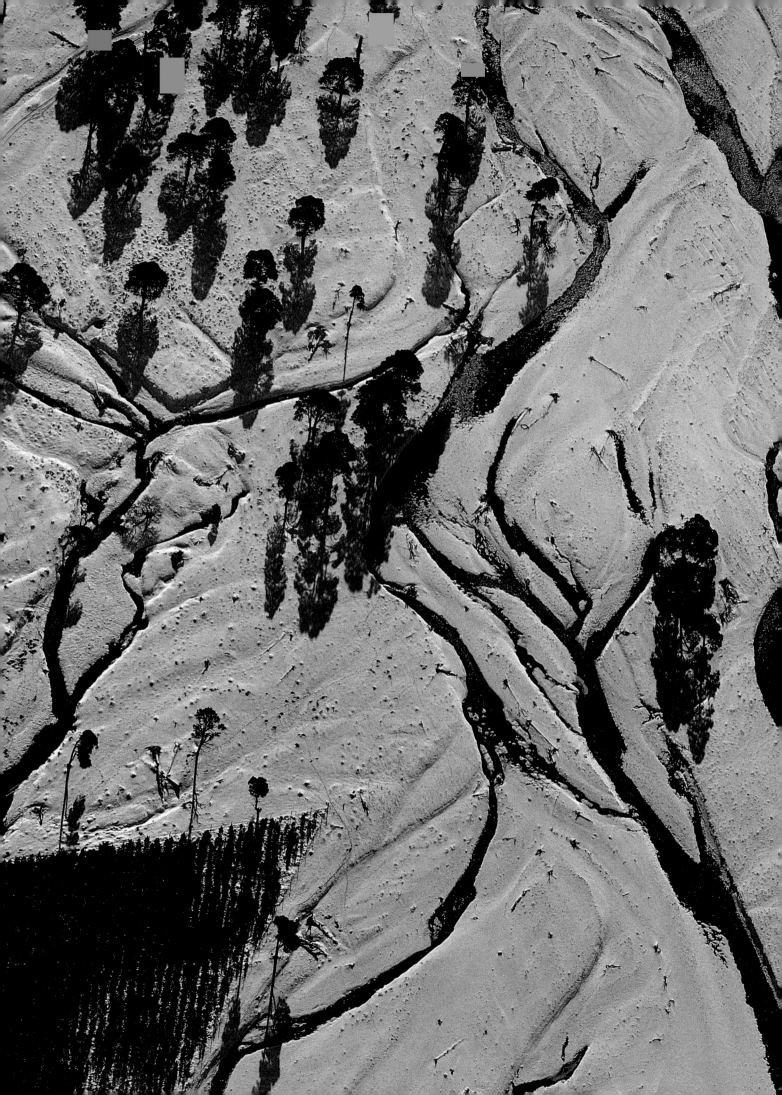

POSTSCRIPT

IN A COUNTRY SUCH AS SCOTLAND, THE WELLBEING OF the human population depends today, as it has always done, on the resources which are available to it. Some of these are inevitably consumed and once used are 'lost' virtually forever from a human point of view. Such is the case with many minerals, especially those which are primary sources of energy like North Sea oil and gas. It can be the case with land too which, if not properly worked, can become eroded and barren. Others, such as fish populations and forests, are renewable if not over-exploited. Yet others are created by mankind: the historical heritage, which has accumulated in Scotland over the centuries, is now one of the resources which are available to the growing tourist industry. This too is vulnerable, however: if an historic site becomes spoiled by excessive tourist development, its value as a resource is diminished. If a town is made so ugly by development that no one wants to live there, then its value as a resource is destroyed as effectively as if it had been a mature woodland – capable of regenerating itself continuously, but which has been turned into a wasteland of peat by clear-felling in a climate of high rainfall.

Scotland's record of caring for the resources on which people have depended for their livelihood has not been a good one. The ancient deciduous forests, which could have been cropped continuously on the coppicing principle, have gone, to be replaced, at best, by rough grazing for sheep or deer, rearing grounds for grouse, or monoculture forests of non-native coniferous species. None of these is capable of supporting the level of rural population which the industries based on mature deciduous forest could have done. Neither are they so visually attractive. It appears that the days in which a plentiful harvest could be won from the sea are gone too, due to drastic depletion of fish numbers partly as a result of over-fishing and pollution. Even the agriculture of the coastal lowlands, which in recent years was apparently a thriving industry, can now be seen to have been existing in a make-believe world of subsidies and bureaucratic directives which brought about the intensive, high-technology working of the land. Its impoverishment in real terms is now apparent with the continued depopulation of the countryside, and now, finally, the reduction of the industry to near bankruptcy.

If there is a single important lesson to be learned from the history of the ways in which the Scottish people have used their resources, it is that attempts to dominate Nature, and neglect of the long-term for the sake of short-term profit, follow an inexorable law of diminishing

SCOTS PINES, GLEN FESHIE, BADENOCH AND STRATHSPEY

159

returns. It would be satisfying to be able to conclude on a positive note with the thought that this lesson might finally be in the process of being learned. It is to be hoped that in future the ideas of developing respect for, and accommodating to, Nature might be allowed to predominate and that the most important issue governing any action which involves a 'resource', be it an historic monument, a pine-clad hillside or a farmer's field, might be that the activity be demonstrably sustainable in the long term.

One Foot in Eden

One foot in Eden still, I stand
And look across the other land.
The world's great day is growing late,
Yet strange these fields that we have planted
So long with crops of love and hate.
Time's handiworks by time are haunted,
And nothing now can separate
The corn and tares compactly grown.
The armorial weed in stillness bound
About the stalk; these are our own.
Evil and good stand thick around
In the fields of charity and sin
Where we shall lead our harvest in.

Yet still from Eden springs the root
As clean as on the starting day.
Time takes the foliage and the fruit
And burns the archetypal leaf
To shapes of terror and of grief
Scattered along the winter way.
But famished field and blackened tree
Bear flowers in Eden never known.
Blossoms of grief and charity
Bloom in these darkened fields alone.
What had Eden ever to say
Of hope and faith and pity and love
Until was buried all its day
And memory found its treasure trove?
Strange blessings never in Paradise
Fall from these beclouded skies.

EDWIN MUIR

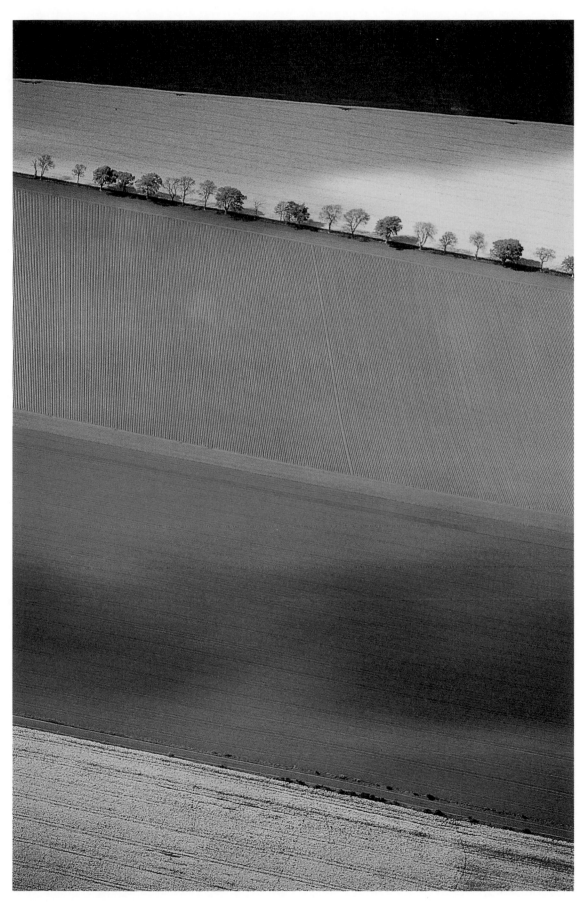

FIELDS, GORDON

Well-ordered fields of even colour are unnatural and are highly unstable systems which can only be sustained by much effort and by the use of high inputs of fertiliser, herbicide and pesticide. The present agricultural system depends on a high level of subsidy, which, in Scotland in the late 1980s, was at the level of £1,000,000 per day. It came about as a consequence of government policies intended to provide a reliable source of food at reasonable prices while giving a reasonable return to the farmer: laudable aims.

This system has been criticised increasingly in recent years due to its effect on the environment and on the rural way of life generally. Employment levels have fallen as farming has become more mechanised and the proportion of the countryside which remains semi-wild has been greatly reduced and the environment generally degraded. The latter effect has happened directly, as a result of the deliberate destruction of habitats such as woodlands and hedgerows, and indirectly, as a result of pollution by agricultural chemicals. The most unanswerable criticism of this high-tech agriculture is that it is not sustainable in the long term. Governments are at last recognising this, but changes in policy, such as the recent 'set-aside' scheme, fall far short of what is necessary to provide a sustainable system for the future.

FORESTRY, GLEN FESHIE, BADENOCH AND STRATHSPEY

Forestry practices are another aspect of rural land use which have been subject to increasing criticism in recent years. As in the case of intensive forms of farming, the principal stimulus for new planting is Government subsidy of one kind or another, which is aimed at decreasing the levels of imported timber. From an environmental viewpoint, this is a worthy purpose, but the manner in which it is being accomplished leaves much to be desired.

The blanket planting of monocultures of alien conifer species, such as is seen here, is the equivalent in forestry of intensive arable farming. It damages the environment, detracts from the appearance of the countryside and gives minimal opportunities for increasing employment levels and, therefore, of arresting depopulation. A more long-term strategy, in which native species are reinstated and their use linked to the establishment of a timber-based rural industry, might provide for a better future.

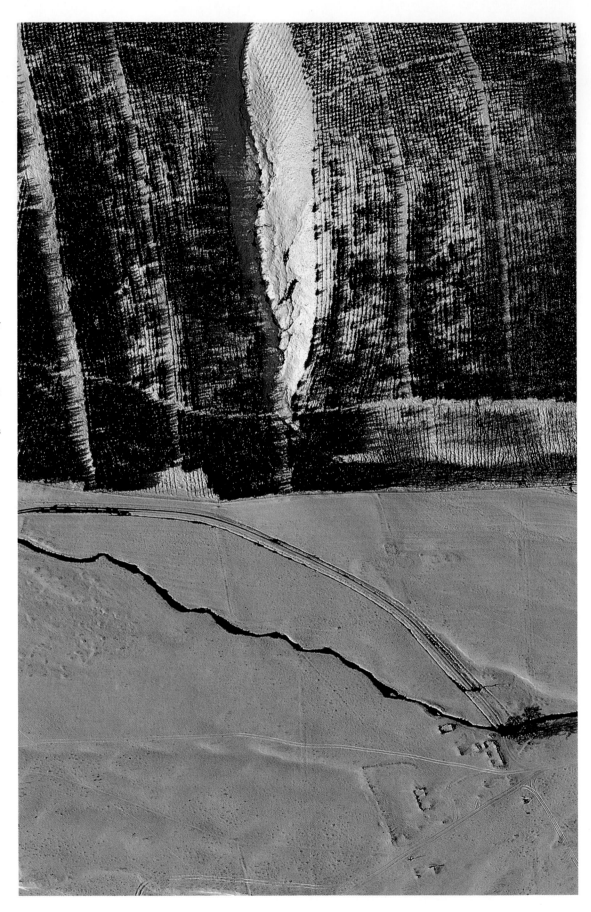

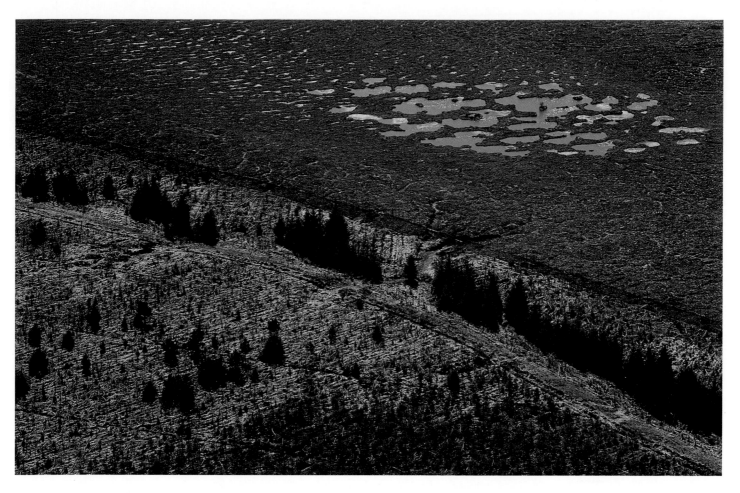

STRATHY FOREST, CAITHNESS

The largest areas of wetland in the British Isles occur in Caithness and Sutherland. Much controversy surrounds the strategy for the future of these peatlands. There is a fairly straightforward conservation argument for preserving this 'wilderness' area in the form in which it has existed for centuries as a habitat for various species of wetland plants, animals and birds. There is a strong lobby, however, which favours developing the area, both by exploitation of the peat itself for fuel and as a soil-conditioner, and for forestry. The latter activity requires that extensive drainage works be carried out. Even so, as can be seen from the photograph, the conditions are by no means ideal for growing trees. It is difficult to see why forests should be planted here, given the amount of unproductive upland which exists in Scotland which would be more suitable for the purpose.

Aviemore

The hills are stark, their outlines hard with frost.
From here, serene, inviolate; but closer, their ancient crusts
Erode into man-made scars, snow-filled and teeming.
The eagle eye pans in, and fixes on
A small irritation, a motion of molecules –
Skiers, swooping like disorientated rooks, go
Orderly like ants, pursuing
Relentless tracks up by twos, down in hordes –
Anthills are huge, snow slopes vast shouting spaces
Telescoped into silence. All that
Minute scurrying toil might make Sisyphus groan,
But from the geological viewpoint
They're just scratching the surface.
Makes a break, too (for us
Not Sisyphus).

JANET WALLER

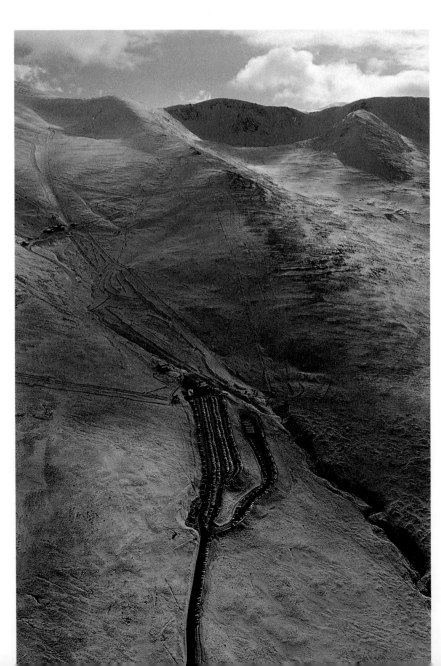

SKIING IN COIRE CAS, CAIRNGORMS, BADENOCH AND STRATHSPEY

Skiing is just one of the many forms of recreation which the landscapes and seascapes of the North-east offer to both tourists and inhabitants. In this context too, it is important that the land should not be considered simply as a resource which is available for exploitation but as part of a delicate system which should be respected and disturbed as little as possible. As in the cases of agriculture and forestry, this is an attitude of common sense and not, as it is often portrayed by those who wish to exploit resources to the point of extinction for the sake of short-term gain, one of sentimentality. If a resource is destroyed, no one benefits in the long term. In locations such as the Cairngorms, the amount of development for recreational purposes which can be sustained before the environment is damaged to unacceptable levels and the amenity of the area destroyed, is very limited.

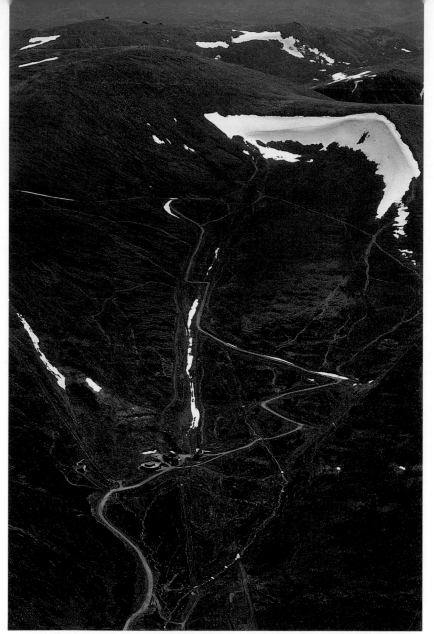

COIRE CAS IN SUMMER, BADENOCH AND STRATHSPEY

The effects of the pressure of visitors of all types on the extremely fragile vegetation of Cairngorm can be judged from this midsummer view of the area. The dangers of excessive tourist development in the Highlands are well articulated in the words of the character Andy McChuckemup, a 'Glasgow property-operator's man':
So – picture it, if yous will, right there at the top of the glen, beautiful vista – The Crammem Inn, High Rise Motorcroft – all finished in natural, washable, plastic granitette. Right next door, *the 'Frying Scotsman' All Night Chipperama – with a wee ethnic bit, Fingal's Caff serving seaweed-suppers-in-the-basket, and draft Drambuie. And to cater for the younger set, yous've got your Grouse-a-go-go. I mean, people very soon won't want your bed and breakfast, they want everything laid on, they'll be wanting their entertainment and that, and wes've got the know-how to do it and wes have got the money to do it. So – picture it, if yous will – a drive-in clachan on every hill-top where formerly there was hee-haw but scenery.*

The Cheviot, the Stag and the Black, Black Oil,
John McGrath

Hills

Leisure hills, motorway connected.
Fashioned ski-ing hills, quality inspected.
Hills with plastic huts erected.
Hills where economic gain's detected.
Hills the planning men corrected.
Hills injected, hills dissected.
Hills the TV resurrected:
man-infected, man-protected. Hills
where nuclear waste's expected:

the long identifying Island hills,
the giant-fighting Shetland boulders,
the thrust and relict hills of Torridon,
and Galloway.

Wherever hills grow hard, put them to the test.

ROBIN MUNRO

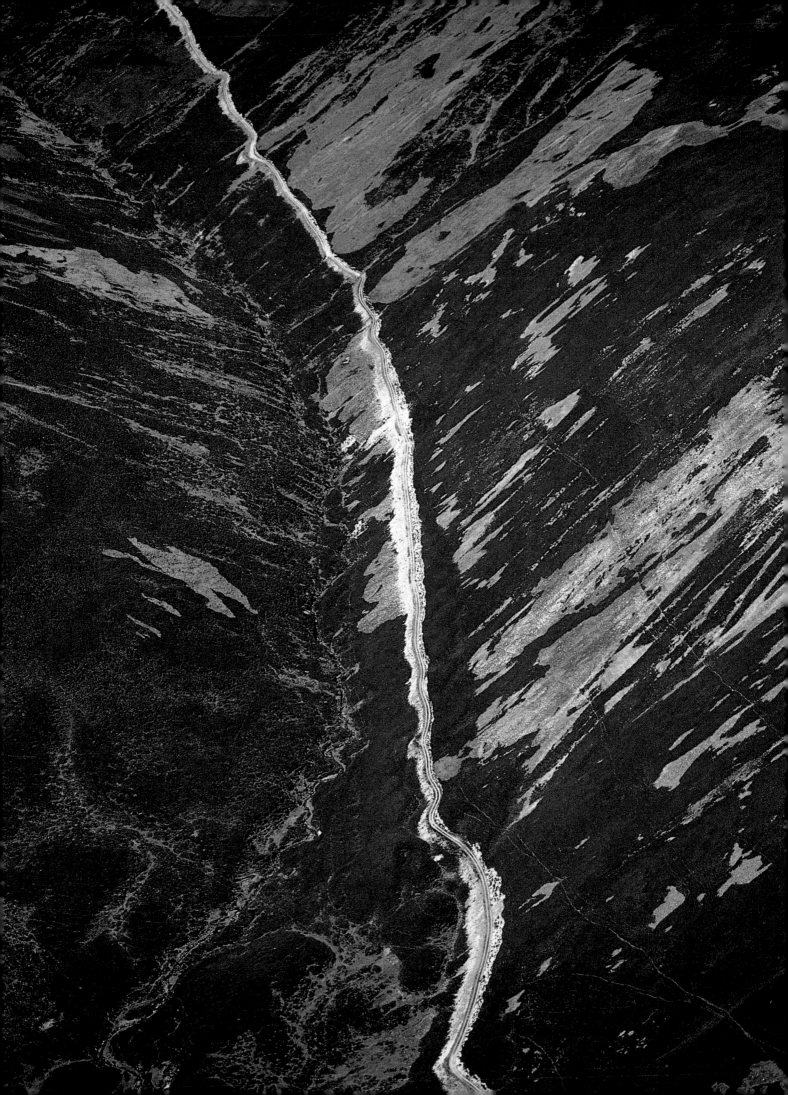

The Guns

Now, on the moors where the guns bring down
The predestinated birds,
Shrill, wavering cries pass
Like the words of an international peace;
And I would that these cries were heard in every town,
Astounding the roar of the wheel
And the lying mouth of the news:
And I would that these cries might more and more increase
Until the machine stood still;
And men, despairing in the deathly queues,
Heard their own heart-beats
Shouting aloud, in the silence of the streets:
'Are we not also hand-fed in a wilderness:
What are we waiting for?'

WILLIAM SOUTAR

SELECTED BIBLIOGRAPHY

Alison, James (Ed), *Poetry of North-east Scotland*, London and Edinburgh, Heinemann, 1978

Baird, W. J., *The Scenery of Scotland*, Edinburgh, National Museums of Scotland, 1988

Barrow, G. W. S., *Kingship and Unity: Scotland 1000–1306*, Edinburgh, Edinburgh University Press, 1981

Bell, Robin (Ed), *The Best of Scottish Poetry: An Anthology of Contemporary Scottish Verse*, Edinburgh, Chambers, 1989

Beveridge, C. and Turnbull, R., *The Eclipse of Scottish Culture*, Edinburgh, Polygon, 1989

Brown, Hamish (Ed), *Poems of the Scottish Hills*, Aberdeen, Aberdeen University Press, 1982

Clapperton, C. M. (Ed), *Scotland: A New Study*, Newton Abbot, David and Charles, 1983

Close-Brooks, Joanna, *Exploring Scotland's Heritage – The Highlands*, Edinburgh, HMSO, 1986

Cruden, Stewart, *The Scottish Castle*, Edinburgh, Spurbooks, 1981

Daiches, D. (Ed), *A Companion to Scottish Culture*, London, Edward Arnold, 1981

Donaldson, W. and Young, D., *Grampian Hairst*, Aberdeen, Aberdeen University Press, 1981

Dunbar, J. G., *The Architecture of Scotland* (2nd Edition), London, Batsford, 1978

Feachem, Richard, *Guide to Prehistoric Scotland*, London, Batsford, 1977

Fraser Darling, F. and Morton Boyd, J., *Natural History in the Highlands and Islands*, London, Bloomsbury Books, 1989

Gibbon, Lewis Grassic, *A Scots Quair*, London, Hutchinson, 13th impression 1974

Grant, Alexander, *Independence and Nationhood: Scotland 1306–1469*, London, Edward Arnold, 1984

Grieve, Michael and Aitken, W. R. (Ed), *The Complete Poems of Hugh MacDiarmid*, Harmondsworth, Penguin, 1985

Kay, Billy (Ed), *The Dundee Book*, Edinburgh, Mainstream Publishing, 1990

King, Charles (Ed), *Twelve Modern Scottish Poets*, London, Hodder and Stoughton, 1989

Leneman, L. (Ed), *Perspectives in Scottish Social History*, Aberdeen, Aberdeen University Press, 1988

MacAulay, Donald, *Nua - Bhardachd Ghaidhlig/*

Modern Scottish Gaelic Poems: A Bilingual Anthology, Edinburgh, Canongate, 1987

Macaulay, J., *The Classical Country House in Scotland 1660–1800*, London, Faber and Faber, 1987

McDowall, R. J. S., *The Whiskies of Scotland*, 4th Edition (revised W. Waugh), London, John Murray, 1986

McGrath, J., *The Cheviot, the Stag and the Black, Black Oil*, London, Methuen, 1981

MacLean, Charles, *The Fringe of Gold*, Edinburgh, Canongate, 1985

Marren, P., *Grampian Battlefields*, Aberdeen, Aberdeen University Press, 1990

Maxwell, G. S., *The Romans in Scotland*, Edinburgh, Mercat Press, 1989

Muir, Edwin, *Collected Poems*, London, Faber and Faber, 1960

Nethersole-Thompson, D. and Watson, A., *The Cairngorms*, Perth, Melvin Press, 1981

Ritchie, Anna, *Exploring Scotland's Heritage – Orkney and Shetland*, Edinburgh, HMSO, 1985

Ritchie, Graham and Anna, *Scotland: Archaeology and*

Ross, S., *Monarchs of Scotland*, Moffat, Lochar Publishing, 1990

Shepherd, Ian A. G., *Exploring Scotland's Heritage – Grampian*, Edinburgh, HMSO, 1986

Simpson, W. D., *Craigievar Castle*, Edinburgh, The National Trust for Scotland, 1978

Early History, London, Thames & Hudson, 1981

Smith, J. S. (Ed), *North East Castles*, Aberdeen, Aberdeen University Press, 1990

Smith, J. S. and Stevenson, D., *Fermfolk and Fisherfolk*, Aberdeen, Aberdeen University Press, 1989

Smith, R., *One Foot in the Sea*, Edinburgh, John Donald, 1991

Smout, T. C., *A History of the Scottish People 1560–1830*, London, Collins, 1969

Smyth, A. P., *Warlords and Holy Men: Scotland AD 80–1000*, Edinburgh, Edinburgh University Press, 1984

White, Kenneth, *Handbook for the Diamond Country*, Edinburgh, Mainstream Publishing, 1990

Whittow, J. B., *Geology and Scenery in Scotland*, Harmondsworth, Penguin Books, 1977

Wormald, Jenny, *Court, Kirk, and Community: Scotland 1470–1625*, London, Edward Arnold, 1981

LOCH TUMMEL AND
LOCH RANNOCH,
LOOKING WESTWARD